THE WORLD OF ROBERT BATEMAN

To Jim...
best wishes
Robert Bateman
Jan/86.

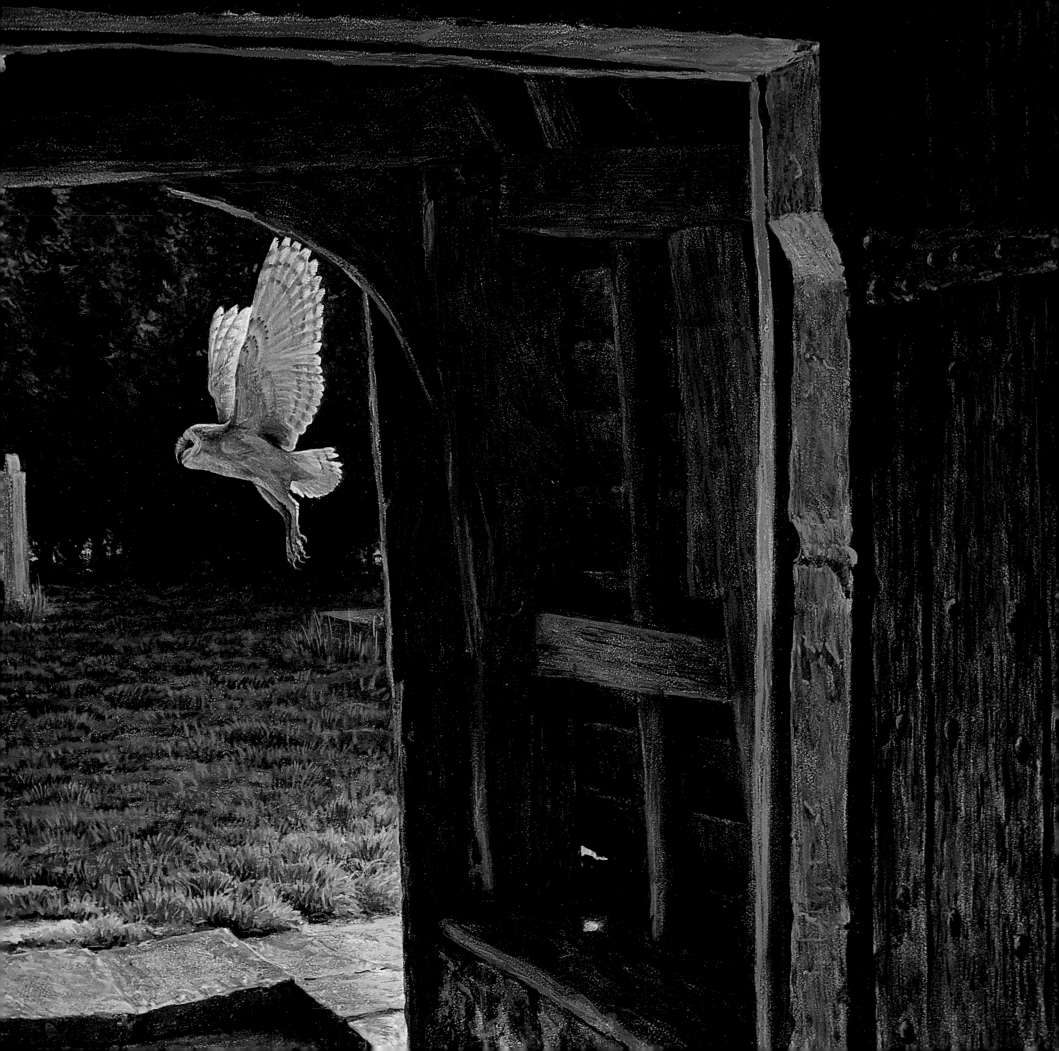

THE WORLD OF ROBERT BATEMAN

Text by Ramsay Derry

Design by V. John Lee

A Random House/Madison Press Book

4

Text and compilation copyright © 1985
by Madison Press Books.

Artwork copyright © 1985 by Boshkung Inc.

All rights reserved under International and Pan-American
Copyright Conventions. Without limiting the rights under
copyright reserved above, no part of this publication may be
reproduced, stored or introduced into a retrieval system, or
transmitted in any form or by any means (electronic, mechan-
ical, photocopying, recording or otherwise), without the prior
written permission of the copyright owners, except for brief
passages quoted by a reviewer in a newspaper or magazine.

First published in Canada by Viking, Penguin Books Canada
Ltd., 2801 John St., Markham, Ontario L3R 1B4.

First published in the United States of America by Random
House Inc., 201 East 50th St., New York, N.Y. 10022.

First published in Great Britain by Viking, Penguin Books,
Harmondsworth, Middlesex, England.

British Cataloguing in Publication Data available.

First Edition 1985.

Canadian Cataloguing in Publication Data.

Derry, Ramsay
 The world of Robert Bateman.

ISBN 0-670-80679-X

1. Bateman, Robert, 1930- . 2. Birds in art.
3. Mammals in art. 4. Painters – Canada – Biography.
5. Naturalists – Canada – Biography. I. Bateman, Robert,
1930- . II. Title.
QH31.B24D48 1985 759.11 C85-098185-9

Library of Congress Cataloging in Publication Data.

Derry, Ramsay
 The world of Robert Bateman.

I. Bateman, Robert, 1930- . II. Title.
ND249.B348D47 1985 759.11 84-29837
ISBN 0-394-54654-7

NOTICE

This book may not be reproduced in any manner or the pages
or artwork applied to any materials listed but not limited to
the following:

– Cut, trimmed or sized to alter the existing trim size of the
pages.
– Laminated, transferred or applied to any substance, form or
surface.
– Carved, molded or formed in any manner in any material.
– Lifted or removed chemically or by any other means, or
transferred to produce slides or transparencies.
– Used as promotional aids, premiums, or advertising or for
non-profit or educational purposes.
– Engraved, embossed, etched or copied by any means onto
any surfaces whether metallic, foil, transparent or translucent.
– Matted or framed with the intent to create other products
for sale or re-sale or profit in any manner whatsoever, without
express written consent from:
Boshkung Inc. c/o Madison Press Books, 40 Madison Ave.,
Toronto, Ont. Canada, M5R 2S1.

The publisher is grateful to the following people for
permission to use their photographs:

*Birgit Freybe Bateman: 16, 23, 26, 34, 37, 39, 45, 48, 51
(top left and right), 52 (bottom left), 54 (top left); Ramsay
Derry: 17, 24, 27, 28, 29, 30, 35 (top left), 51 (bottom
left), 58; John Evans, Ottawa: 52 (top right); Norman R.
Lightfoot: 54 (top right), 56, 60; University of Guelph
Illustration Services, Herb Rauscher photographer: 52 (top
left); Hubert de Santana: 15, rear jacket flap; John Warden:
35 (top right), 52 (bottom center).*

Produced by:
Madison Press Books
40 Madison Avenue
Toronto, Ontario
Canada M5R 2S1

Printed in Italy

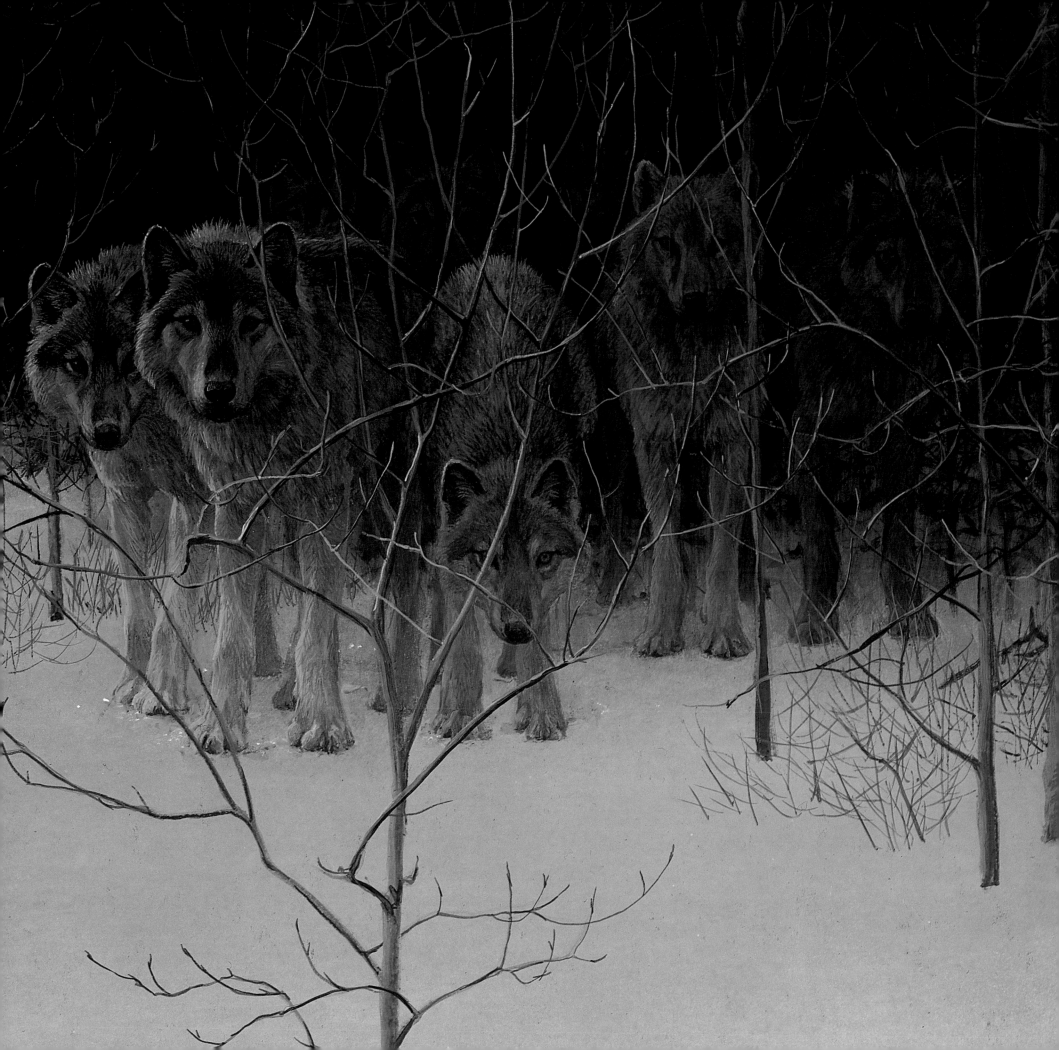

6 | *To my children, Alan, Sarah, John,*
Christopher, and Robbie, with appreciation
for their companionship and for bringing joy
to my world. I hope that they find the
rewards in our natural and human heritage
that have meant so much to me.

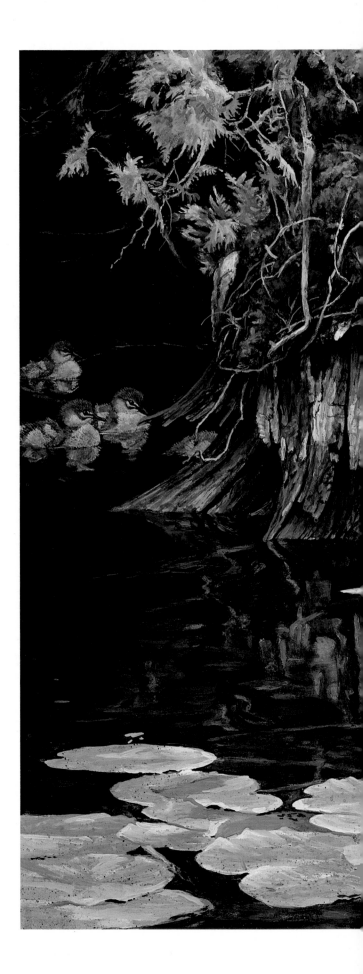

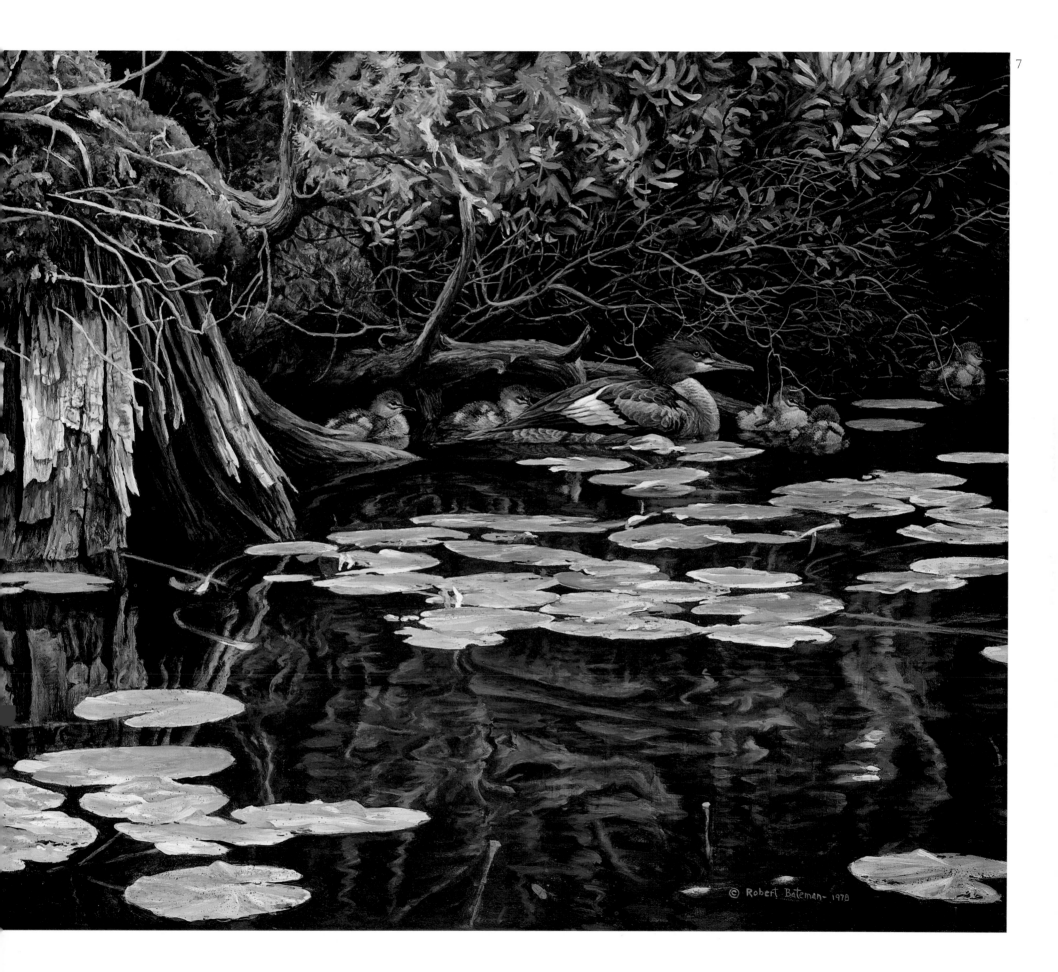

© Robert Bateman - 1978

8 *"I can't conceive of anything being more varied and rich and handsome than the planet Earth. And its crowning beauty is the natural world. Whether it's here in Ontario or in the Antarctic or in Africa, I want to soak it up, to understand it as well as I can, and to absorb it. And then I'd like to put it together and express it in my paintings. This is the way I want to dedicate my work."*

Robert Bateman, 1981

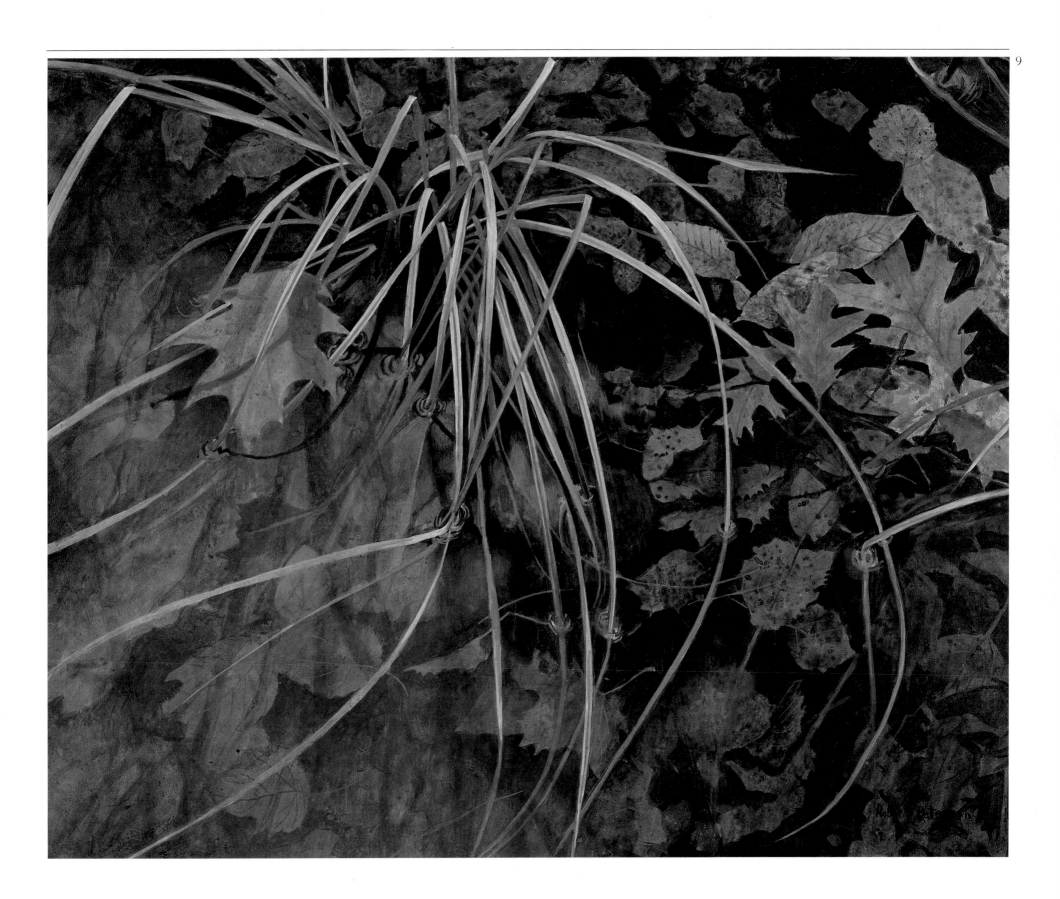

10 The publisher would like to thank the following people whose encouragement, support, and co-operation helped make this book possible.

Ian Ballantine, Annie Bateman, Birgit Freybe Bateman, Tom Beckett and the staff of The Beckett Gallery, Major Brian Booth and the staff of The Tryon Gallery, Jack Coles and the staff of Nature's Scene Ltd., Eco Summer Ltd., Dr. Bristol Foster, Alfred King III and the staff of The King Gallery, Michael Levine, Richard Lewin, Robert Lewin and the staff of Mill Pond Press, Ron Ridout, Gordon Tamblyn, Donnalu Wigmore.

Page 2/Barn Owl in the Churchyard; (detail), acrylic, 16 × 20″, 1979

Page 5/Clear Night — Wolves; (detail), oil, 36 × 48″, 1981

Pages 6, 7/Merganser Family in Hiding; oil, 22 × 36″, 1978

Page 9/Leaves and Grasses in Pool; acrylic, 15 × 20″, 1967

Pages 10, 11/Tiger at Dawn; acrylic 30 × 48″, 1984

Page 12/Demidov's Galago; acrylic, 24 × 18″, 1975

Page 61/Queen Anne's Lace and American Goldfinch; (detail), acrylic, 11 × 15″, 1982

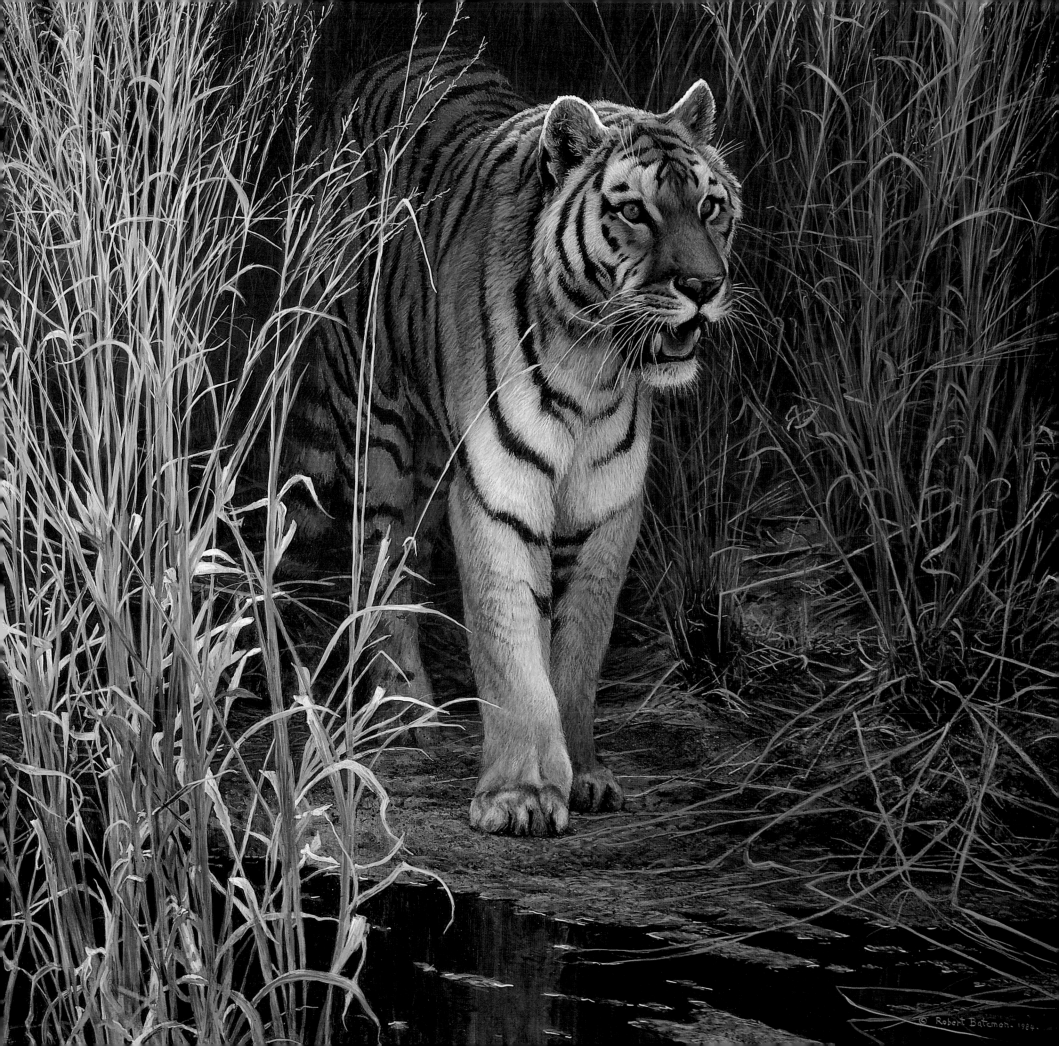

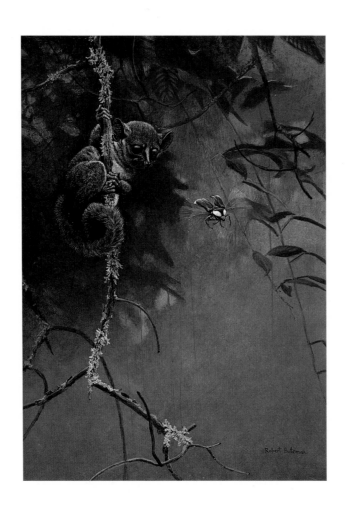

CONTENTS

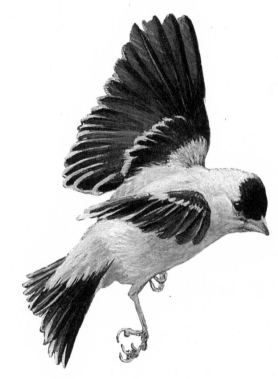

ROBERT BATEMAN AND HIS WORLD

A Profile By Ramsay Derry

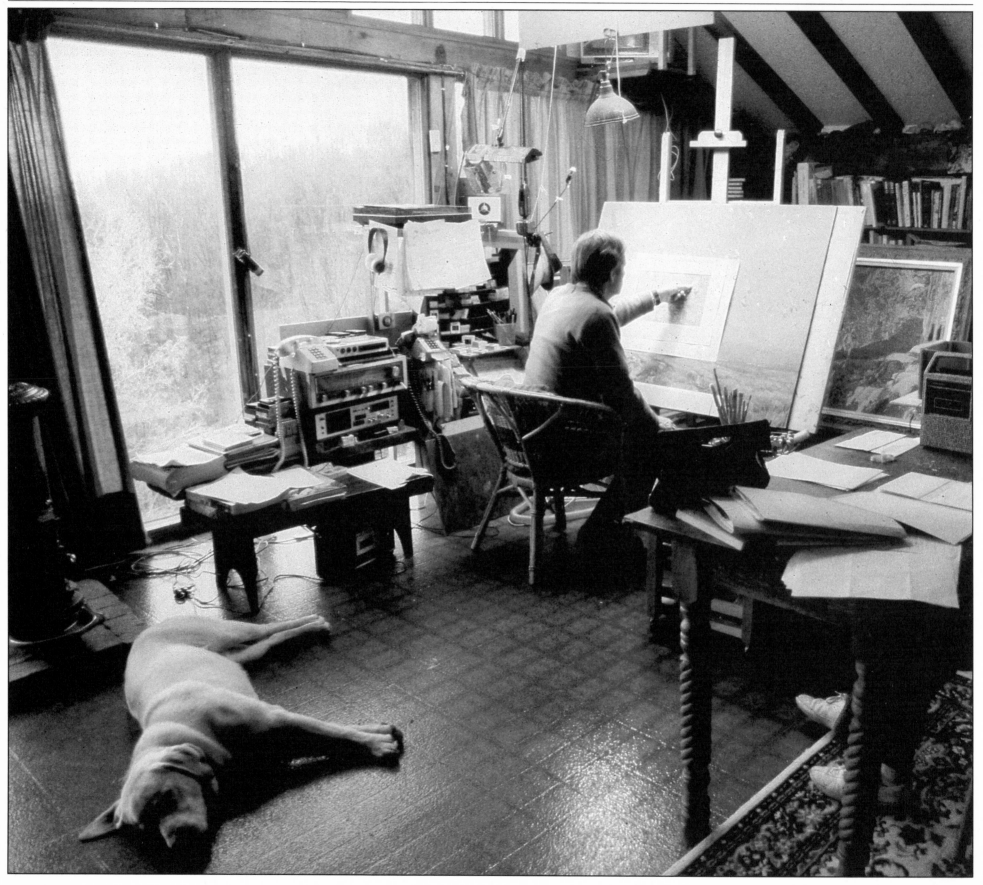

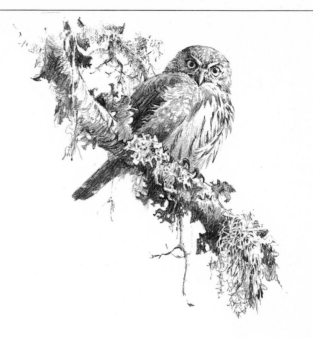

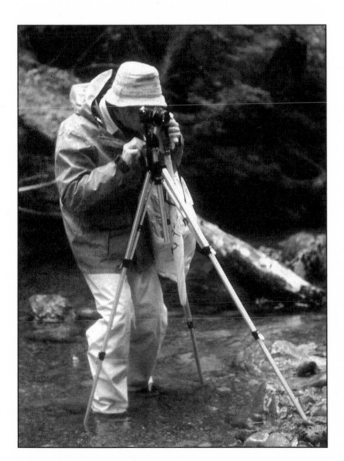

Opposite: Bateman in his studio.

Above: The artist in the field. Queen Charlotte Islands, 1982.

Top, right: Pygmy owl, 1985.

When I think of Robert Bateman, three images come to mind. The first and dominant one is of the artist in his studio. On the easel is a large painting of a tiger. In the early afternoon the great cat had loomed dramatically from the painting; within an hour or so it had retreated behind a screen of reeds. On the artist's lap is a smaller painting of a hawk. As he talks, he works on both paintings, moving from one to the other casually — the same brush painting the same color on little sections of each, though they are totally different in subject, scale, and tone. Beside him, to his right, is a little trolley with his paints and brushes and sponges and water. As he works, he wipes his brush off on the underarm of his old sweater. He wears a visor against the studio's fluorescent lights which are gradually taking over from the fading afternoon light coming through the large windows.

The second image is of the artist in the field. In a gentle, misty rain, Robert Bateman is stumbling up a slippery mountain creek bed. Encumbered with a camera on a tripod, a sketchbook, and an umbrella, and wearing an Irish tweed hat, a slicker, and bright-yellow rain pants, he is a pleasantly bizarre figure, reminiscent of the eccentric nineteenth-century field naturalists. He looks at everything: the lush vegetation, the texture and colors of lichens on the rock, the quality of the light.

The third image is of Bateman the public figure. Genial and dapper, with only a slight aura of the studio and the out-of-doors, he is lecturing to a large audience at one of the openings of the hugely popular exhibition of his paintings that has been touring Canada and the United States over the past three years.

On occasions such as these, he is likely to tell the story of his career as an artist. He does this in an easy, self-deprecating manner, showing slides of his paintings, starting with some of his childhood works. This talk traces the stages of his career as an artist, and is also an easy lesson in how to look at a Bateman painting.

Robert Bateman was born in 1930 and grew up in Toronto when the countryside was closer to the city than it is now, and the ravines beside his family home were filled with small wildlife and migrating birds. He became obsessed with both art and nature at an early age and spent most of his youth drawing, painting, and learning about the local bird and mammal life. His paintings from these years clearly relate to his mature work: the animal subjects are not

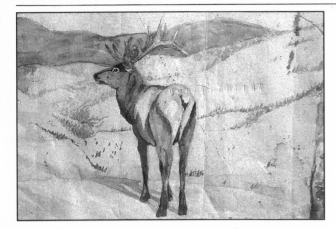

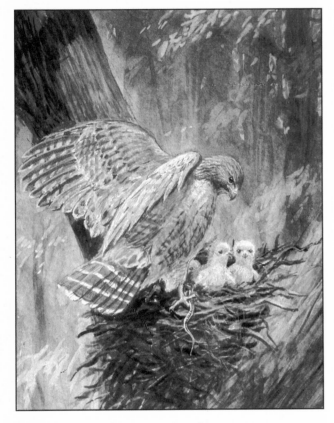

Top: Elk, 1942. "This is one of my first serious attempts at wildlife painting, and was a Christmas present for my mother when I was twelve. The model for the elk was one of a herd in a photograph in the *National Geographic* magazine, and the background is a combination of another photograph from the *National Geographic* and a local Toronto golf course."

Bottom: Red-shouldered Hawk, 1948. "The last of my pure wildlife paintings for many years, painted when I was eighteen. After this I moved on to other styles of painting."

Above, right: Bateman painting in Algonquin Park, 1949.

confronting or responding to a human viewer, and there is a careful and knowledgeable presentation of the surrounding habitat.

At that time, Toronto's Royal Ontario Museum was beginning its fine program for budding artists and naturalists, and all of his early training came from their accessible and able staff. By the time he was seventeen he had an excellent general knowledge of North American bird, mammal, and plant life. This was augmented by summer jobs with wildlife research teams in Algonquin Park in northern Ontario and later, during his university and post-graduate years, on biological and geological field parties in Newfoundland, Ungava in northern Quebec, and on Hudson Bay. Travel, generally focused on wildlife biology, became important to him. His first journeys took him around North America, then to Europe, and, ultimately, when he was in his late twenties, around the world on a year-long journey in a Land Rover.

From an early age he could draw and paint extraordinarily well, and he instinctively concentrated on animal and nature subjects. As a teenager and throughout his university years he took lessons in sketching and painting techniques from several established artists. During his twenties and thirties he explored the world of art and acquired a comprehensive and sophisticated understanding of contemporary painting, and, as he explains in his lecture, his skills as a nature artist were restricted to sketching.

"When I was eighteen I was starting to think of myself as an artist, not necessarily a professional, but somebody who was seriously interested in art, and I wanted to paint as artists painted. So I borrowed books from the library, and read art magazines and visited art galleries. But in none of these did I see any art with animals in it. If you remember, in the 1940s and 1950s you did not see art with wildlife in it framed and hanging on the walls of galleries. You saw it sometimes in magazines or in calendars but never shown as Art with a capital A.

Well, I was interested in Art, so I dropped animal art like a hot potato, and I also turned against detail in my work. I thought, if you can do something with three strokes, then you're an idiot to spend three hundred doing the same thing. You should try to capture the essence. And so I entered my impressionist phase."

A study of Cézanne was a major influence, especially in his approach to composition. "Ever since then, I've treated a painting as an assemblage that an artist puts together on purpose. He recreates nature, so to speak, and every element in the painting is selected and has a purpose."

Throughout the late 1950s, Bateman enthusiastically followed contemporary movements in art, including abstract expressionism, admiring such artists as Jack Shadbolt and Harold Town in Canada, and Mark Rothko, Clyfford Still and, especially, Franz Kline in

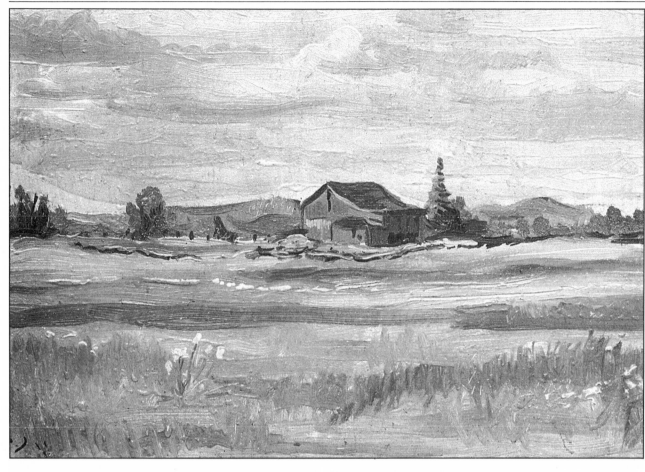

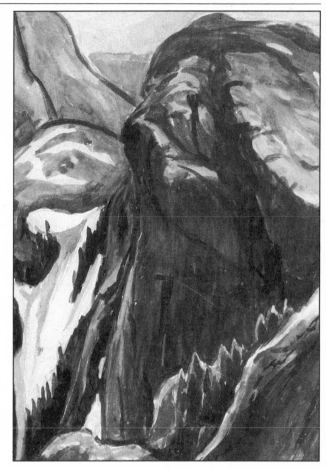

the United States. He responded to this sort of painting purely as art, but he also found that it gave him a new way of looking at nature. "If you take a piece of the natural world, whether it's a big landscape or a little piece of bark, and look at it in abstract terms of curves and tones and contrasts and color and shape, it opens up a tremendous new range of possibilities. Just learning to look at things from an abstract point of view had a big impact on me."

In these years he moved through impressionist, cubist and, ultimately, abstract-expressionist styles. His works from this period may seem quite unrelated to the paintings for which he is now famous, but a sequence of slides during his lecture shows how the abstract shapes of these earlier works reappear in modified form in his realistic paintings.

Of his abstract and semi-abstract works he says, "This was the high-art Bateman, so to speak, but at the same time the underground

or low-art Bateman was, in his sketchbook, still doing very naturalistic accurate renderings of nature. But I considered these to be just records, not real art."

The artist who had the most profound influence on Bateman was Andrew Wyeth, whose work he first saw at a major exhibition in 1962 in Buffalo, New York. He was affected by Wyeth's personal vision and by the combination of abstract forms and compelling representations of the real world in his paintings. "Here was a wonderful abstract artist who painted the real surface of the real world."

Wyeth was the example and the catalyst Bateman needed to bring together his two areas of interest. "What happened was that the high-art Bateman and the low-art naturalist, doing all these sketches and drawings in nature, came together and eventually produced the kind of thing I'm doing now. It was an amazing event for me. It took me about three years

Left: Haliburton Farm, 1949. "This is an easy-going, somewhat impressionistic painting of one of my favorite places, the farmland around our cottage in Haliburton. When we were growing up there in the summers, my brothers and I used to enjoy the farm activities like milking and haying."

Above: Mount Arrowsmith, Vancouver Island, 1950. "On my first big cross-country trip when I was twenty, I travelled with my friend Erik Thorn to Vancouver Island. When camping, we carried all our painting materials, as well as specimen collecting and taxidermy equipment, and regular camping gear. The packs weighed eighty pounds each, and we took three days to get up the mountain. At this time I was very influenced by the Group of Seven artists, and, like them, wanted to complete all my paintings on the spot. Another strong influence on me at this time was Rockwell Kent – not only his painting, but his example of an adventurous life."

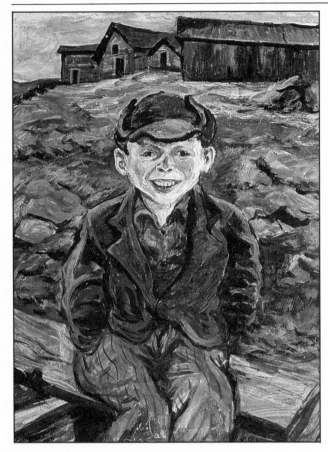

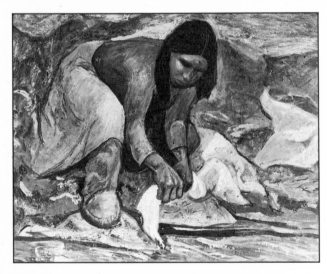

Top: Newfoundland Boy, 1952.

Bottom: Agnak, Ungava, 1953. "I was walking back to our camp from an Eskimo village when I saw this woman doing her washing by a stream. I made a quick sketch, and the following winter did the painting."

to work my way through it, but by 1967 I was into realism with full force."

Through the remainder of his lecture he analyzes a series of his paintings, demonstrating how, behind the realism, there are dominant abstract shapes and rhythmic patterns developed out of cubist techniques; how both the wildlife subject and its habitat are presented with equally careful attention; and how the whole painting is filled with echoes and inter-relationships of pattern, shape, and color. Robert Bateman had graduated in honors geography from the University of Toronto in 1954, a course which gave him a broad understanding of the natural world and a lasting appreciation for the unique qualities of natural phenomena. To his geography degree he added a teaching certificate, and for the next twenty years he supported himself and his family as a high-school teacher of both geography and art in Burlington, thirty miles west of Toronto. This was never drudgery for him; he's a natural, dedicated teacher, and falls back into that role effortlessly whenever he gives an art or photographic seminar or a public lecture.

In 1963, just after he had seen the Wyeth show, he went with his first wife, Suzanne Bowerman, to Nigeria as a teacher for two years, and it was there that he began painting in the style which is now so familiar. By the time he returned to Canada his career as an artist was taking on new momentum. Although he had never planned to paint full-time, the demand for his paintings increased until it reached the point where he had to make a choice between teaching and painting.

By the late 1970s, Bateman was recognized as one of the world's outstanding artists in the field of animal art. Since then, his paintings have become enormously popular and he has achieved a degree of public celebrity, a condition that he finds both exhilarating and distracting. He has been the subject of numerous newspaper and magazine articles, and a recent television special was the fourth film to feature him. He has been given an impressive array

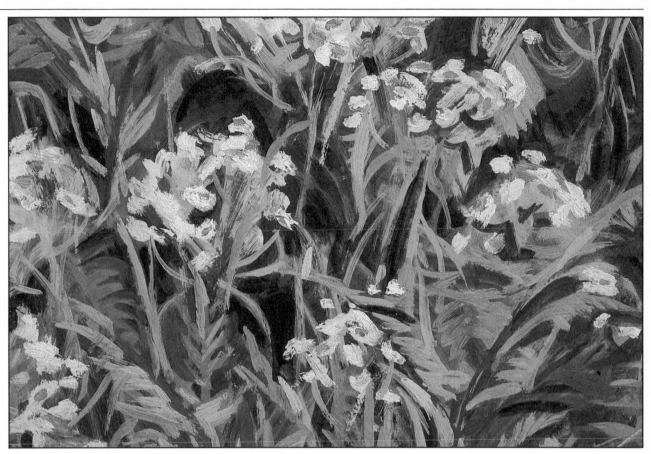

of honors and awards and receives constant requests for public appearances.

For the most part Bateman responds positively to these pressures. Although he sometimes begrudges time that has to be stolen from painting, he genuinely likes meeting new people and enjoys opportunities of talking about art, nature, and, particularly, conservation. He is an insatiably curious naturalist, a willing teacher, and a dedicated conservationist, but he remains an artist first and foremost. His sketchbook is always with him and he pulls it out to draw whenever he sees something of interest, whether he is driving his car (a very alarming experience for a passenger), or is at a committee meeting, a ballet performance, or a social event.

He has been married for the past ten years to Birgit Freybe Bateman. An artist and art teacher as well, she is in every way his closest associate, his constant companion in the field, and his consultant in the studio. She acts, in effect, as his studio manager — really a full-

Opposite right: Snowfence, 1962. "The five years of classes I had with the Canadian artist Carl Schaefer were a very important period of training for me. He taught us to work with boldness, to have power and rhythm in the main structure of the painting, and brushwork that showed vitality. This painting reflects that training. In my present work, I want the brushwork to be as unobtrusive as possible, but I still try to have strong rhythmic compositions, and in their early stages, my current paintings are somewhat in the style of this picture."

Above: Everlasting, 1961. "I remember how liberating it was to realize that a landscape did not need to have a centered subject or a horizon. Here I have played with the patterns and textures in a square yard or so of Haliburton countryside. Later, Andrew Wyeth's example encouraged me more in this direction, and a number of my realistic paintings have this kind of composition."

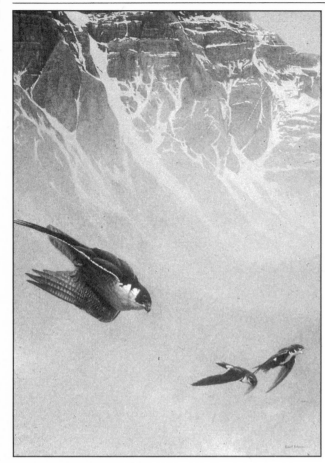

Above: Peregrine Falcon and White-throated Swifts, 1976.

Right: Untitled, 1960. "The painting on the right is one of my most purely abstract works – an action painting without an underlying subject, concerned purely with the interplay of shapes, texture and colors. It uses the same principles of composition I continue to use in my realistic paintings. I look at the rectangle of the board I am going to paint on, and then build within it a series of shapes and relationships. Because most of the content of this painting is at the top of the rectangle, there is an instability to the composition which I like and have often used.

"In some ways the abstract work is a precursor to one of my later realistic paintings, *Peregrine Falcon and White-throated Swifts*. Both of them are approximately the same size, 40 x 30", and have the weight of the composition at the top, with a series of dark and light interlocking shapes, and a darting action in the lower part of the painting. At the bottom of each is a shape – the cloud in the Peregrine painting – which sets up a tension across the open space."

time job — keeping a record of the paintings and arranging appointments. She also runs the household, which includes their two children, Christopher and Robbie, as well as, during the holidays, Alan, Sarah, and John, Bob's three children by his first marriage.

Both Bob and Birgit Bateman were closely involved with the small team that put together the first book on his painting, *The Art of Robert Bateman*, published in 1981. The three of us who worked on that book, the publisher, the designer, and myself, as editor and writer, had been faced with selecting approximately seventy-five paintings from a body of over 250 works. It was obvious that there were scores of paintings that should be included in a further book; moreover, Bob has in the past four years continued to be extremely productive. We found ourselves thinking of a second book almost as we were finishing the first.

So I began again the agreeable process of interviewing him at length, discussing the selection of paintings to be included, and asking him to talk in detail about the individual pictures. Most often these conversations took place while I sat beside his easel, either at his house near Milton, Ontario, or at the log house he has built near his family cottage in Haliburton. The microphone of the tape recorder was clipped to the top of the painting he was working on, or to the rim of his tin of water, and it picked up the soft scraping of the brush on board or the gurgle of it splashing in the water. Sometimes I followed him on walks through the woods near his house or cottage, and, on occasion, tracked him on more far-flung expeditions.

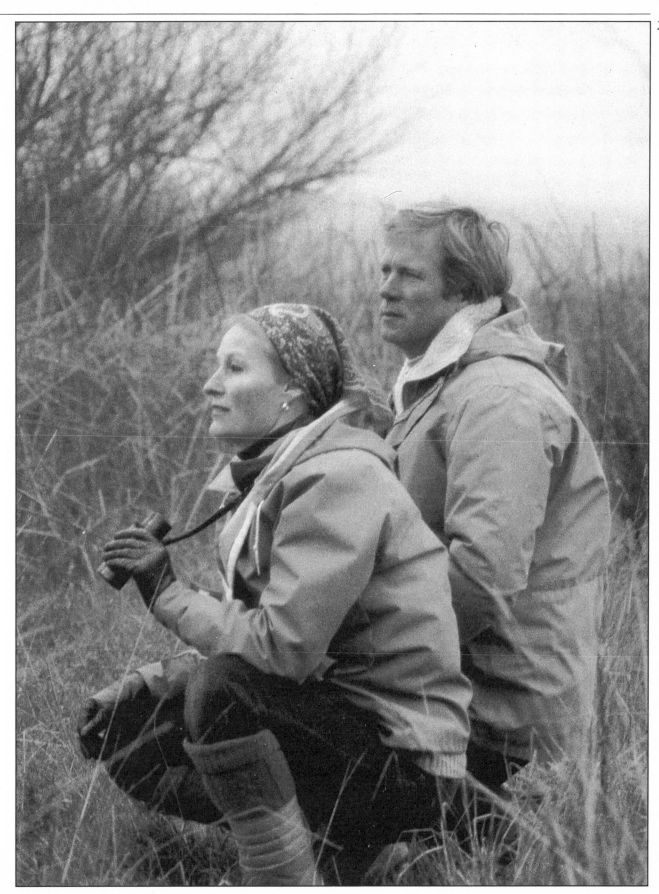

Bob and Birgit bird-watching at Butte Sinks, California.

When the Batemans told me that they had agreed to lead an art seminar in the Queen Charlotte Islands, it seemed an ideal opportunity to see Bob operating at once as a naturalist, a teacher, and an artist, and in a setting both remote and spectacular.

The Queen Charlottes, which hang off the coast of British Columbia just south of the Alaska panhandle, are extraordinarily beautiful: mountainous, with colossal forests of fir and spruce, they have a marvellously rich and varied natural life. Once the domain of the Haida Indians, the islands have now only a small population in a dozen settlements and small towns, and access to most of the region is by boat or float plane.

The seminar was set up by a Vancouver-based travel organization called Ecosummer which, through several summer weeks, runs a variety of specialized tours of the Queen Charlottes from a tent base camp set up at the south end of the islands. The young, enthusiastic, and knowledgeable staff are supported by a series of guest experts in art, photography, biology, and anthropology. Bob was the guest artist for the week, and the dozen or so participants were amateur or professional artists with an interest in nature.

The Queen Charlotte Islands are a wonder-fully appropriate place for an art seminar, not only because of the wealth of natural beauty, but also because there are, on their original sites, some of the finest and most spectacular examples of aboriginal art in the world — the great carved totem poles of the Haida Indians. In addition, the Queen Charlottes provided the settings for many of the great, green, brooding canvases of one of the most distinctive of Canadian painters, Emily Carr.

Traditionally shrouded in mist, these coastal islands have one of the highest rainfalls in the world, but during our June visit there were long days of almost unbroken brilliant sunshine. The days were spent exploring the coast in inflatable outboard motor boats, seeing cliffs of nesting seabirds, eagle nests, sea lions, seals, and the remains of Haida villages which emphasized how, not long ago, the area had effortlessly supported a wealthy, vigorous culture. The intertidal zone is as complex and interesting as any in the world, and the beach life is fascinating. The same variety can be seen, even more spectacularly, underwater, and Bob and Birgit, who are keen snorkelers and scuba divers, soon had donned their wet suits and plunged into the hideously cold north Pacific water. Evenings and parts of each day were given over to drawing and sketching classes

Above: From the Queen Charlottes sketchbook.

Opposite: Exploring in the Queen Charlottes.

and informal lectures from the Ecosummer staff and from both Batemans. We saw more every day than it seemed possible to absorb, and it was often hard to choose between exploring and sketching or painting.

In circumstances like this, Bob Bateman's enthusiasm for photography comes to the fore. Since university he has been a keen photographer, and he often lectures on the subject to camera clubs. Though most of his own photographs are taken for purposes of documentation, he is also an accomplished artistic photographer. When considering photography as an art form, he looks for many of the qualities which characterize his painting — strength and originality of composition, a fascination with the variety and richness in nature, and a delight in the unexpected.

He keeps his cameras hanging about him or within reach, and over the years a good many cameras and lenses have come to grief as he has leapt from a boat to shore, leaned too enthusiastically out of a Land Rover, or scrambled up a cliff in search of an elusive nest. One of the few signs of tension in the Bateman marriage can be observed when Bob cries out too peremptorily to Birgit for a different lens or a new roll of film when she is intent on her own photography of the same event.

Bob is regularly asked if he uses photographs when he paints, and his answer is yes, lots of them. While he is working on a painting he may refer to dozens of slides, looking for technical details of his animal, botanical, or geological subjects, and he is certainly attracted from time to time by a mood or coloration in a photograph. But all his paintings are imaginative, selective recreations of a variety of observations. For Bateman, the practice of, in effect, painting or copying a photograph is simply uninteresting. He does not use the technique of projecting a photograph onto a canvas or board, either to scale out a scene (similar to the *camera obscura* method used by the old Dutch masters) or to render a painting in detail (as exemplified by the recent photorealists).

Sketching at Anthony Island.

He has wonderful ease and confidence as a draftsman, and when watching him work on a painting — whether he is roughing in the basic shapes at the beginning, or manipulating and adjusting major features at even a late stage in its development — it is impossible to imagine him having the patience, let alone the interest, to try to duplicate a photograph.

More significant is how perspective in some of his paintings is influenced by photography, or rather by the lenses used in photography. He very much likes the foreshortening effect of the telephoto lens, which gives what he describes as a "handsome" appearance to a landscape by bringing forward and heightening the background. He has used this deliberately in some paintings such as *Orca Procession* (page 124) and *Road Allowance* (page 143).

Here in the Queen Charlottes, where we are surrounded by irresistibly photogenic landscapes, it is characteristic of Bateman that when he wanted us to think about good photography he made us look at the ground. During a walk up a mountain streambed a few hundred yards from our campsite, with the sunlight glinting through the giant spruce trees, he urged us to look downwards at the rocks, lichen, mosses and ferns, to appreciate the different effects of light sources. "Turn in a full circle looking downwards a few yards ahead of you. You can see that when the light is coming from behind you — the usual direction for amateur photographers — all this thick vegetation looks like so much coleslaw. But if you turn so that a photograph would be back-lit or side-lit, the ingredients become isolated and big forms and patterns emerge. Now an interesting picture becomes possible."

Not far from our base camp lay Anthony Island, which has the rare distinction of having been designated a United Nations World Heritage site, in recognition of the Haida heritage. The Haida totem poles throughout the Queen Charlottes and adjoining coastlands have, for the most part, decomposed, been carried off to museums, or been destroyed, but on Anthony Island, many of the poles are still in place and the foundations of a few of the Haida's great communal houses are still evident.

The major archeological site is the remains of the village known as Ninstints, beautifully situated on a little, protected bay with a view to the sea beyond. When we first visited the island, the village, though deserted by its original inhabitants perhaps seventy-five years ago, was a hive of activity. A party of archeologists were measuring and X-raying the totem poles and the remains of the houses, and carefully, almost surgically, cutting away some of the encroaching vegetation in order to preserve the remains in their present state.

The Haida totem poles were carved with figures of various animals symbolic of the status and heritage of the different families, and in reworking these figures over many generations, the Haida artists evolved a sophisticated level of abstraction and distortion. Artists in this society were held in high regard. According to one reminiscence, "A carver of

totems was a high man. In former times there were men for every calling; as some were good speakers, others were makers of totem poles."

During a drawing class held around one of the finest of these poles, Bob, an enthusiast for primitive art, explains the artistry of the carvings. "What you are going to find when you start drawing these poles is how good these carvers really were." He goes on to show that, as in the Parthenon, nothing in the totem carvings is exactly vertical or horizontal: "Nothing is on a flat plane. As you move around the pole, the view changes and every aspect is in transition and has constant interest for the eye. The swelling and shrinking forms and the shapes within shapes are typical of Haida art and remind me of objects that are reflected in water."

As his listeners sit and draw the totem pole from different angles, Bob identifies first a hermit thrush by its song, and soon afterwards a song sparrow, a junco, and a fox sparrow.

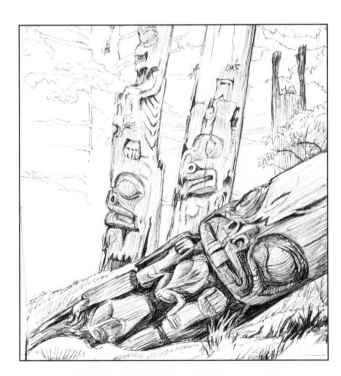

Above: Totem poles, Anthony Island, Queen Charlotte Island sketchbook, 1982.

Right: Ninstints site, Anthony Island.

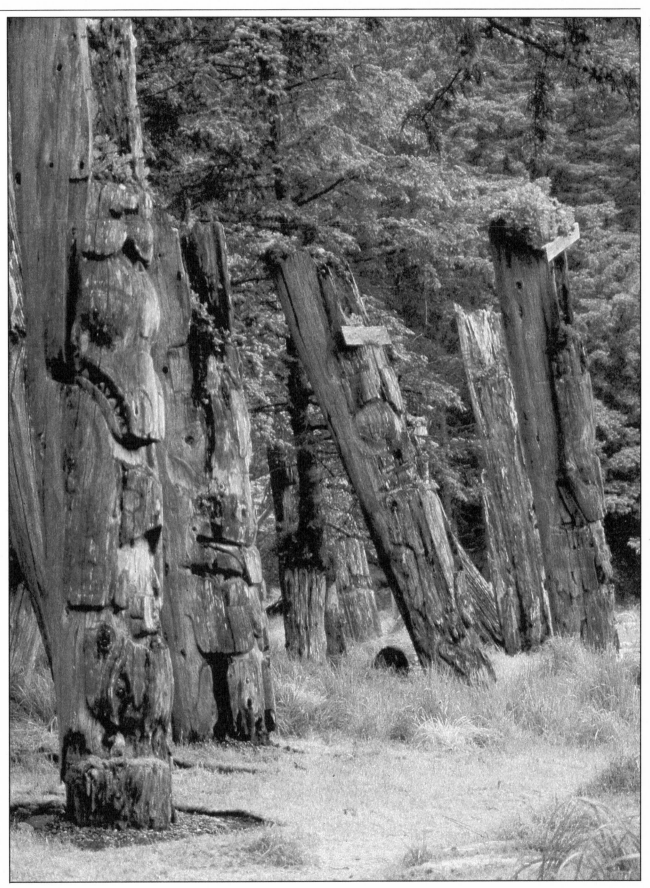

Later in the afternoon, after a walk through the huge, cathedral-like forest to the other side of the island, we see a westward perspective of small islands stretched out over the sunlit sea. A peregrine falcon shoots across the sky, and in another informal lesson, Bob explains how, in painting, distance can be conveyed by thickening the atmosphere and how most colors begin to lose their distinction as they recede into the distance, where blue begins to dominate. A few minutes later, a tiny speck emerging out of that blue distance resolves into a kayak being paddled down a ray of reflected sunlight towards us. As the kayak draws near there is a shout of recognition — it is Bristol Foster, one of Bob's closest friends from their days together thirty years ago at the Royal Ontario Museum, and his companion on the 1957-58 Land Rover trip around the world.

Foster, as the director of Ecological Reserves for British Columbia, was in the area with a colleague taking a census of the seabirds that nest on some of the smaller islands, and he had agreed to join briefly the Ecosummer group. A dynamic and entertaining man with a passionate commitment to wildlife and environmental conservation, he explained in an evening lecture by the campfire some of the unique features of the Queen Charlottes. For climatic and geological reasons, a number of species of plants and animals have evolved separately on these islands, which makes them like a minor Galapagos. But there is nothing minor about the magnificence of the forests, which have unfortunately attracted large-scale logging operations licensed by the British Columbia government. Already huge areas of mountainside on the islands are horribly scarred by logging and this southern tip, which has never been touched, is now threatened.

The following morning, Foster took us to one of the seabird nesting sites, which are normally off-limits to tourists. Under the entire grassy top of the island was a network of burrows holding the nests of thousands of Leach's petrels. The quantity of these birds seemed astonishing, as did the fragility of their

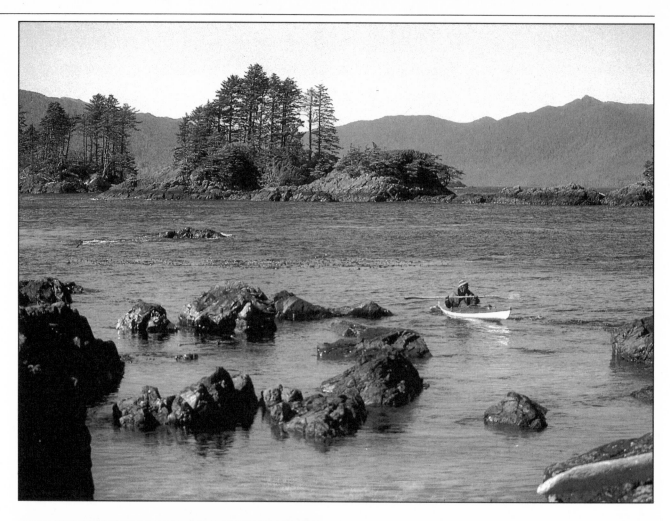

habitat. A fire, casual trampling by humans, or an infestation of rodents could easily destroy practically the entire population.

One afternoon Bob was leading a sketching class on a little island near our base camp. The less artistic of us were out in a boat struggling into wet suits for snorkelling when suddenly,

down the inlet, a small pod of orca, or killer whales, appeared. The high dorsal fins were as unmistakable as the speed, exuberance, and confidence with which they moved. The pod consisted of several mothers and some younger whales, none of them small. A grown killer whale is capable of easily gulping down

a man, but the species has, unaccountably, an almost unblemished record of benevolence towards humans. They circled the boat, and one zoomed just beneath it. Then they swam towards the shore, perhaps attracted by the group of sketchers standing there, and began to slide about, half-submerged, rubbing themselves on the smooth rocks. This all took place within a few minutes but that was long enough for Bob's quick sketching to capture the scene.

Finally, with a kind of easy deliberation, the whales moved swiftly out to sea.

On the last full day of the trip there is a light rain in the morning. Bob, in particular, is glad to see this change in the weather. The days of sunshine have been wonderful for sightseeing, but misty atmosphere is more characteristic of these islands and to his mind it is preferable

Above: (left to right) Robert Bateman, Bristol Foster, Birgit Bateman, Jim Allan of Ecosummer.

Opposite, top: Bristol Foster at Anthony Island.

Bottom, left: A Leach's petrel chick. Bristol Foster was estimating the populations of the different species of burrowing seabirds by withdrawing the chicks or nesting parents in sample burrows, identifying them and then returning them.

Bottom, right: Bob and Birgit touring in the Queen Charlottes.

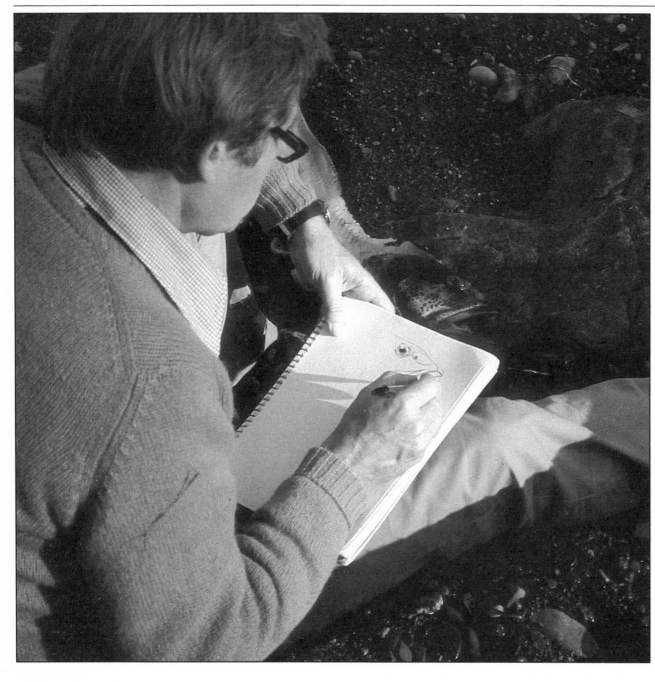

for depicting a scene or storing it away in his memory.

After lunch at the base camp, Bob, Birgit, myself, and two others set off by outboard to revisit Anthony Island. On this quiet, misty afternoon the sea is almost oily flat. Midway across we encounter a marvellously extroverted school of Pacific white-sided dolphins. Fun-loving and curious (it seems impossible not to give human characteristics to these creatures), they leap about in the water around us. One of them bumps the bottom of the boat playfully as he sweeps beneath us. Another, when we run the engine, rides the boat's bow wave. They seem to want to play all afternoon. A hundred yards or so ahead one smacks its tail rhythmically on the water.

Suddenly, in front of us among the leaping porpoises, a vast baleen whale rises half out of the water. We are stunned and sit still in the boat. The porpoises have vanished. There is a great swirl in the water, and, after a moment, the forty-foot creature — it is identified as a fin whale — surfaces silently and gently immediately alongside us and gazes at us steadfastly. Then, its curiosity apparently satisfied, it gives a ghastly exhalation of foul sea breath and sinks, making scarcely a ripple.

We motor slowly towards Anthony Island, approaching the Ninstints site through its tiny harbor. The archeologists have departed; the village is now deserted, and, on this still, gently lit afternoon, magically quiet. Wandering among the leaning totem poles is a young black-tailed deer, and nearby in a tree sits a bald eagle.

We explore and wander separately for several hours, reluctant to disturb this resonant, allusive mood. Bob moves around the carved poles, sketching and photographing. The sense of spiritual association with the past is very strong. This will be the setting of one of his most evocative paintings.

Above: Bob sketching the head of a ling cod that had been caught for supper.

Right: Ling cod head, Queen Charlotte Island sketchbook.

Opposite: Spirits of the Forest — Totems and Hermit Thrush, 1982; (see page 127).

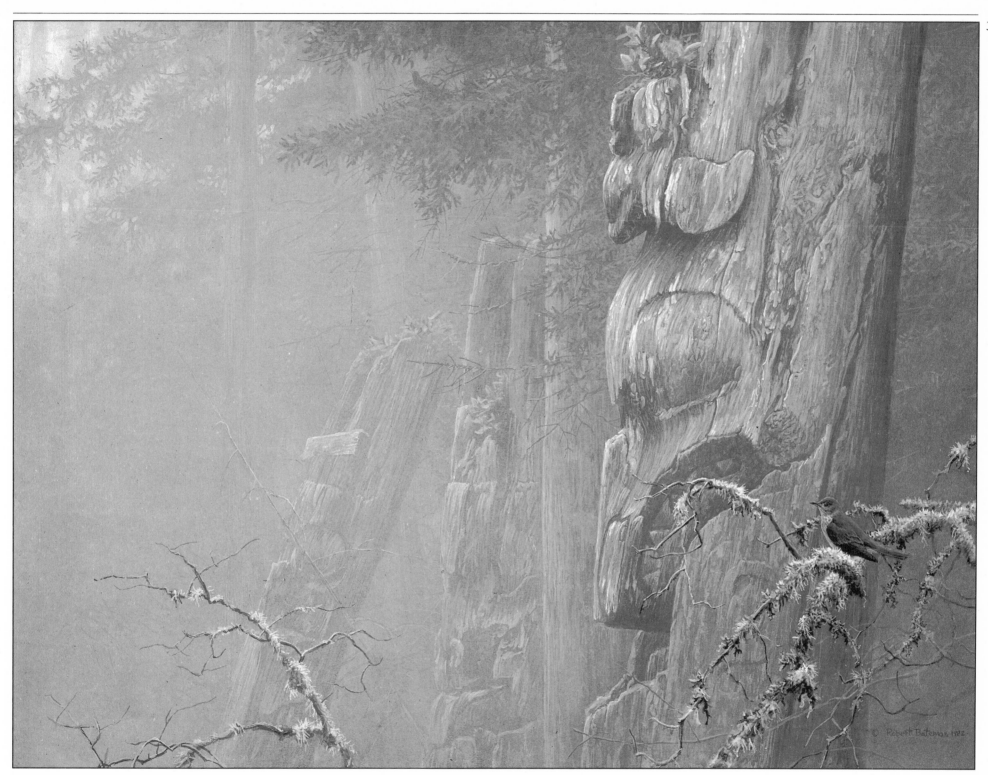

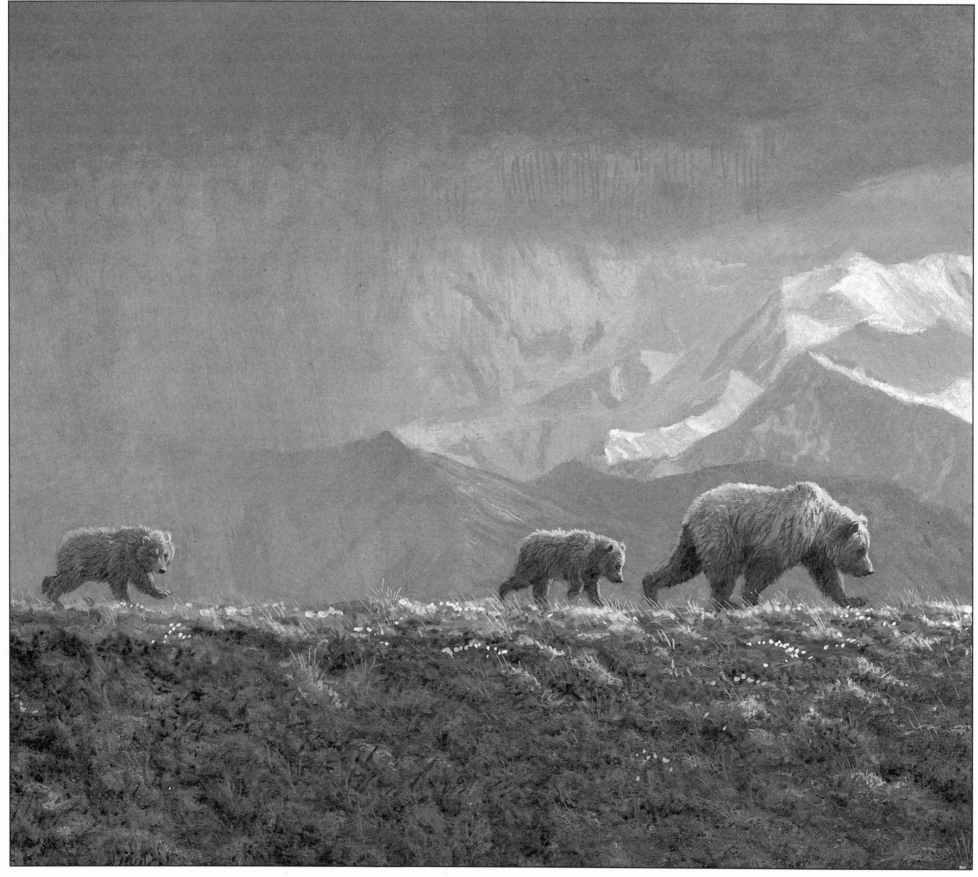

Opposite: Along the Ridge — Grizzly Bears, 1984; detail (see page 121).

Right: Young Gray-Crowned Rosy Finch, 1983.

Bob completed the totem pole painting a few months after he visited the Queen Charlotte Islands, but not all his trips are followed so swiftly by paintings of subjects he has seen. In fact, travel for him is not directly related to painting. He rarely travels primarily to find settings or subjects, and some of his trips, however interesting, have yielded no paintings, though he may have filled books with sketches and boxes with photographs. "When I come to a new area I have the same sense of adventure I had when I was seventeen. I look at it first as a naturalist and start identifying the different species and looking for what is new and exciting. It's at a later stage that the artist in me comes into play, and then the two move along together."

He has covered an impressive proportion of the world in his travels over the past few years. Many of the trips have been with groups in which he plays a formal or informal role as artist or naturalist. In particular, he and Birgit have often travelled as guests of the Lindblad travel organization, sometimes on board one of their cruise ships. The company invites artists, naturalists, or writers to join their tours with no responsibilities but to fulfill a role rather like that of a

writer-in-residence at a university; they are available for discussion and perhaps to give an occasional lecture. These trips have taken Bob and Birgit to the Falkland Islands and the Antarctic, to the Great Barrier Reef, to the Galapagos, through the South Seas, to Japan, and recently to Burma and Thailand.

The Batemans cross and recross North America frequently on birding trips and naturalist tours, but they did not discover Alaska, which Bob found to be as rich in wildlife as Africa, until 1983. During their visit, they explored the Katchimak Bay coastline south of Anchorage, and Denali National Park, which convinced him that Alaska was the continent's ultimate wildlife area — as he puts it, "wilderness headquarters for North America," with exceptional and spectacular opportunities to see a great variety of wildlife, including big game.

The trip originated with an invitation from the Anchorage Audubon Society to judge its national art exhibition of Alaskan wildlife. This coincided with a chance to join the final leg of "Wild America Revisited," a tour that was reproducing the famous pan-North America birding marathon undertaken in 1953 by Roger Tory Peterson, the inventor of the *Field Guides,* and the British ornithologist

James Fisher, and described in their book *Wild America.*

The Alaskan wildlife art exhibition is an annual event in Anchorage, and is judged by a senior artist in the field. In addition to judging the exhibit, Bob took part in artists' workshops, an activity he welcomed because he thoroughly enjoys analyzing and critiquing paintings, whether his own or other people's. He is far from doctrinaire as a critic, and when he looks at wildlife art is always eager to find work that is fresh and that has painterly qualities beyond the accurate presentation of the animal. As celebrity judge, he also had a secondary role; to help give some publicity to the conservation issues the Audubon Society was fighting for at the time.

Alaska, with its spectacular natural conditions and resources, is the scene of a running confrontation between developers and conservationists, with the conservationists in the decided minority. As John McPhee wrote in *Coming Into the Country,* his 1977 book about Alaska, "In Anchorage, if you threw a pebble into a crowd, chances are you would not hit a conservationist, an ecophile, a wilderness preserver."

The issue being fought by the Audubon Society at the time was a threat to a rich

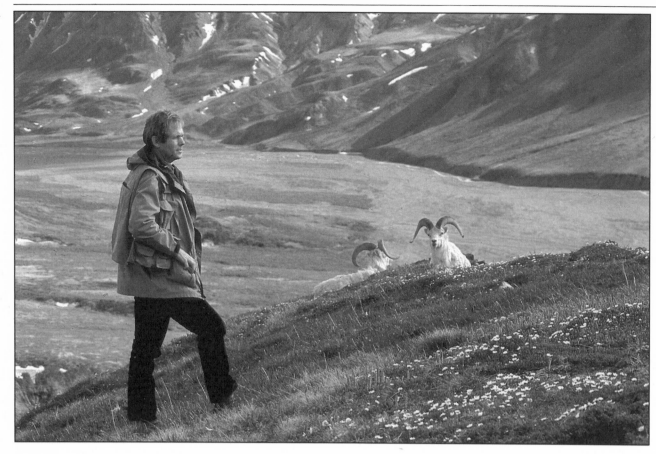
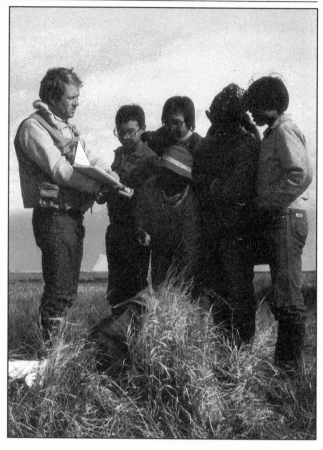

marshland near the outskirts of the city. A proposed housing development would deplete and contaminate the ground water; in effect destroying the marsh. Marshes are one of Bob's particular enthusiasms, and he enjoys revealing their mysteries to people and explaining the role of marshlands in the overall ecology. In his few days in Anchorage, during the course of the numerous interviews which were ostensibly about him and his art, he managed to introduce the marsh issue regularly.

During the visit arranged for them in Denali National Park, the Batemans had exceptional views of a variety of animals, including grizzlies and Dall sheep. These mountain sheep are so shy in the wild that close observation is only a matter of the greatest good luck. But here, the group of seven rams Bob saw were sufficiently confident that he could get close enough to sketch them in detail, and one ram actually approached him. He and Birgit also had a close, almost too close, encounter with a mother grizzly and her two cubs.

The park also has the overwhelming spectacle of Denali, or Mount McKinley, as it used to be known. With the greatest height from base to peak of any mountain in the world, and with no mountains of comparable height around, Denali presents a vista of overpowering grandeur, at least on the occasions when it is not hidden in clouds. Bob found himself challenged to conceive a landscape painting which could present the mountain without allowing it to consume the entire painting. The result, *Along the Ridge* (page 120), has as the main subjects, set in a panorama of tundra and mountain ranges, the comparatively tiny figures of the grizzly and her two young; high above the whole scene floats, half-hidden in cloud, the top of the great mountain.

When the Batemans joined it in Alaska, the "Wild America Revisited" tour had already made a semicircular sweep of the continent and was en route to Chevak, a mainly Eskimo settlement in the middle of the Yukon River

delta. Roger Tory Peterson and James Fisher, on their 1953 tour of the continent, had been seeking the greatest assortment of bird species. In mainland Alaska they had chosen the delta of the Yukon River as it flows out into the Bering Sea because of its extraordinary concentration of waterfowl, including the magnificent emperor goose and the rare, spectacled eider duck. This vast region — covering thousands of square miles of water-logged tundra, mosquito-ridden in the summer, interlaced with innumerable subsidiary rivers and channels, and accessible only by plane or boat — did not then normally attract visitors.

In the succeeding thirty years Chevak has not acquired many tourist amenities, and for the week that the Batemans and their twenty fellow bird-watchers stayed there they were obliged to provide their own accommodation — tents at the end of the airport runway, the only fairly dry land. The mosquitoes were appalling and the weather infinitely variable, offering all four seasons in a single day. The food reflected

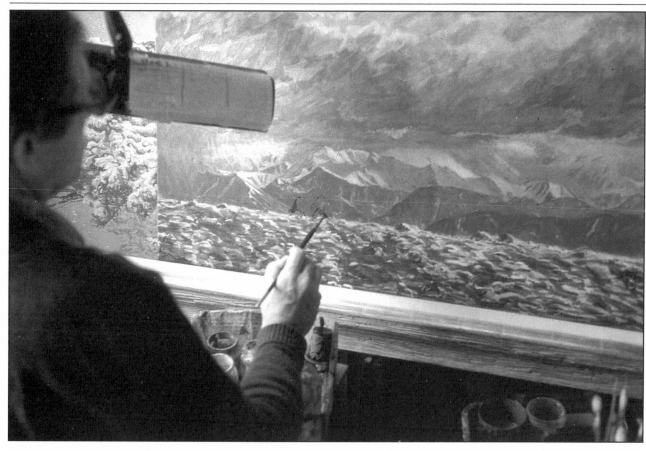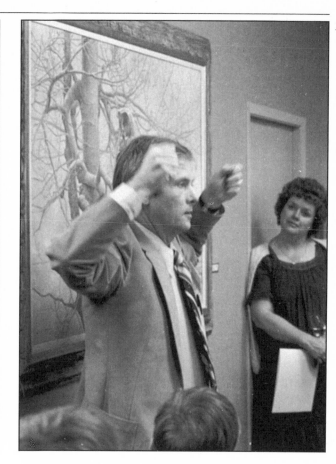

the limited circumstances (a typical meal, according to Bob, consisted of boiled pork-chops with stewed mosquitoes), and the toilet was a bucket with a view of the runway.

But easily outweighing any of these discomforts was the excellent bird life. The campsite was shared with a nesting Lapland long-spur. Besides the great range of ducks and geese and flights of tundra swans, there were both red and red-necked phalaropes, the graceful long-tailed jaeger, and quantities of peeps — the various smaller species of sandpipers.

From Chevak, the group flew to one of the most remote parts of the United States, the island of St. Paul in the Pribilof Islands, which are flung out in the middle of the Bering Sea two hundred and fifty miles north of the Aleutians, and were chosen in 1953 by Peterson and Fisher for their wonderful concentration and variety of sea birds. Birders eager to enlarge their life lists of birds they have observed are also attracted to the Pribilofs by the presence of "accidentals," in this case species of Asiatic

birds that make only chance visits to this outpost of North America.

The islands have more to show than birds. They were Russian until the Alaska Purchase of 1868, and the Russian influence is still especially strong. Many of the people are Aleuts, originally brought from the Aleutian chain in the 1700s to harvest the fur seals that breed here in huge numbers. In fact, the islands' main industry is the sealing, which is fundamental to the Aleut way of life. The seal harvest is carefully controlled and the fur seal herds, which were close to extinction at the beginning of this century, have now recovered.

These are the northern fur seals, which breed almost exclusively in the Pribilofs. Bob had previously seen the southern species when he visited the Falkland Islands and the Antarctic and he has subsequently done a painting of these (*Old Whaling Base and Fur Seals*, page 91). He finds fur seals, with their somewhat shapeless bulk, "almost like a badly stuffed toy," curious animals to consider for a painting.

Opposite, left: With Dall sheep, Denali National Park.

Opposite, right: Informal workshop, New Chevak, Alaska.

Above, left: Along the Ridge in progress, April, 10, 1984.

Above, right: Speech at the opening of the Alaska Wildlife Exhibition, Anchorage.

The fur seals in the Pribilofs constitute one of the biggest single herds of large mammals in the world, with a population of about a million. The Batemans looked over beaches swarming with these heaving, lumpish creatures. The herds are dominated by bulls intent only on maintaining huge harems. The unsuccessful bachelor bulls are left outside the herd (and are the ones slaughtered), while the bulls brutalize their many wives, who are much smaller, and frequently and casually kill their offspring.

Bird-listing was the original motivation for both the Peterson-Fisher trip and the 1983 tour. The Batemans are both enthusiastic listers, and Bob often leads birdathons. Nonetheless, he is quick to see the absurd side of this passion for listing, and he was amused when a slatey-backed gull, an Asiatic bird, was identified in the midst of a flock of several hundred more common gulls, and the bird-watchers lined up to peer through a telescope at the gull one at a time before happily adding it to their lists.

For Bob, the purpose of the Pribilof trip was to see the enormous seabird colonies nestling on the spectacular cliffs, and the trip had been planned to coincide with the peak of the breeding season. Layer upon layer of seabird species cover the cliffs, rivalling the fur seals in numbers, noise, and smell, and exceeding them by far in variety and beauty. The dominant family was the "alcids" – murres, puffins, murrelets, and auklets – stout little birds designed for swimming, with streamlined bodies and short, narrow wings. In order to take flight they must hurl themselves from the precipice, dropping as much as a hundred feet before they gain enough momentum to fly. On their return from their fishing expeditions they speed towards the cliff and must brake and land on a few square inches of ledge. The whole cliff face is alive with the comings and goings of tens of thousands of these birds.

The commonest were the murres, attired in formal black and white, somewhat like very small penguins. The most exciting for the group were the tufted and horned puffins and three species usually seen only in the Bering Sea, the least, the parakeet, and the crested auklet, bizarre and droll in appearance.

Getting a good view of these birds on their nests was a challenge in itself, since one had to lean out over the cliff as far as possible. Bob would lie on his stomach, hanging over the cliff with his camera while Birgit held on to his legs.

A surprise feature of the visit to the Pribilofs was a meeting with Roger Tory Peterson himself. Peterson had revisited the Pribilofs several times since his 1953 visit, and on this occasion was leading a trip on another island. But he came over to St. Paul to meet the tour reproducing his 1953 trip – and to try to photograph the crested auklet. For most members of the "Wild America Revisited" party this was a great occasion with a legendary figure; for the Batemans, it was a chance to see an old friend.

Now in his seventies, Roger Tory Peterson is still a man of extraordinary vigor and enthusiasm. Probably the world's most honored naturalist (he has been awarded the Presidential Medal of Freedom and was nominated for a Nobel Peace Prize), he revolutionized bird identification with the publication in 1934 of his *Field Guide to the Birds*. That first edition appeared when he was only twenty-six. Over the ensuing fifty years he has revised and refined his original work into a comprehensive system of naturalist observation. Thanks in large part to his work, it is now possible to gather detailed information about bird occurrence on the broadest scale, an important indicator of environmental health. Since they were first published, his *Field Guides* have, directly or indirectly, educated practically every bird-watcher and ornithologist. For Bob Bateman, a copy given to him when he was twelve led him on his first steps as a serious bird-watcher.

Peterson first approached the challenge of bird identification as an artist. He had been trained at the Art Students' League and at the National School of Design in New York City, and as a young, aspiring bird artist he was inevitably influenced by the two great figures in American bird artistry, Audubon and Fuertes. As an artist, Peterson has felt somewhat trapped by the success and demands of his invention; he has written that when he began his *Field Guides,* "simplified pattern and schematic effect were employed so as to teach field identification more directly. This led many people to think that the decoy-like drawings were my basic style." But in recent years he has returned, as he puts it, "to proper painting,

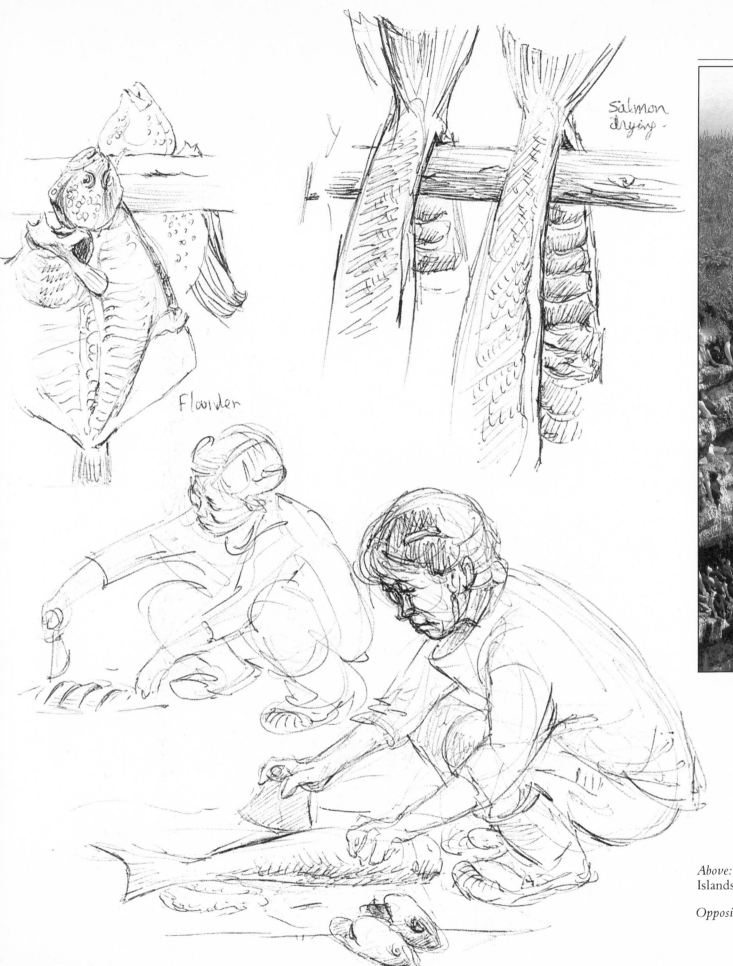

Salmon drying.

Flounder

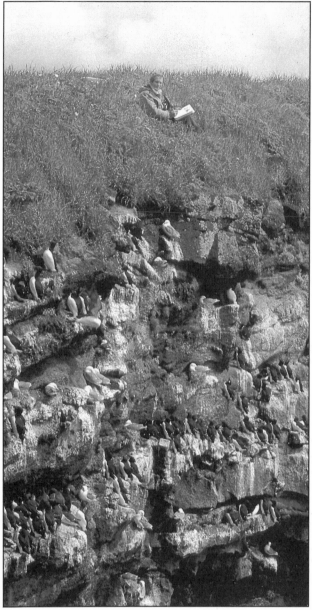

Above: Sketching at the seabird cliffs, St. Paul, Pribilof Islands.

Opposite and left: From the Alaska sketchbook.

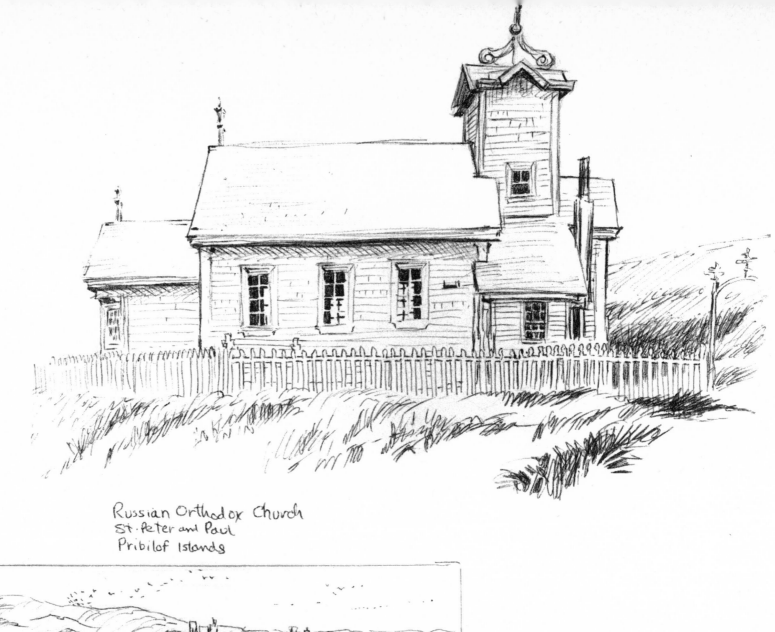

Russian Orthodox Church
St. Peter and Paul
Pribilof Islands

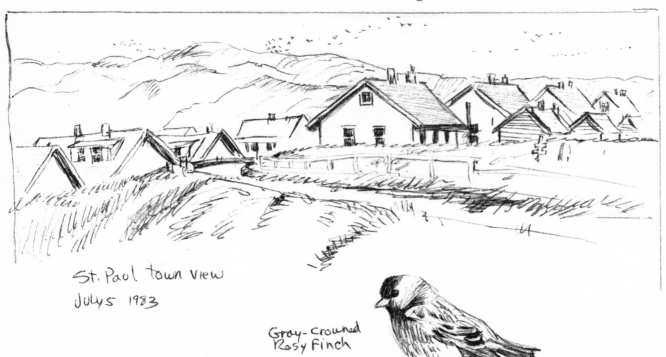

St. Paul town view
July 5 1983

Gray-Crowned
Rosy Finch
the common town bird

first with Audubonesque portraits . . . and later with paintings of birds with full environmental backgrounds. I am now experimenting in the direction that . . . several others are taking; a more painterly approach, bringing me back full cycle to my art school training."

Roger Tory Peterson first met Bob Bateman at the *Animals in Art* exhibit at the Royal Ontario Museum in Toronto in 1975, although he first saw Bateman's work nearly twenty years before their reunion on the Pribilof Islands. It was in the mid-sixties, and Peterson was passing through Nairobi, Kenya. "I saw my first Bateman — a spirited painting of a wildebeest in full gallop . . . hanging above the mantelpiece in the house of a friend in Nairobi. The wildebeest was handled simply and impressionistically. It reminded me of the wall paintings of game animals by Stone Age men in the caves of southern Europe — except that it was obviously more sophisticated. [A version of this painting is reproduced on page 70.] I asked my host, Bristol Foster, who had done it. He said it was by a young friend of his, Robert Bateman, who at that time was in Nigeria teaching geography and art."

The two painters eventually became friends and have travelled together in Kenya and Japan. When they meet, their conversation turns easily from nesting colonies to slide storage, from washes and glazes to telephoto lenses, the shop talk of the bird world, and long-term hopes and ambitions in painting, whether they are at Peterson's beautifully equipped studio in Old Lyme, Connecticut, or in a hotel room in the Pribilof Islands.

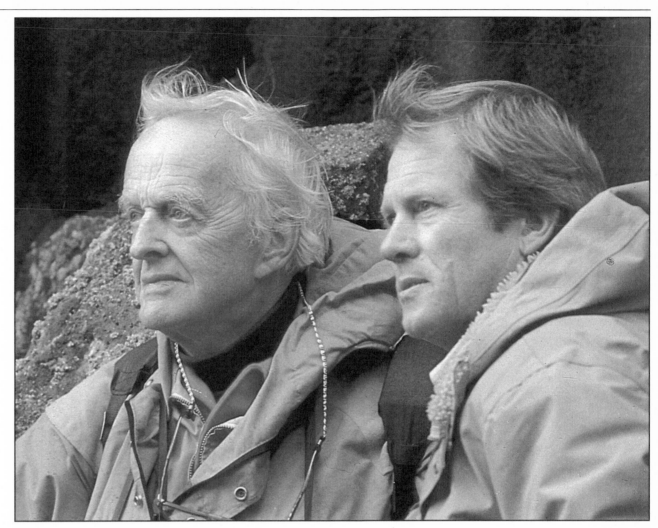

Peterson, who wrote the introduction to *The Art of Robert Bateman,* has been an important, enthusiastic, and generous admirer of Bateman's paintings, with an exceptional capacity for appreciating Bateman's combination of a naturalist's observation and an artist's imagination.

This chance encounter with Roger Tory Peterson in the Pribilofs provided a fitting climax to the "Wild America Revisited" tour and to Bateman's first experience of Alaska. But what he had seen made such a strong impression on him that he was to return to Alaska for further explorations within a year.

Above: With Roger Tory Peterson, at St. Paul, Pribilof Islands.

Opposite: Pribilof sketches, 1983.

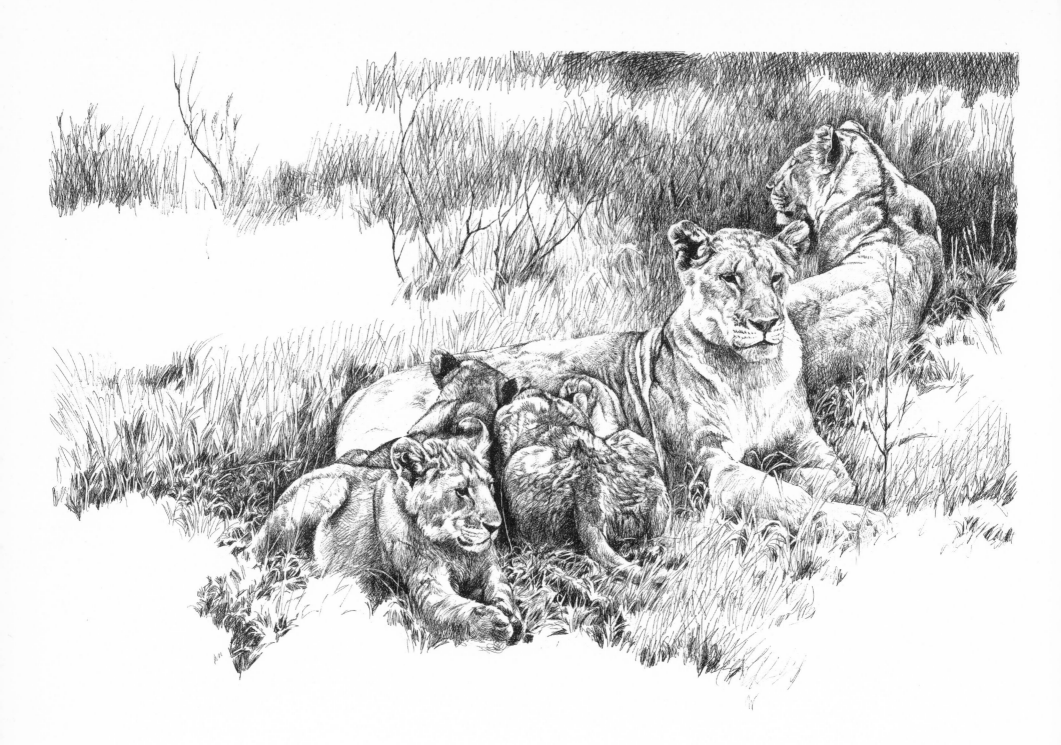

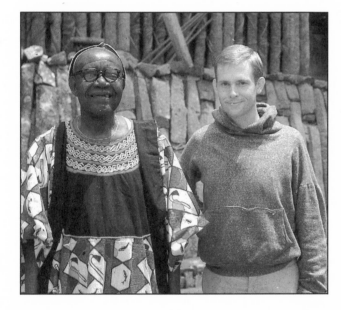

Top, right: From the African sketchbook.

Above: With the Fon of Bafut, Nigeria, 1963. This Nigerian chief was a leading character in Gerald Durrell's book, *The Bafut Beagles.*

Opposite: Lionesses and Cubs, 1975.

When Bristol Foster phoned Bob Bateman in Toronto in 1956 to propose a trip around the world in a Land Rover, Bob was incredulous. But after further thought, he realized that there was no reason for him not to go. Within a week they were planning the trip with a school atlas. Both men were then in their late twenties, well-educated and enthusiastic naturalists, with the background and contacts — especially in the field of wildlife biology — to give a focus to their travels. They knew that the heart of the trip for both of them would be Equatorial Africa, stretching from Ghana through the Congo and culminating in the great gamelands of East Africa. For Bob, Africa represented the natural world in a pristine state, with unspoiled plant and animal life and unique tribal communities.

They started out from England in 1957, and travelled down the west coast of Africa by sea, landing in Ghana, where they were joined by a fellow naturalist, Erik Thorn, before proceeding eastwards across the continent.

Among their memorable experiences was a stay with a tribe of pygmies in the Congo. This particular tribe was being studied by the now-eminent anthropologist Colin Turnbull, who introduced them to the tribe and trans-lated for them. The pygmies — or Ba Mbuti, traditional forest dwellers — had developed over the millennia exceptional skills of self-sufficiency and a subtle, infinitely detailed knowledge of their jungle world. They were an object lesson in living in harmony with the environment.

These skillful hunters of small animals and birds, using nets and bows and arrows, were willing to bring their visitors along on a hunt and were glad to take advantage of a ride to a more distant area. Three Canadians and twenty-seven Ba Mbuti were squeezed into the Land Rover, and the pygmies sang as they drove along. Bob still remembers the song and says, "What I especially liked about it was the typical Ba Mbuti philosophy it expressed. 'Everything is great, the forest is wonderful, and everything is going really well.' All their songs are really hymns of praise."

Bob, Erik, and Bristol were also able to apply the Ba Mbuti hunting skills in the interests of science. They were collecting various small animal specimens for Canadian and American museums but in the Congo jungle they were having difficulty collecting specimens of mice, shrews, and bats, as the tiny creatures were being ravaged by ants before

they could be retrieved from the traps. The Ba Mbuti, however, were able to hunt the mice very effectively with their bows and arrows, and for a modest fee presented Bob with an excellent collection.

These encounters with tribal people in the Congo, in East Africa, and later in India and southeast Asia, made an impact on Bob that was both immediate and lasting. At the time he was excited by the sheer novelty and variety of the ways in which humans could live. In retrospect he realizes that on that trip, less than thirty years ago, he had seen not only wildlife and forest and wilderness areas, but also distinctive and tribal ways of human life that have since disappeared. His keen sense of this loss has contributed greatly to his commitment to conservation and preservation.

Undoubtedly, the memories of that trip center on visits to the great animal parks of East Africa. Foster remembers, "We'd been waiting for months for this; we were in big game country at last." They were astonished by the great herds of animals, "even better than we had dreamed about." The high points of the trip were the Ngorongoro Crater and Serengeti Park. Though both areas are now highly organized for tourists, in 1957 they were not, and exploring them was a real adventure.

Bob recalls, "Everybody at the time kept saying to us, once you've been in Africa you'll always come back, and it sure happened to both of us. I knew I would come back to Africa, somehow, though I didn't know then how I would get there or what would bring me."

He did indeed come back to Africa, first in 1963, when he went to Nigeria as a high school teacher under a Canadian external aid program. At the same time Bristol Foster was in Kenya, teaching wildlife management at the university of Nairobi. He had excellent access to the game reserves, and Bob was able to spend two months there with him. During his

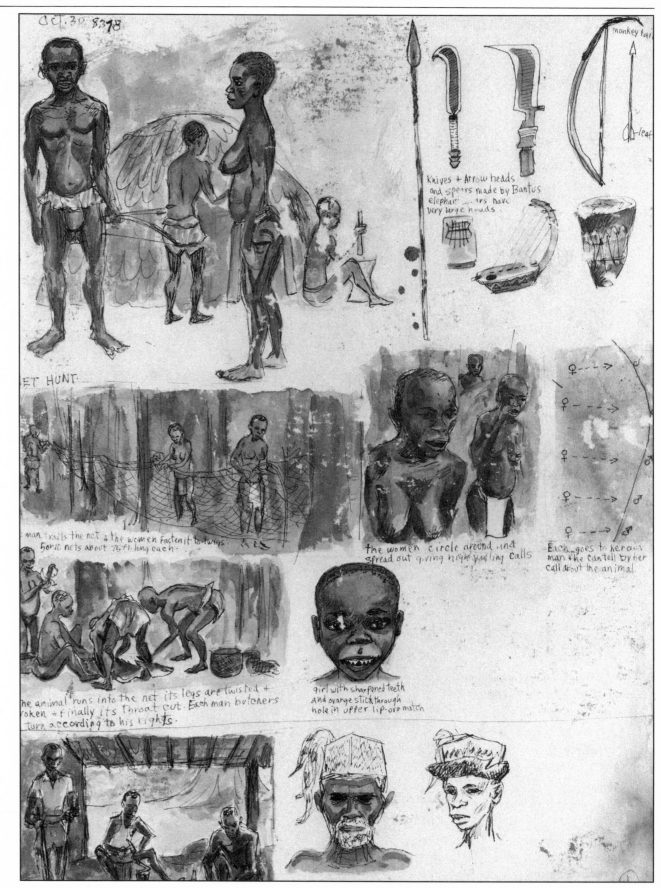

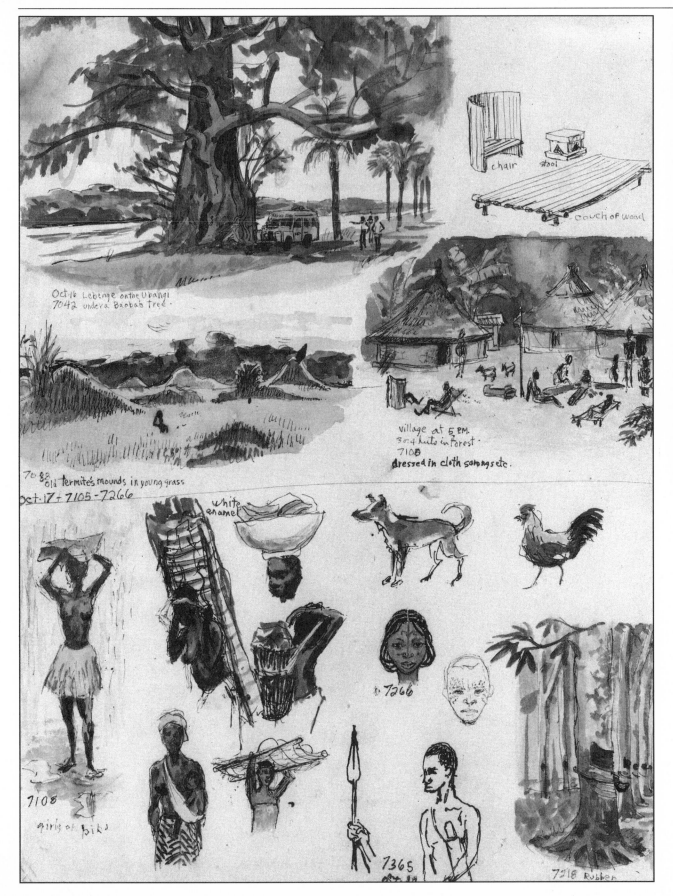

Above: Congo River, 1957. "One great thing about our round-the-world trip was that there was time to stop whenever we wanted. I would paint and Bristol would explore and photograph. We stopped at a crossing of the Congo River and on the spot I did this painting somewhat in the style of Emily Carr."

Opposite and left: African Notebooks, 1957. Ba Mbuti pygmy tribe; Eastern Congo tribe. "Soon after we landed in Africa, I realized I was wasting time thinking about being hot or hungry or uncomfortable instead of paying attention to what there was to see. So I bought a large sketchbook and began recording every distinction I could see in vegetation and landform, in types of people and their dress and way of life. I would draw as we drove along in the Land Rover, and then add color when we stopped. This exercise was very exciting because it made me increasingly aware of the amazing variety that exists on the planet."

two years in Nigeria, Bob was absorbing the impact of Andrew Wyeth's work and he began to heed Foster's urgings that he paint African wildlife realistically. Foster displayed these paintings in his house in Nairobi (where they were seen by, among others, Roger Tory Peterson), and acted as Bateman's informal

44

Left: Thomson's Gazelle, 1964. One of Bateman's first full-scale presentations of African wildlife subjects. When it was exhibited in Nairobi it led to the first serious public interest in his work.

Opposite: Batemans on safari, 1982. Left to right: Christopher, Sarah, Alan, Birgit.

Bob has returned to Africa, and especially East Africa, many times since 1965 and is familiar with most of the animal- and bird-watching areas. He is nearly always accompanied by Birgit, but until recently there was never an opportunity to take any of his children, something he had long wanted to do. "In the summer of 1982, I finally was able to fulfill a dream that I'd had for five or ten years — to go with the kids to Africa. I'd saved for it and planned for it and postponed it a year or two, and finally we actually did it." With three of the five of them — Alan, then seventeen, Sarah, sixteen, and six-year-old Christopher — they travelled in classic safari style with a guide and staff. Although nearly all the territory had been covered by Bob in the past, he judges this the best trip he has ever taken to Africa.

"I keep going back to Kenya because it's certainly one of the richest places for wildlife and because the big animals tend to be more accessible there than in some of the other areas. Looking for wildlife is always uncertain, which is why it's so exciting. You hope that the animals will be there but often they aren't. And then it's up to your skills and luck as to how much you'll see. What we were really hoping for, although it was a bit too early in the season, were the great wildebeest and zebra migrations in the Masai-Mara Reserve. Luckily, they were early. The big masses had moved in, bringing with them the predators, in particular the lions, that always follow along after their food. And so we had absolutely magnificent luck from that point of view."

The other species were just as co-operative for the Bateman family. They had good sightings of leopards in the Aberdares, and saw many of the beautiful giraffe gazelles or gerenuk in Samburu. At the bird sanctuary at Lake

agent when a local gallery became interested in exhibiting them.

These early Bateman paintings of African animals are comparatively straightforward: the subject is front and center and the surrounding landscape is fully realized but subordinate. It was several years before the wildlife subjects in his paintings would be subsumed into the landscape and before he was able to assimilate into his work the strong abstract structures, cubist and impressionist techniques, and thematic transformations that have made his paintings so powerful and distinctive.

But his first African paintings presented the wildlife wonderfully well: they were both accurate and beautiful, and seemed to capture the spirit of the animal. They soon found admirers, first among wildlife biologists and naturalists based in Nairobi, and then among a broader public.

For the next few years, after he had returned to Canada, many of his paintings featured

African wildlife, and Bateman developed a reputation in Nairobi and London before he became well known in Canada or the United States. African subjects have continued to form a significant proportion of his painting over the past twenty years, and, partly because they are often of big animals, they are among the most dramatic. Some of the animals have a particular fascination for him — lions and other big cats, and also elephants, whose massive shape and infinitely complex hide give it a double fascination.

In his African paintings Bateman does not make the landscapes exotic or spectacular. Though many of them are set around the magnificent Mount Kilimanjaro, that mountain itself has not yet appeared in a painting. Instead, what he is attracted to more often than not, whether in Africa or at home in Canada, is the ordinary; the worn and sometimes scruffy bit of countryside that is easily overlooked by most people.

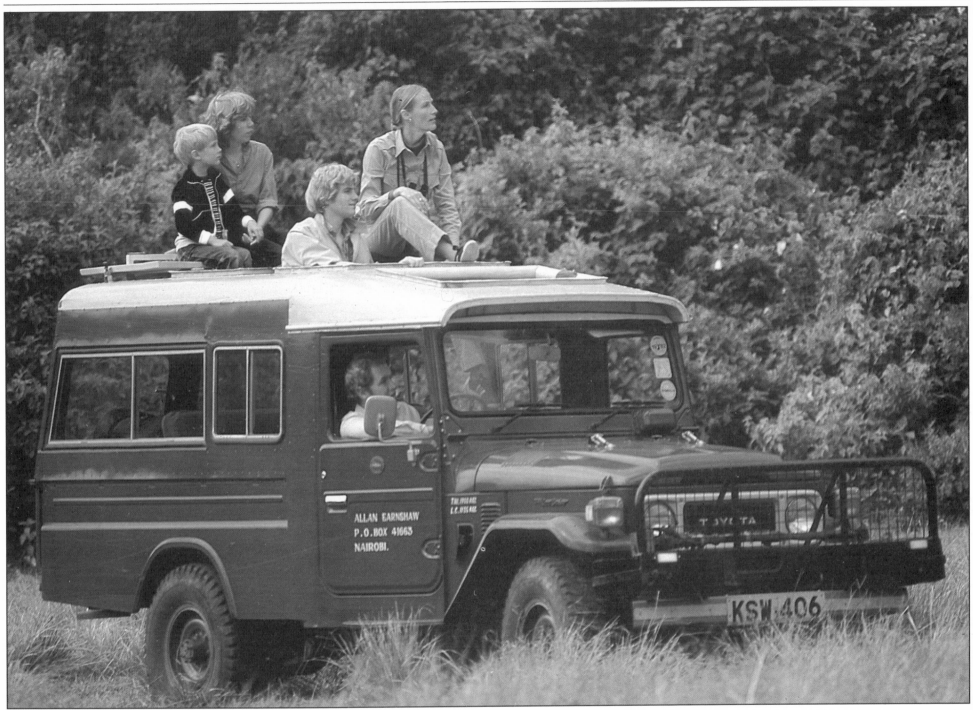

Baringo, the Batemans' bird-listing accomplishments were challenged by the safari leader, Allan Earnshaw. He invited them to break their own day-and-a-half record of species listed, made a few years earlier at Point Pelee in southern Ontario. They all rose to the challenge, and Africa won by sixteen species; their total for the trip was over three hundred. Birgit remembers their idyllic safari routine.

"Our typical day started before light with the sound of the warm water being poured into the canvas wash basins and the dawn chorus of birds in the background. With the first light we would set out in the big Toyota landcruiser with our heads and shoulders projecting from the three roof hatches. Christopher's favorite perch was beside his friend, the senior game scout, Awaka, who had in his younger days

scouted for various members of the royal family and who, though now in his seventies, still had sharper eyes than anyone.

"Allan Earnshaw knew the country so well that we usually managed to avoid all the other tourists and had the feeling that we were alone in Africa. He would always plan a special sunset-viewing location — perhaps a bend in a river where we could watch the elephants cross

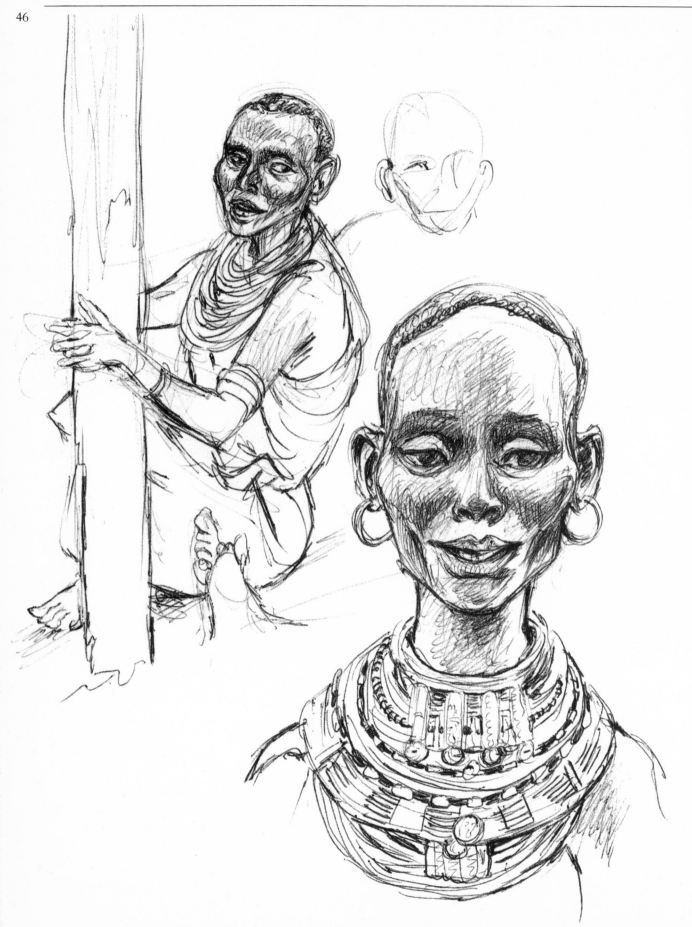

Sketching a Samburu girl, Kenya, 1982.

in the afterglow, or perhaps high on a hilltop near where a pride of lions was waking up for their evening hunt.

"Then we would drive back through the twilight, looking for the glow of the campfire in the darkening African landscape. Soon there was a warm shower, and then a cold drink while we sat in camp chairs around the fire, exchanging stories and listening to the sounds of the African night."

Bob had a copy of *The Art of Robert Bateman* with him and was able to show some of his paintings to the African guides on the safari, men who spend most of their lives with these animals in their natural settings. He understood only a few of their remarks which were in Swahili, but from the enthusiasm of their conversation and the way their fingers pointed at the paintings, he concluded that his work met with their approval.

At a party in Nairobi which included several of the wildlife biologists and naturalists who work in Kenya, one young woman, an expert on the wildlife of Amboseli Park, was looking through a copy of *The Art of Robert Bateman* and came on one of his big elephant paintings, *Bluffing Bull,* painted in 1979. "That's Cyclops," she said, and then added, "But it can't be. He only has one tusk."

Bob had to admit that he'd added the second tusk. "But I was flattered that she'd recognized him by the particular features of his face. He apparently was a famous old reprobate in Amboseli Park."

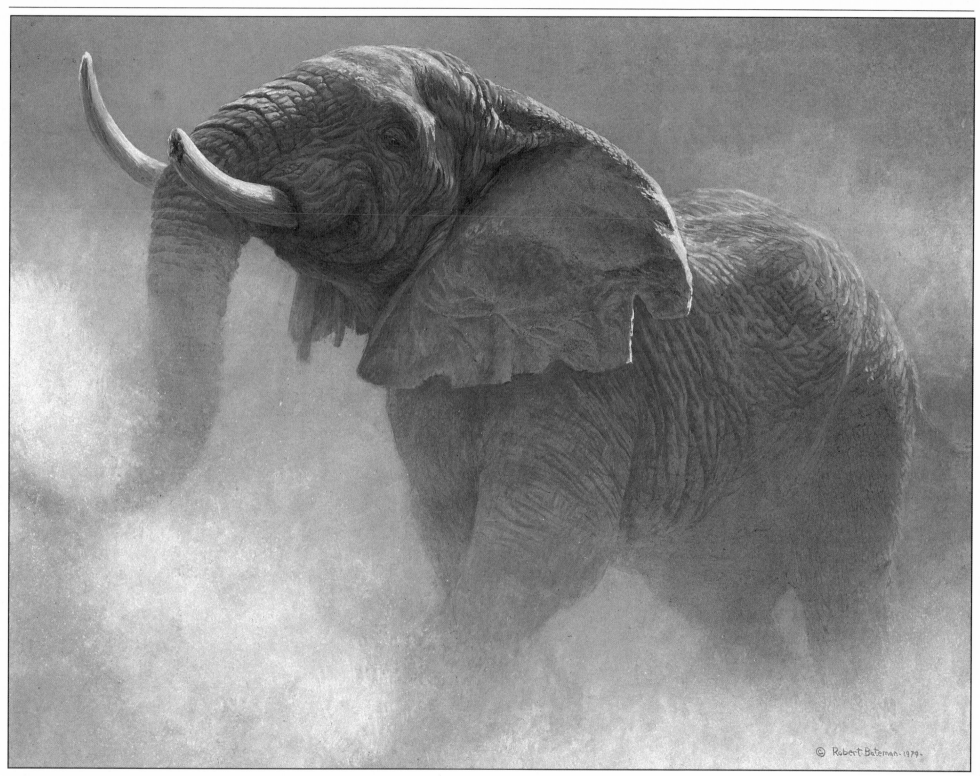

Bluffing Bull, 1979.

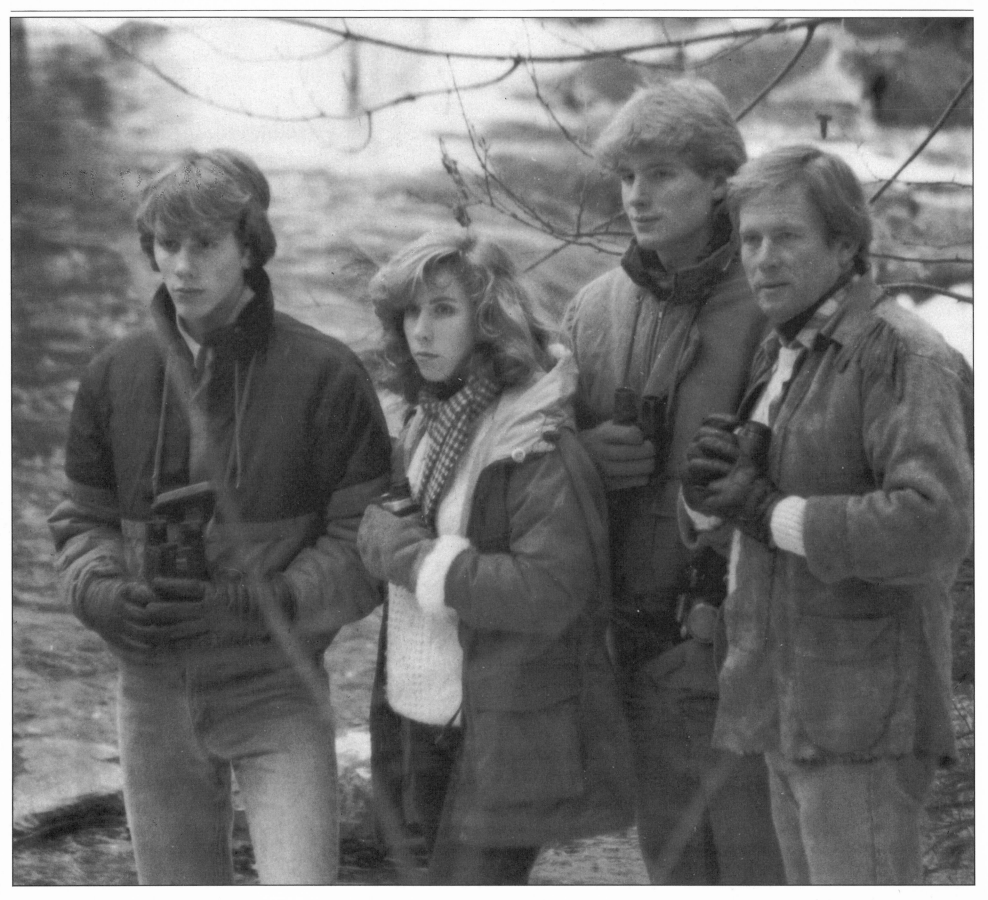

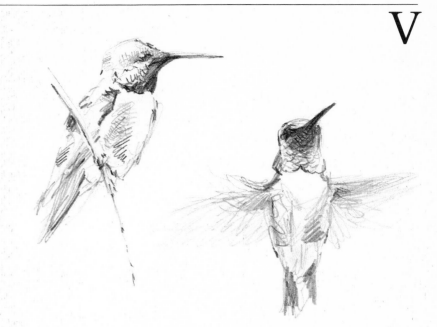

The Bateman calendar for the year ahead is always alarmingly full. There is usually at least one major trip planned with the family, and Bob and Birgit usually set off a couple of other times by themselves. But the calendar is also filled with many other commitments all over the continent: opening ceremonies, visits to galleries, lectures, conservation meetings, charitable events, media interviews, publishing and editorial meetings.

Nonetheless, Bob's daily working routine is dependable, and his productivity as an artist comes not only from his assured technical skills and an image bank of ideas, but also from a capacity for steady, hard work. Each year he completes between eight and twelve major paintings and perhaps a dozen smaller ones. When he is at home, despite the distractions, Bateman spends at least eight hours a day at the easel. He is usually working by nine-thirty and works through until one o'clock. After lunch and a short afternoon nap he is painting again by three-thirty. At the end of the afternoon there is a break to go hiking, bicycling, or cross-country skiing, an early supper with Birgit and the children, and then another period of painting until ten o'clock or, more often, midnight.

Home is the house near Milton, Ontario,

an hour's drive west of Toronto, that Bob designed nearly twenty years ago. For several years they have been planning to move to British Columbia, and a house and property have finally been found on one of the beautiful islands that lie between Vancouver Island and the lower mainland.

The family continues to spend a large part of every summer at the lake in the Haliburton district of Ontario, where his parents have kept a cottage since Bob and his two brothers were boys, and a region that has provided many of the subjects and settings for his paintings. Until recently, Bob and Birgit and all the children shared the same cottage with his mother and other relatives. A couple of years ago, however, Bob and Birgit began building a handsome log house nearby, set beside the widening of a little river and looking across to a fine cliff of Precambrian rock. Bob worked closely with the builder and had a large hand in the design and the finishing details. The house is comfortable but simple: on the lower level an open living, dining, and kitchen area surrounds a huge fireplace, and there are two small bedrooms; on the second level there is one large gallery, half of it used as a sleeping loft and the other half used by Bob as a studio.

The summer days pass with family life

Top, right: Ruby-throated hummingbirds, 1985.

Above: A typical month of the Bateman calendar.

Opposite: John, Sarah and Alan Bateman with their father.

Top: Haliburton Cottage, 1952. This was where Bateman spent his summers from 1938.

Bottom: Buck's Slides, 1960. A rapids near the Batemans' family cottage in Haliburton. The painting shows the influence of the artist Carl Schaefer.

swirling around Bob as he paints. He also canoes, swims, plays with his children, sings folksongs with his friends, and works on the house, but normally, unless he has some reason not to, he paints. "I generally like life to go on around me and just to keep working right through it. I'd find it boring to be tucked away alone in some ivory tower. I never worry about interruptions or about privacy — I've got no special alchemy or secret techniques. I'm fairly oblivious and single-minded when I'm painting, but the work is intuitive, not verbal, and so I can often talk to visitors or people on the phone and still keep working."

When the weather is good he lugs the current painting down to the dock and works there. Paintings-in-progress are treated carefully, but not with any special reverence. They are heaved up and down stairs, lowered from balconies, brought in hurriedly from the rain. (Bob seemed only mildly irritated when a pet lovebird took to perching on a large half-finished painting, its droppings adding a Jackson Pollock touch to the work.) On occasion, Bob has amused his children by working their names or initials into a painting, hidden, for example, in the lichen patterns on a rock.

There are periodic consultations with family and friends on the development of a work. Birgit, who has the eye of an artist, is the most important critic of all, and is especially influential on the composition of a painting. But his mother, who sent him off to art and natural science courses at the Royal Ontario Museum when he was twelve, is still one of the people he depends on to tell him if a painting is working as he intends it to on a representational level.

He is close to his mother and takes great pleasure from including her in events at which he is honored or his work is celebrated. In the last few years five universities have awarded him honorary degrees, and in 1984 he was made an Officer of the Order of Canada, the country's formal recognition of its most distinguished citizens in various fields. He has also received numerous awards from American and Canadian conservation and art associations.

Perhaps the most singular of his honors was the commission Bob received early in 1981 from Canada's Governor-General. He was to create a painting which would be the Government of Canada's wedding present to the Prince of Wales on his marriage to Lady Diana Spencer. Bob was unabashedly excited by the commission. He had only three months or so in which to complete the project, but in spite of this deadline he enjoyed working on the painting, titled *Northern Reflections,* in which he was able to introduce themes which were typical and evocative of the Canadian wilderness and also characteristic of his own work. [The painting is reproduced on page 161.] When Bob and Birgit were in London later that summer, after the royal wedding, they had the pleasure of seeing the painting on public display with all the other wedding presents at St. James's Palace.

For any serious artist, the primary interest lies in doing the painting and being satisfied with it. Bob was painting happily for many years before his work sold at all, and if, in the future, the public were to lose interest in his work, he would, without doubt, keep on painting. But he is gratified that large numbers of people see and enjoy his work, whether as original paintings, as prints, or as reproductions in books.

Although most Bateman paintings are in private collections, many of the originals have been seen by the public in the extraordinarily popular retrospective exhibition of his work that has been touring Canada and the United States for the past several years. The exhibition originally opened in Ottawa and went on to Quebec City, Saint John, Winnipeg, Vancouver, Edmonton, and Toronto. It was then reorganized and remounted in San Francisco, and has so far been seen in St. Louis and Cincinnati. As it moves about the continent, the selection has gradually changed; some paintings are returned to their owners — the show depends in large part on their good will — and others are borrowed to replace them.

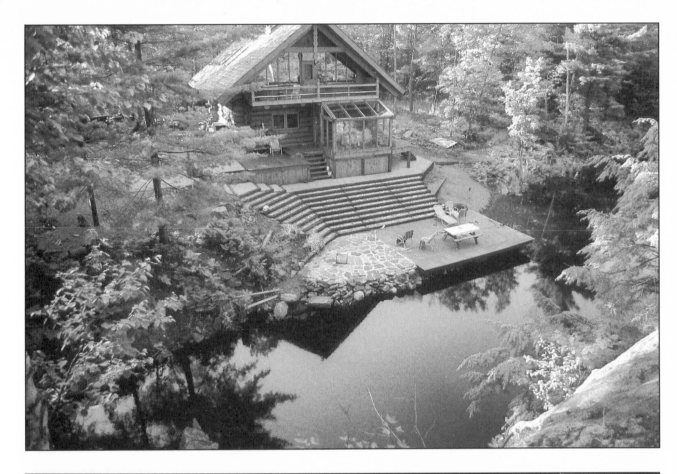

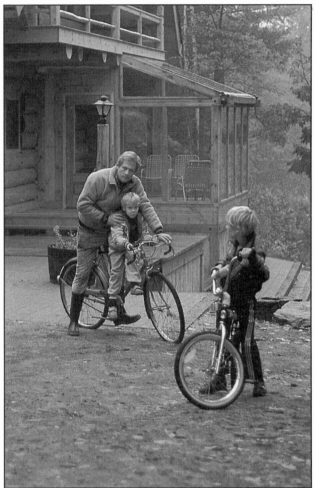

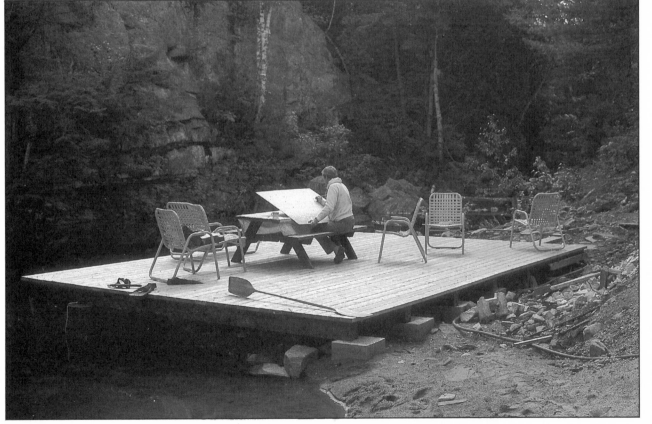

Above: Bicycling with Robbie and Christopher.
Top, left: The log house.
Bottom, left: Painting on the dock.

This exhibition has invariably drawn large, sometimes record-breaking crowds to the host galleries, and the openings are major social events. When Bob is present, he usually gives one or more lectures in conjunction with the show. In San Francisco, at the California Academy of Sciences, he lectured on three successive nights, all of them sold out.

When new Bateman paintings are offered for sale at private gallery showings, they don't remain on the market for long. All are sold by draw; potential buyers register and the person whose name is drawn has the first chance to buy. This avid market for his paintings has existed since the late 1970s and has inevitably led to higher and higher prices. When an artist's works are in such tremendous demand,

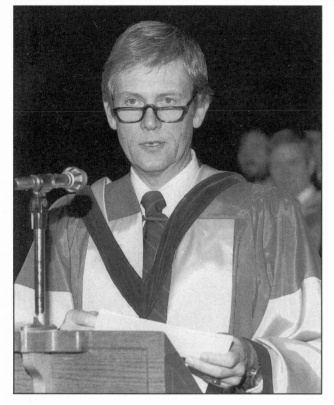

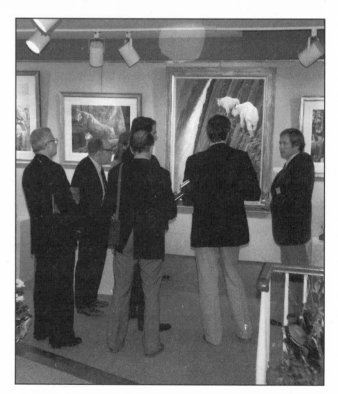

Top, left: Convocation Address, University of Guelph, 1985.

Bottom, left: Bob's mother, Annie Bateman.

Above, right: Receiving the Order of Canada, 1984. Left to Right, Birgit, Bob, His Excellency the Governor-General and Mrs. Edward Schreyer.

Bottom, center: A book signing, Anchorage.

Bottom, right: Gallery opening, New York City.

Left: "We were in London when all the wedding presents were on display at St. James's Palace. Expecting that *Northern Reflections,* the painting given to Prince Charles by Canada, would be in the exhibit, we couldn't resist going to see it again. We devoted a morning to standing in the rain in a typical British queue filled with dripping umbrellas. After a four-hour wait we entered the palace − only to find no trace of the painting. Eventually we realized that the national presents were displayed in a separate room, but even then we couldn't find it. At long last we spotted it by the exit, hanging at knee-level. It was outshone by a large case of glittering gold jewelry presented by Saudi Arabia, but at least it was sharing a pegboard with distinguished company − a painting by Raoul Dufy, a present from the Republic of France. As it was hung so near the floor, almost no one noticed it; when a gentleman did finally stop to look at it carefully, I was so delighted that I rushed up and introduced myself."

there is a real and legitimate pressure to reproduce works in prints or reproductions. Some years ago, before his work reached its present level of popularity, he was approached by Mill Pond Press, a fine-art publishing house, with a proposal to produce limited-edition reproductions of his paintings.

The program has been more successful than he or his publishers ever dreamed. The passionate interest aroused by these prints is a remarkable reflection of the appeal of his paintings; of all the artists in North America whose work is presented in this way, he is probably the most sought after. Bob is constantly amazed by the popularity of the prints and the tremendous personal interest in his work they have created. There is nothing cynical about him: he is genuinely gratified by the stream of letters and phone calls of appreciation he receives.

Mill Pond Press publishes Bateman's paintings in editions of 950, with an additional fifty-six artist's proofs and twenty publisher's proofs. The popular success of these prints is indicated by the fact that some of them now have a secondary market value that is several times greater than their original list price.

Limited-edition reproductions of this sort are the subject of some contention in the art

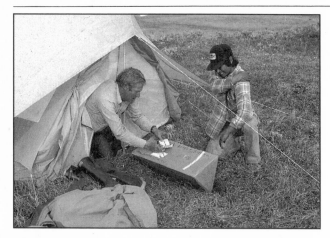

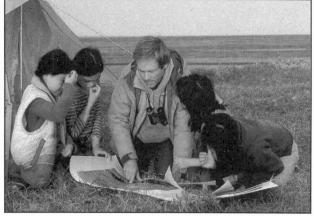

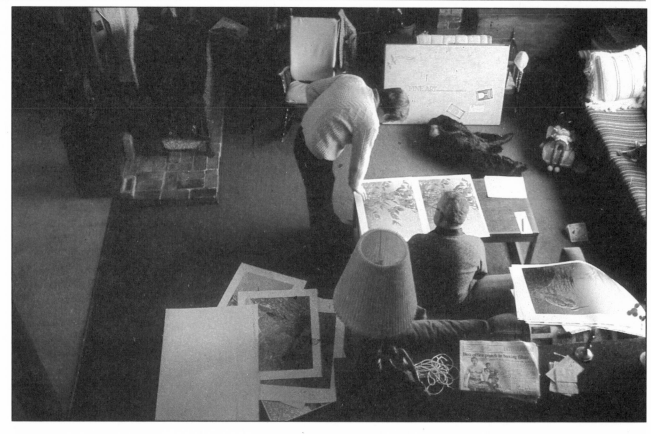

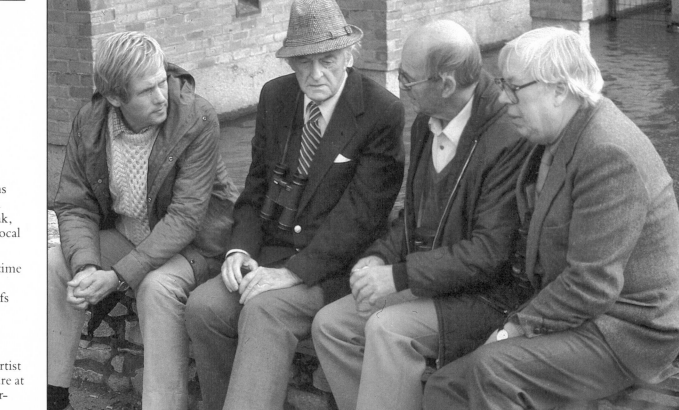

Above: Mill Pond Press goes to extraordinary lengths to accommodate itself to Bateman's travels. *(Top)* A bundle of print proofs is delivered to a tent in Chevak, Alaska. *(Bottom)* Bob checks the proofs with some local assistance.

Top, right: Checking proofs with Bob Lewin. Each time a Bateman painting is published as a limited edition print there is a painstaking process of checking proofs and print runs, and finally numbering and signing each print.

Right: Left to right: Robert Bateman, Roger Tory Peterson, Sir Peter Scott, the distinguished British artist and conservationist, and Lars-Eric Lindblad. They are at Sir Peter's Slimbridge Wildfowl Trust, in Gloucestershire, England.

world, occasionally arousing incensed and rather metaphysical arguments about the definition of a print and the implications of a limited edition. Some makers of original prints argue that reproduction prints should not be signed and numbered. Bateman responds that he signs and numbers for the same reasons they do: market interest and quality control.

Bob is directly involved with each edition, checking the color proofs in intense detail. His paintings reproduce extremely effectively, the only difficulty arising from the fact that the camera tends to "see through" the many thin layers of paint which are characteristic of his technique. Working from the first color proof, he may ask for as many as ten additional colors to refine the accuracy of the printing. Sometimes, even after the final run before the prints are cut and trimmed, he may feel obliged to ask for a further revision, in which case the printing is destroyed and proofing begins again.

The popularity of his work and the interest in the man himself have made him an influential spokesperson and an increasingly effective fundraiser for a variety of wildlife and conservation organizations. He often provides an original painting to be auctioned at a major charitable event or a signed print for which there may be a draw. Some of these activities have taken him to exciting and unusual social occasions. In Monaco, Bob and Birgit had a meeting with the late Princess Grace, and the sale of reproductions of the painting he presented to her at that time, along with two subsequent works, raised over a million dollars for conservation projects of the Canadian Wildlife Federation.

As privileged residents of the wealthier parts of the world, Bateman believes that North Americans and Europeans have a special responsibility to help conserve the natural world. It always seems particularly appropriate, therefore, when his painting, which celebrates the natural world, can contribute towards its preservation.

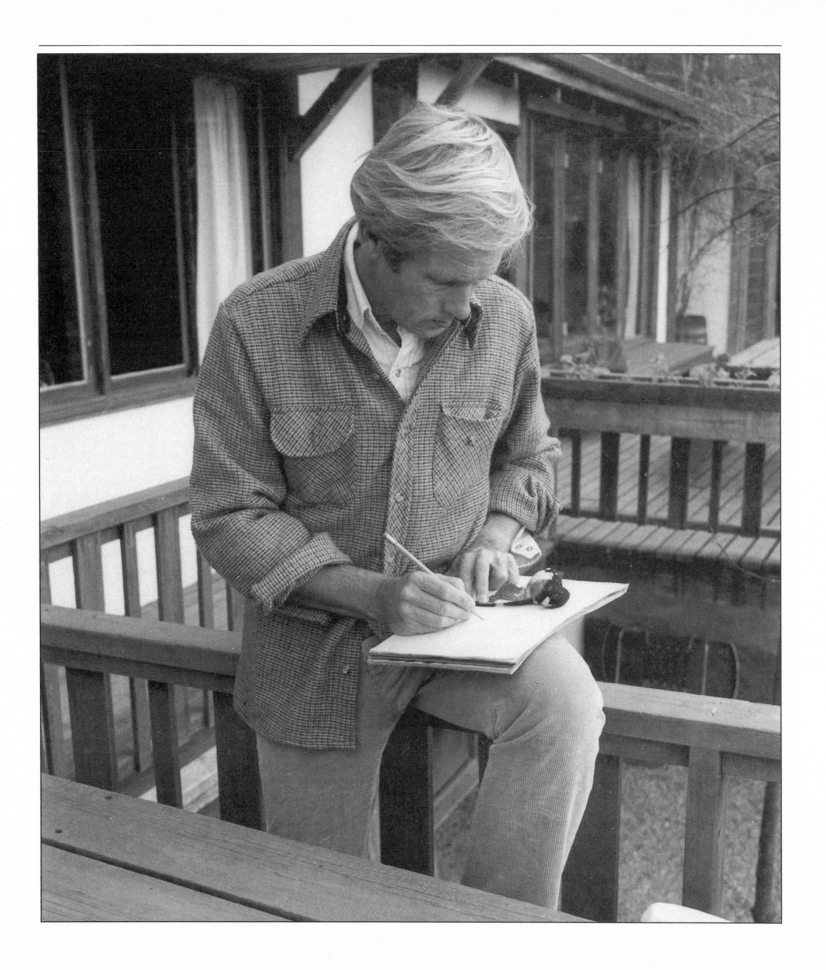

One early morning in May, I joined Bob when he was taking part in the North American breeding-bird census organized annually by the United States Department of Fish and Wildlife. He has done this for the past twelve to fifteen years and the crack-of-dawn departure from his house is something of a ritual. These expeditions have varied in their pleasures. Garry Crossman, a former high-school teaching colleague who, with Birgit, has been Bob's partner on the census for most of these years, remembers some black, windy, rainy, cold dawns, weather that no bird would want to be out in — and no bird-watcher, either. But this year, census day began with a perfect spring morning and a strong sense of anticipation and excitement.

The census depends on the volunteered help of thousands of selected expert bird-watchers across the continent. Each census-taker reports on the birds observed in a precisely specified area at a specified time. The statistics gathered are fed into a giant computer in Maryland and the results are formulated in a variety of maps, graphs, and print-outs. For ornithologists and naturalists the findings are interesting as a register of the waxing and waning populations and changing migration patterns of the nearly seven hundred species of birds that inhabit North America.

This census also has more far-reaching implications as a sort of early warning system for changes in the environment. Like the canaries taken by coal miners into the mines to warn them of noxious gases, the sharp decline of a species or a change in the general bird population in some areas may be the first warning or indication of a disturbance in the environment that could affect other wildlife or human welfare.

The actual census-taking is both disciplined and simple. Along with every other census-taker on the continent, Bob is required to start exactly half an hour before sunrise, first recording the temperature, wind velocity, and cloud cover. Observations are to be taken at fifty pre-determined locations, each one a half-mile apart, recording the number of each species which can be seen or, more important, heard over a period of exactly three minutes. The rules are strict: census-takers are ordered not to guess, not to list a bird they know is there but do not actually see or hear, and not to compensate at one census point for errors or mistakes they may have made at some earlier location. The all-knowing computer does its own compensating.

Bob's assigned route follows a series of country roads through the farmland northwest of Toronto. We drive through the early morn-

Top, right: Canada Geese sketched from the window of Bateman's studio.

Opposite: Drawing from a specimen.

Above: Bird Census, May, 1983.

Opposite: View from the Pine, 1968. "This is a view of my own particular natural habitat. The stream runs near our house, and the house itself can be seen on the left side of the painting. I was conscious of how the stream had eroded and shaped the surrounding landscape. I am continually delighted by the complexity and variety that can be found in almost any kind of countryside."

ing light to the first census point and check our bearings and the clock. I have been given the job of time-keeper, starting each count and stopping it after the regulation three minutes. Garry is record-keeper, noting down the birds that are identified as Bob calls them out. Bob, as census-taker, becomes like a selective radar screen, standing by the side of the road and turning slowly to absorb the bird-life information within range. He quickly spots any birds that are in sight; a tiny speck high up may be a pileated woodpecker, distinguished from a crow by its bounding flight. But he identifies more than three-quarters of the birds by their calls. He listens intently to the indiscriminate twittering of a fine spring morning and then calls out the species, separating one individual bird from another: "English sparrow, robin, meadowlark, two mallards, chipping sparrow, robin, killdeer, ten red-winged blackbirds, savannah sparrow, grackle . . . "

At the end of the three minutes I cut him off and we drive half a mile up the road to the next spot, repeating the procedures forty-nine times in the next few hours. Some of the spots are comparatively empty of birds and others are so rich that it's hard to squeeze them all in during the time allotted. Bob notes differences from previous years. "Purple martins — three purple martins in a purple martin house that we've never seen before. About eight English sparrows, ten starlings, six purple martins, savannah sparrow, bobolink, eight red-wings, bobolink, another savannah sparrow, two more savannah sparrows, vireo — is that the slurred sound of the solitary vireo?" Three minutes. "Another vireo!" Too late.

The sight may be puzzling to the plump figure in a gray jogging suit who comes puffing by: three men standing by the roadside, the first holding a stop watch, the second writing on a clipboard, and the third holding binoculars and gazing into the firmament, chanting the names of bird species. But the earnest jogger does not break stride.

This is a delightful way to spend an early morning and there's an added piquancy in the realization that downtown Toronto lies only thirty miles away. The city's great office towers, glistening and silhouetted in the pink morning light, are visible to us, but we are on quiet gravel roads, in a landscape of farmland and woodlots.

This southern Ontario countryside has been home to Bob since his childhood, and he continues to find it as full of interest and fascination as ever. Despite the wealth of exotic ideas and images that he is exposed to every year in his travels, he continues to return in his paintings to settings that are within a few miles, or even a few yards, of his house. This is not because he is obsessed with the familiar, but because he looks every day at the detail of nature, always finding something new, special, and of interest.

His instinctive curiosity as a naturalist was strengthened by his university education in geography; he is committed to an interpretation of geography that emphasizes the uniqueness of individual regions, including climatic differences, varieties of wildlife and plantlife, and the styles and traditions of their human life. He delights in the subtlety of these differences, whether in neighboring farming regions in France, in the rugged half-settled country of northern Ontario, in Africa, or in the magnificently varied Pacific coastline where he soon will be living.

Over the years this has developed into a deliberate philosophy, almost a kind of pantheistic religion for him: "I consider it a principle of life itself that the more finely you are tuned into its details, the more fully you can appreciate it. It seems to me that enjoying nature means being able to identify things and to appreciate differences and distinctions, to be interested in the particular and to delve into the details."

He does not mean by this that it is essential in itself to know the correct names of all the plant and animal species and subspecies. What is important is to be able to recognize the infinitely subtle and unique distinctions in nature. Without this ability, one falls into what

Bateman calls the "Oh, wow!" style of nature appreciation, in which the viewer exclaims with delight at the sight of some natural phenomenon — a sunset, a spectacular mountain vista, a brilliantly colored tree in autumn — but then can go no further, except perhaps to exclaim again.

Bob enjoys sharing with others his appreciation of the complexity and variety of nature and the pleasures of careful observation. When he was teaching high school, he would encourage his students' ecological awareness by getting them to examine in careful detail a few square feet of a meadow and to identify every plant, type of soil, and anything else that could be distinguished, and to name them, using any system of naming that they liked. Now, accompanying him on this bird census, I find his enthusiasm infectious and the wealth of informed observation inspiring. As he stands beside the road, identifying birds on a May morning, this activity is not only a contribution to scientific statistics; it is also a celebration of the natural world.

By nine-thirty we have completed the census and the pages of data are ready to be fed into the Maryland computer. The day is warming up and the birds are settling down. As we drive home, conversation turns to Utopian educational philosophies, which continue to fascinate Bob years after he gave up teaching. But mainly his mind is on the painting day ahead of him; he is deciding which of the paintings underway he will turn to and how it is going to develop.

At mid-morning, Bob is at his easel, painting steadily while juggling phone calls and domestic conversations. Watching him move so swiftly from the preoccupations of a naturalist on the census to those of an artist at work lets me see more clearly the coherent relationship between his attitude to nature and his approach to art.

In talking about his paintings, Bob repeatedly refers to the abstract structures or concepts from which they originated. There is no doubt that the abstract structure of these works is fundamental to their success and to the satisfaction he gets from them. The move he made in the 1960s away from abstract painting towards fully rendered realism was not a rejection of abstraction, but an assimilation of it. It allowed him to emphasize the particular, the unique in nature, which is now so much a feature of his art and which was, for many years, at odds with the prevailing principles of contemporary art.

"I couldn't do this in my art if I were a color-field painter or if I had continued doing purely abstract work. What I am interested in is the complexity of the world, and what I find so exciting are the differences and distinctions between things. I could represent a group of trees with a gray mass that I could put on with a roller in twenty-five seconds, but for me that's not enough. I want to pay homage to these trees and I want you to know what kind of trees they are."

He looks to the paintings of the great Canadian artist Tom Thomson for the combination of the excitement of sensuous paint and a deep understanding of nature. "When you look at a Thomson oil sketch, if you know northern Ontario seasons, you can tell not only what month he painted, but what week he is depicting."

Representational painting may not seem to be pushing at the outer edges of artistic expression when compared to some avant-garde manifestations, but that does not mean that it is a safe or unadventurous form of painting. In fact, what is surprising and refreshing to find in Bateman, an artist working with such assured techniques and within a style with which he is familiar and confident, is how much adventure, excitement, and uncertainty comes with every painting.

"I think an artist should be completely open to ideas and inspiration the whole time, right to the very last minute. Sometimes it's fun when a painting is coming along well, but sometimes it's drudgery. There are times when it's really frustrating, when I'm just wallowing or feel as if I'm out on some kind of foggy plain with no idea which way I should be

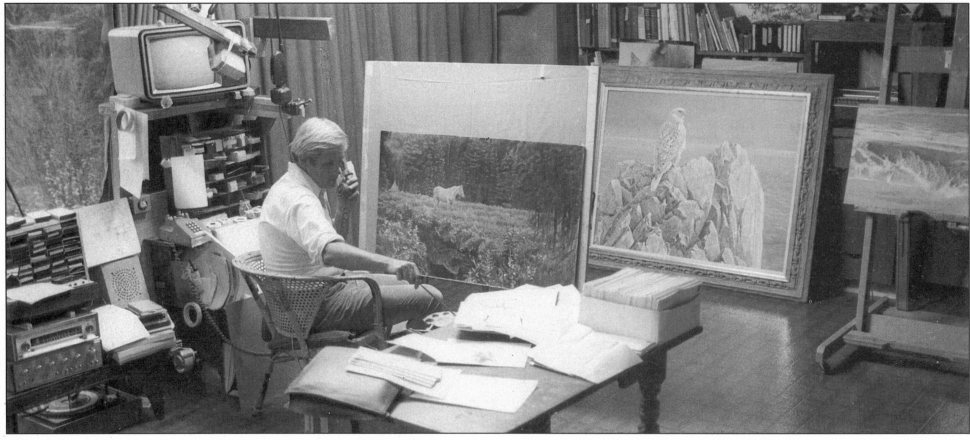

Above: Bateman at work.

going, or what the painting will be like when I finish. It's never a complete mystery, since I have the idea that started the painting, but in most of my paintings there are a lot of surprises as I go along. Some of these are unpleasant and others are pleasant. When something happens that I didn't expect, I want to be able to exploit it. I always want to be nimble, light on my feet, ready to jump this way or that as the painting develops."

The drama can become more intense towards the completion of a painting, when Bob decides he must make a major change in the content of the picture or when he applies thin, light-colored washes over the entire painting. It's always alarming to watch this process, after he has worked for weeks on a painting and it appears virtually finished. One of his methods is to mix the wash, which may be a **dispiriting** gray or mud color, and then pour it directly from the jar onto the painting, temporarily obliterating the image. He then spreads the wash around using a little sponge over large areas of the painting to dramatize some major structural force. There have been failures. On one important painting — for which there was a deadline — he had tried a new final glaze which looked fine when he applied it. But the next morning a crackle effect had covered the painting and Bob had to spend many hours delicately removing this layer while trying not to disturb the underlying surface.

"It gets a little risky at times if you've invested hundreds of hours in a picture, to take a chance near the end. But I don't think that matters. I strongly believe that an artist should have a certain disrespect for his picture in the sense of not being afraid of it. It's like having a pet bear or a pet lion — you can't be afraid of it or you'll never be able to tame it or put it in its place. So I know I have to be totally ruthless with a painting at any stage.

"I've done very radical things towards the end of a painting. I've wiped out an entire week's work, scraped it off with a razor blade, painted over it, and started again. Often I'll paint over a section of something and I know that if it doesn't work I've got hours and hours ahead of me to repair the chance that I took. I'm prepared to take these chances partly because I always have the confidence that I can get back something I've already achieved. For me it either has to be exactly the way I want it, or I'd rather not have it at all.

"When I'm working on a picture I have all kinds of thoughts and ideas about what I'm going to paint tomorrow and the day after tomorrow and next week. I doubt if I will ever run out of ideas. And I can't imagine not painting or drawing; I paint or draw because I have an urge to do it. This urge is not necessarily pleasurable, in fact it's often frustrating, but I seem to have been born with it. Painting is as full of surprise and complexity for me as is the world of nature and that is why I expect to continue in this way for as long as I am able to hold a brush."

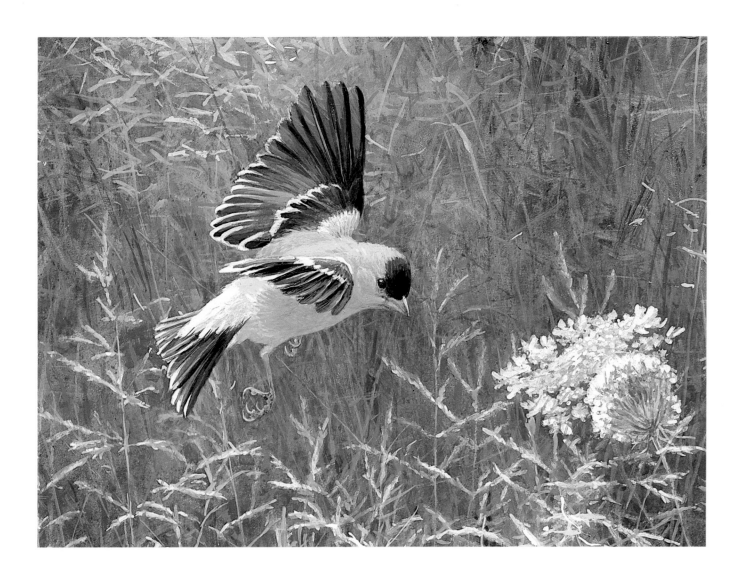

Both of these East African pictures are rich, complex landscapes, but they are very different in scale. I have always been attracted to intimate scenes — a few square yards of seemingly ordinary field or forest floor or scrubland which are filled with variety and complexity if you look carefully. The dik-dik painting is one of these miniature full-fledged landscapes. The scale is small because dik-diks are small, the smallest of African antelopes, only about twelve inches high. You can see the scale of the painting by the relative size of the elephant dung, a typical feature of dik-dik habitat, as are the different grasses and bushes and the volcanic rock.

Dik-diks are attractive animals to look at and to paint. They resemble tremendously condensed, high-strung race horses. Every muscle shows, and their anatomy and bone structure seem very tight and interlocked. They are exceptionally nervous and you usually see them either in a freeze position or else springing out of sight.

The baobab tree has the sort of sculptural form and rich texture that I find very exciting in nature. Although the baobab's branches are relatively short, the trunk is massive. Old, hollowed-out ones can be used by humans for temporary shelters — I have seen one serving as an overnight prison and another as a poacher's lair. The trunk of this baobab reminded me of a great castle or a piece of mountainous landscape, the worn and scarred surface of the tree telling something of its history. The bark of the baobab tree attracts elephants, and they have torn off great vertical strips to chew. They hook their tusks under a slab and then pull it away with their trunks. Eventually they will demolish the tree totally and it will collapse in a ruin.

The two impala bucks establish the scale of the picture. I cropped the branches of the tree to emphasize its massiveness and to create the strong, white, negative background shapes. This reflects the influence on my work of the abstract expressionist Franz Kline. When one stands back from the painting, which is five feet high, the tree is a strong, simple form.

Dik-diks; acrylic, 24 × 36″, 1975

Dik-dik; pencil, 7½ × 10″, 1985

Baobab Tree and Impala; acrylic, 60 × 48″, 1975

Leopards

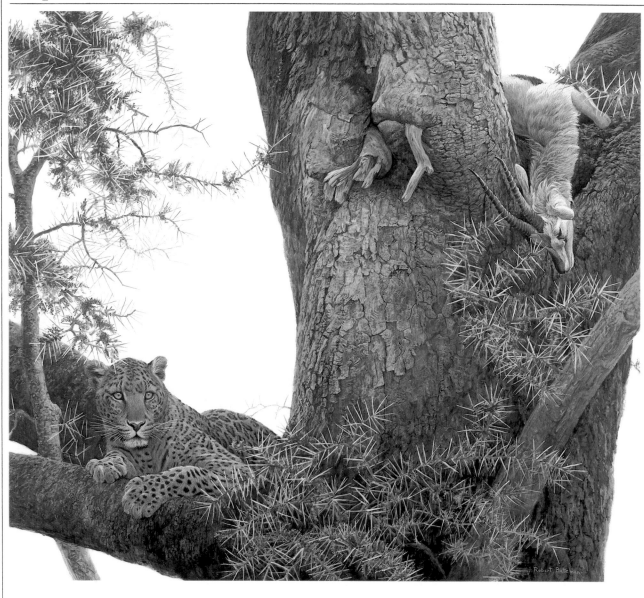

On safari in Tanzania quite a few years ago, we spent a lot of time peering up into trees looking for leopards — without success. They are comparatively hard animals to see in the wild — much more difficult, for instance, than lions or cheetahs — and I had never had a really good view of one. Finally, at the end of a long day, we were told where one had been sighted, and hurried to the spot. The leopard had climbed up into a tree with a fresh kill, a Thomson gazelle. It was a tremendous thrill for me to be able to observe this in a leisurely fashion.

The leopard was still too tired to eat, for the gazelle which he had just hunted down and dragged up into the tree must have weighed almost as much as he did. He just lay there watching us, with only a slight sense of nervousness and tension, looking more like a big pet cat ready to have its supper than the vicious killer one might imagine him to be. I was aware of the very natural, almost peaceful relationship of predator and prey.

When I came to paint the picture, I didn't portray any gore, but you can see the stickiness around the throat of the gazelle where the leopard has strangled it. Even in death, the Thomson gazelle seemed a delicate and lovely creature. As I worked on the painting, the drooping shape and broken limbs of the gazelle interested me, and I echoed them in the drooping, broken branch of the tree. I wanted the power of the painting to come from the big, white elemental shapes, and I placed the leafy branches in a circular arrangement to keep the viewer's eye moving around the whole format.

In *Leopard Ambush,* by contrast, I wanted to convey the intense stare of a great cat concentrating on its prey. In the composition of the painting I emphasized the direction of the leopard's gaze and the path of his leap by strengthening the diagonal crevices in the rocks. As I painted, the image of an arrow in a tightly drawn bow occurred to me. The leopard is the clenched hand of the archer, the lines of the cliff suggest the arrow, and the drip stains at the left represent the bow. The composition is one of highly strung tension that may at any moment be released.

Leopard and Thomson Gazelle Kill; acrylic, 33½ × 39″, 1975

Leopard Ambush; acrylic, 36 × 48″, 1982

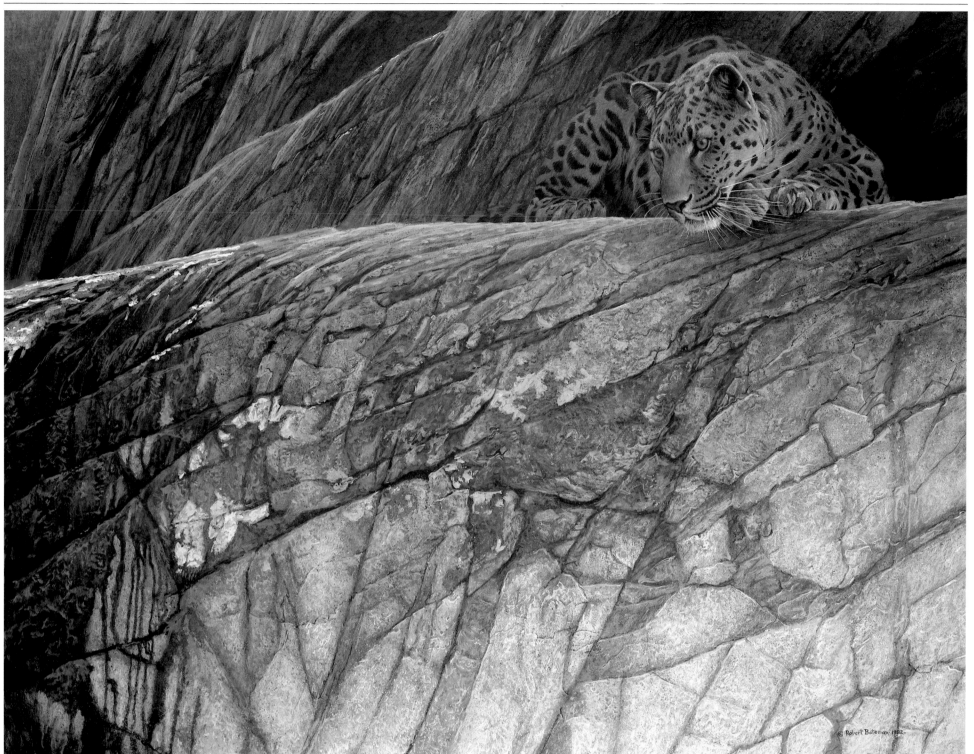

Elephants/Giraffes

When I saw this gnarled old stump it seemed to me a whole world in itself. The insect tunnels and the wear and tear of weather and age fascinated me and became the driving force for this painting. The shape and texture of the stump and its curving dead roots suggested elephants as a related subject. Even at a distance, elephants are impressive animals, but they usually prefer to keep some kind of cover between you and them, particularly if they've got young ones with them. I put them behind a screen of scruffy, chewed-up trees and they are also veiled by the dust which they normally stir up when disturbed.

As I painted these giraffes, I was thinking of the rock paintings of the Kalahari bushmen, which have a dusty texture and are flat, with fading colors. One of these paintings in particular has a beautiful rocking rhythm in the legs of the giraffes. I wanted to convey this mural-like flatness and to capture this soft dusty light. The only sharp contrasts in the picture are the pebbles and grasses at the bottom. I was also thinking of the horses on the Parthenon frieze, with their interlocking legs and overlapping necks and heads which give such a strong sense of motion.

The giraffe — with its improbable neck, its appearance of lightness (though it weighs over a ton), its almost china-doll facial expression, and the contrast between its apparent awkwardness and the languid fluidity of its motion — is an extraordinary animal. When I am at work painting a wildlife subject, I find myself almost unconsciously entering into the life of the animal, imagining its own perception of itself and the world. As I thought of seeing everything from the height of a giraffe, and of having to move around on such long limbs, I was reminded of a time in my childhood when my friends and I used to walk around on stilts.

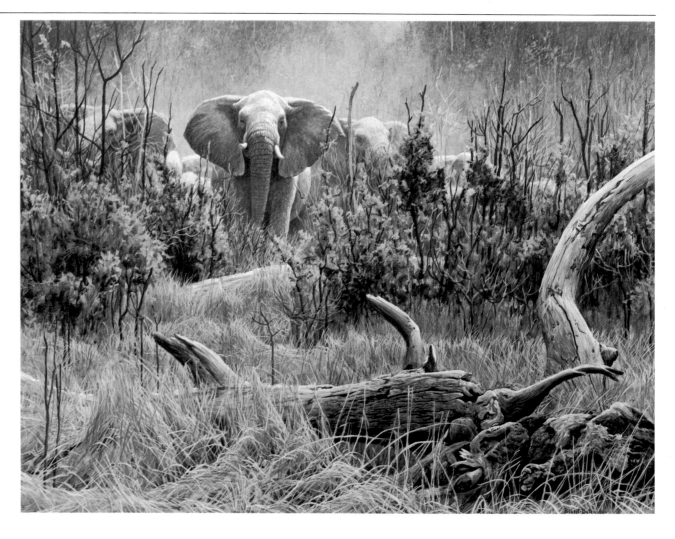

Elephant Herd and Log; acrylic, 30 × 40″, 1975

Galloping Herd — Giraffes; acrylic, 30 × 24″, 1981

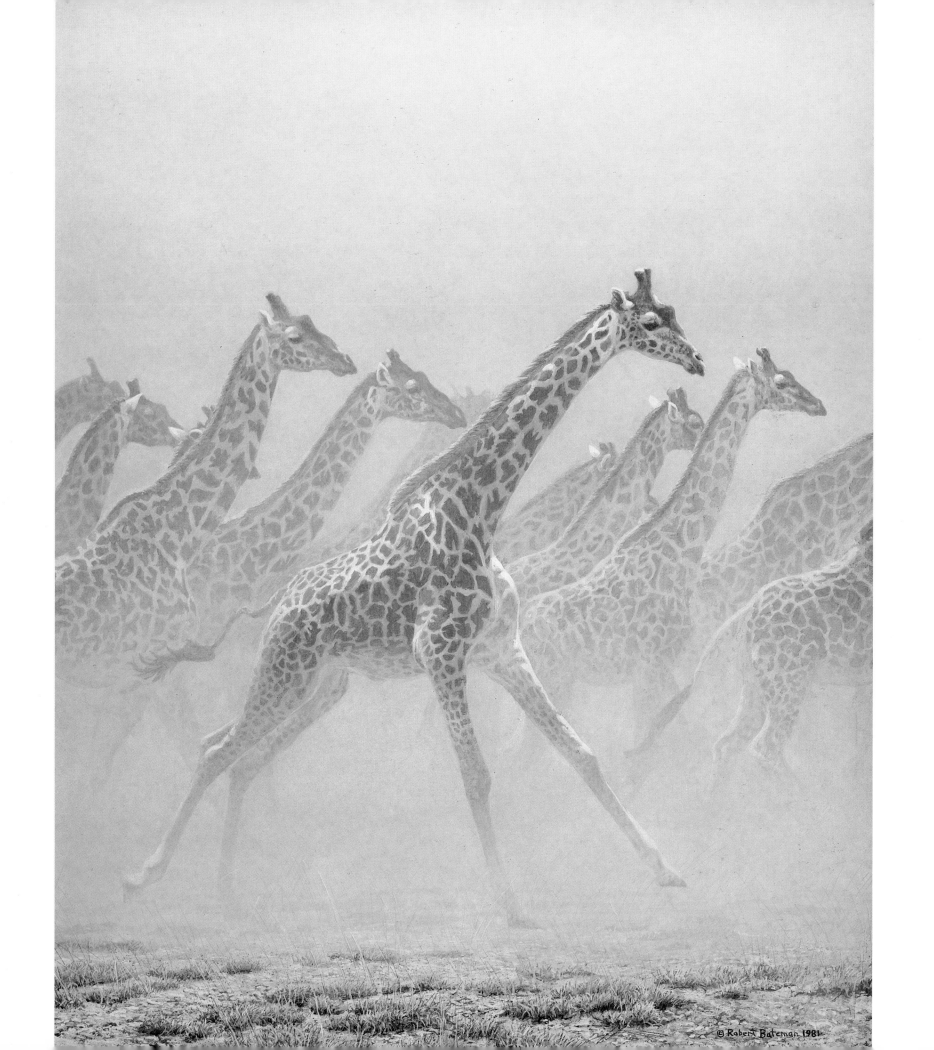

© Robert Bateman 1981

Zebra/Buffalo

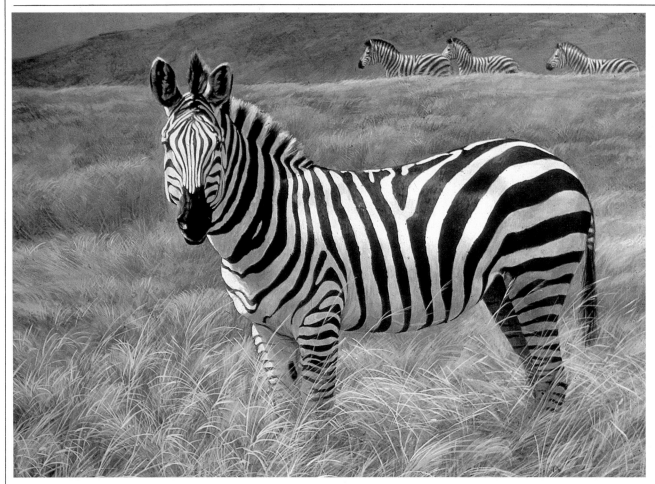

I put these zebras in a rather lustrous landscape with some back-lighting and gave a lot of attention to the grasses in the foreground. Seen close up, the black and white stripes of zebras seem such a strong coloration that it's hard to imagine not being able to see them whenever they are in range. But at any distance the stripes blend easily into the landscape, breaking up into shadows and becoming indistinguishable from the surrounding trees and bushes.

The beautiful Mount Kilimanjaro rises in the background of the setting of *Buffalo at Amboseli,* but I was more interested in conveying the detail and texture of this old buffalo's own habitat — the trees, stumps, grasses, dust, and mud that surround him in the late-afternoon light. As often happens, while I was painting I found a shape that interested me and that became a theme in the picture — a sickle shape that appears in the buffalo's nostril and in his horn. This is echoed in the shadow of his horn on his flank and in another shadow on his rump, in the dry branches in the foreground, and in the mud.

Zebra; acrylic, 24 × 36″ (approx.), 1966

Buffalo at Amboseli; acrylic, 32 × 48″, 1975

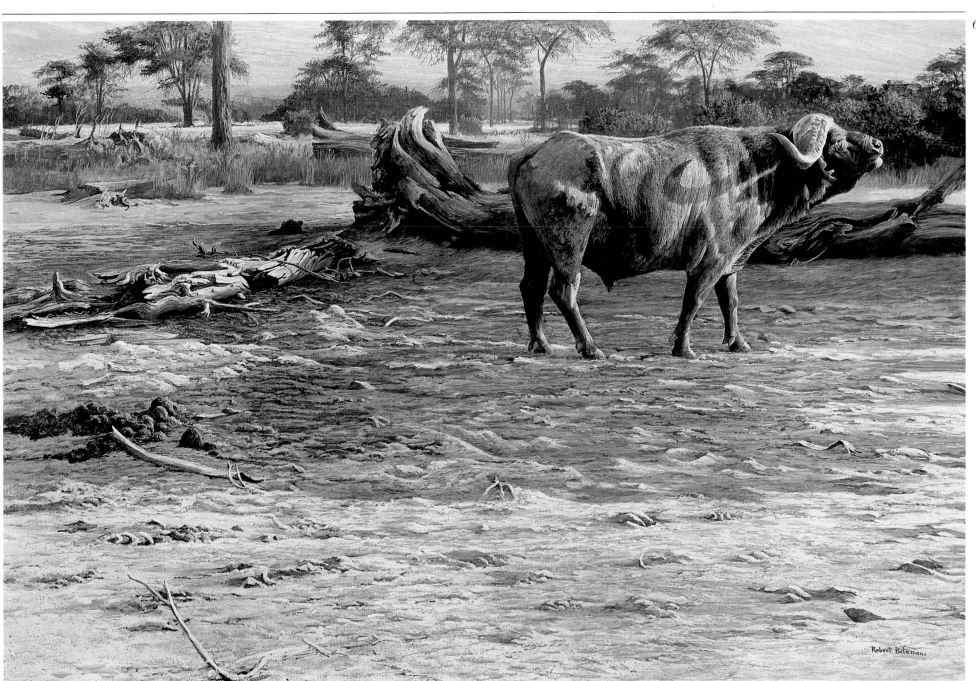

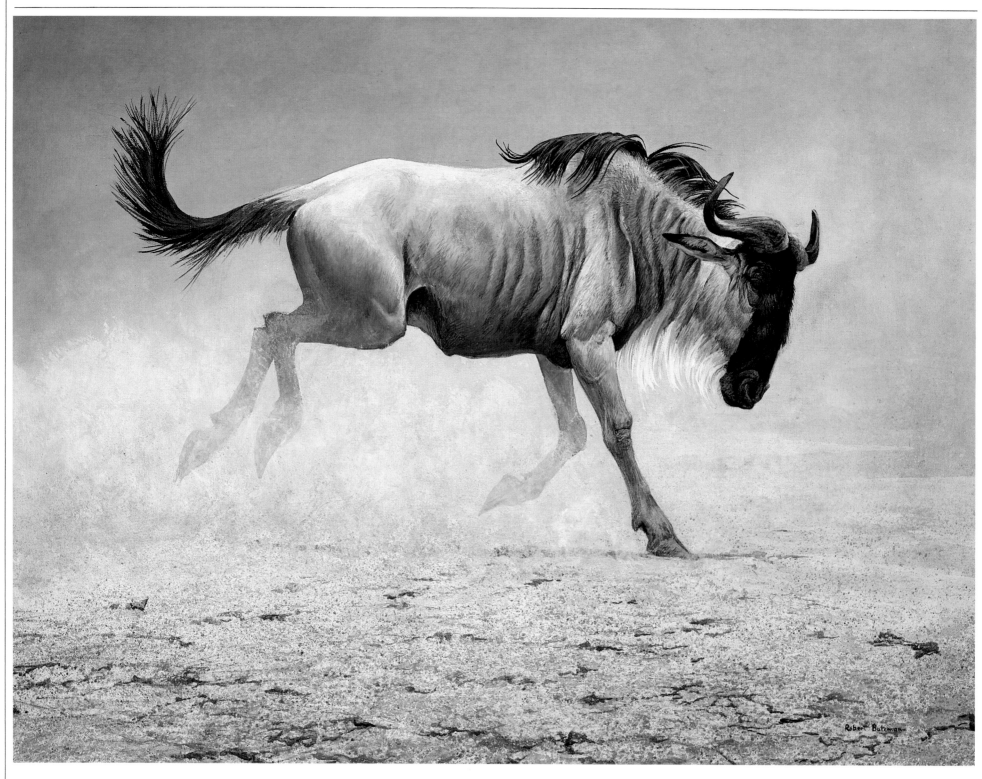

Wildebeest; acrylic, 30 × 40″, 1964

Wildebeest Head; pencil, 14½ × 9¾″, 1975

Wildebeests at Sunset; acrylic, 40 × 30″, 1975

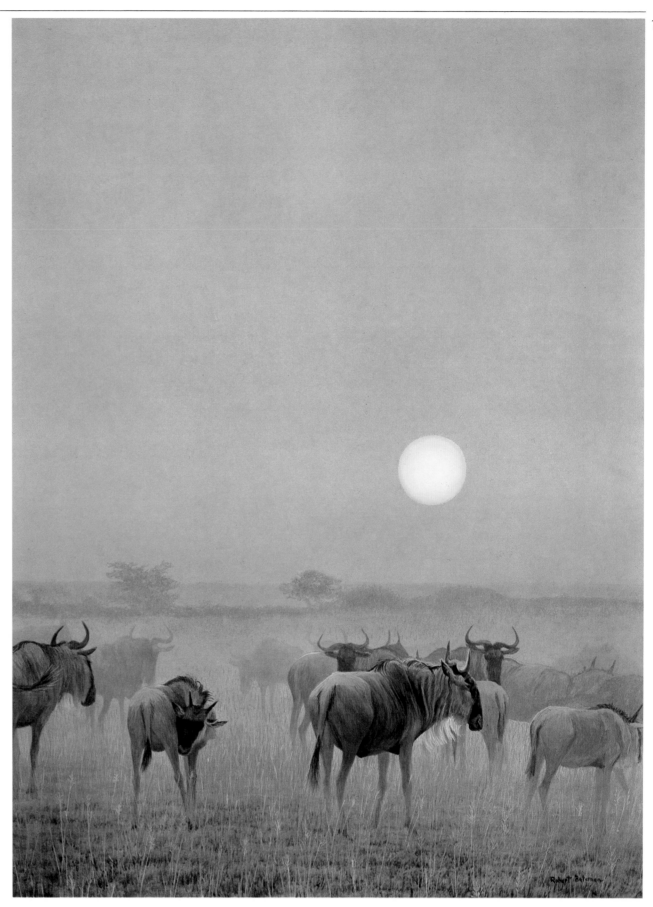

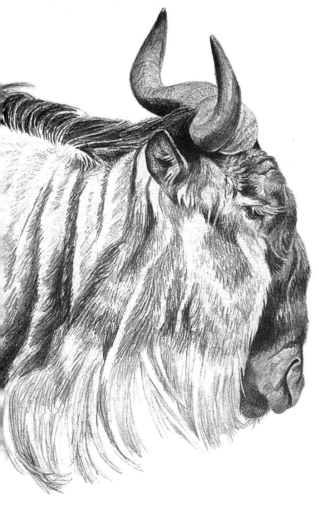

The wildebeest is a peculiar-looking antelope. An African legend explains how God put it together with the bits and pieces he had left over after creating all the other animals. Wildebeests (also known as gnu) travel together in large herds, and occasionally, for no apparent reason, they go a little berserk and start frisking and galloping about, leaping up and down and kicking their heels in the air. It is one of these moments that I depicted in the painting on the left, which was one of my first African paintings.

One evening in Amboseli Park in Kenya, on our way back to camp we saw in the setting sun a big herd of wildebeests drawing together for the night. I was impressed by the mellowness of the mood and by the light and color — a kind of liquid gold over everything just before the sun dropped below the horizon. When I was doing the painting, I experimented with different sizes and places for the sun; finally I put it just off the classic dynamic point of the rectangle of the painting.

Striped Swallows

I enjoy the shape of swallows — the tight, sleek lines; the head, almost like a little metallic knob; and the chiselled quality of the face. These striped swallows, a bird you see along the rivers of east Africa, are perched on a piece of driftwood whose smooth swooping lines, worn by water and wind, echo those of the swallows. In this savannah country, the long periods of drought cause the trees to grow in contorted shapes. The bits and pieces of grass hanging on the driftwood suggest a recent flood.

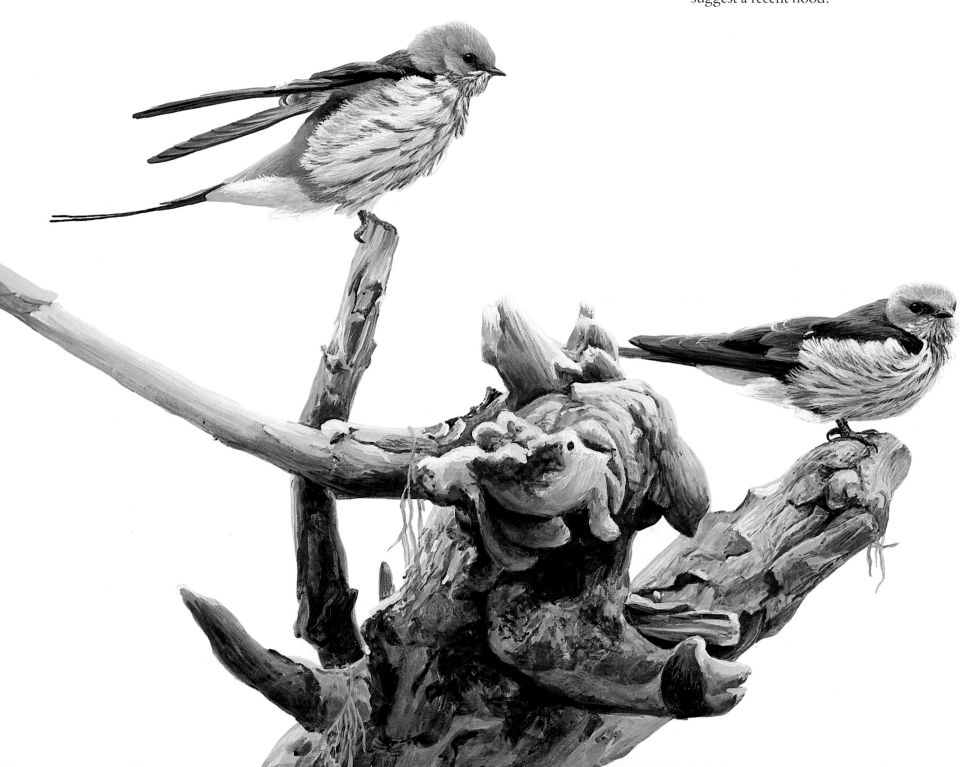

African Fish Eagle

The fish eagle is the African equivalent of the North American bald eagle. I don't want to denigrate anyone's national symbol, but the fish eagle, aesthetically, seems to me to be superior to the bald eagle. It is slightly smaller, but the white on the head is much cleaner and whiter and covers a larger area. The body is not just blackish-brown, like the bald eagle's, but has great patches of chestnut as well as velvety black in the feathers. The fish eagle's beak and legs are also a more brilliant yellow. Bald eagles are primarily scavengers of dead or dying fish and they sometimes rob other birds, such as ospreys, of their prey, whereas fish eagles always capture live fish. The bald eagle has a rather pathetic squeaking cry, but the fish eagle has the most brilliant clarion cry of all the birds of prey, a really loud yodelling call which it sometimes makes while throwing its head so far back that it almost touches its tail.

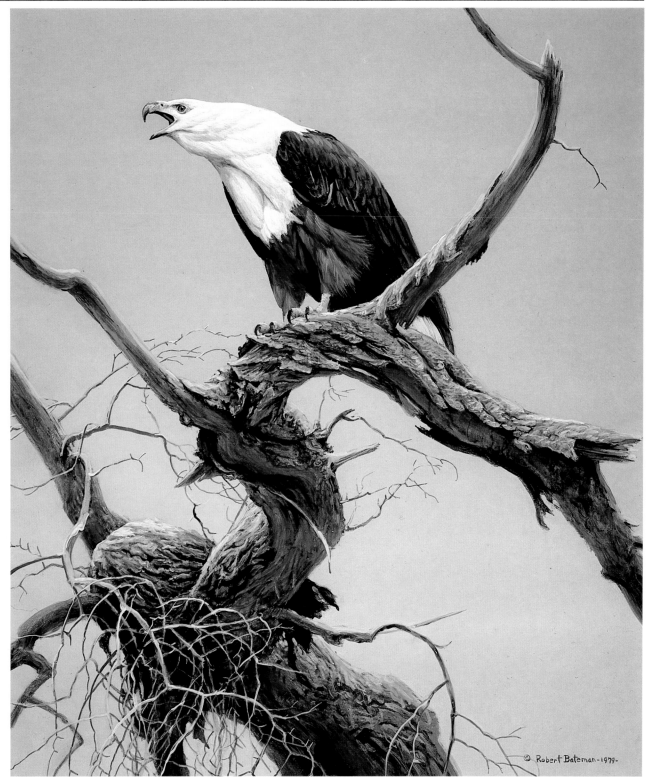

Striped Swallows; acrylic, 16 × 24″, 1975

African Fish Eagle; acrylic, 24 × 20″, 1979

Blacksmith Plover

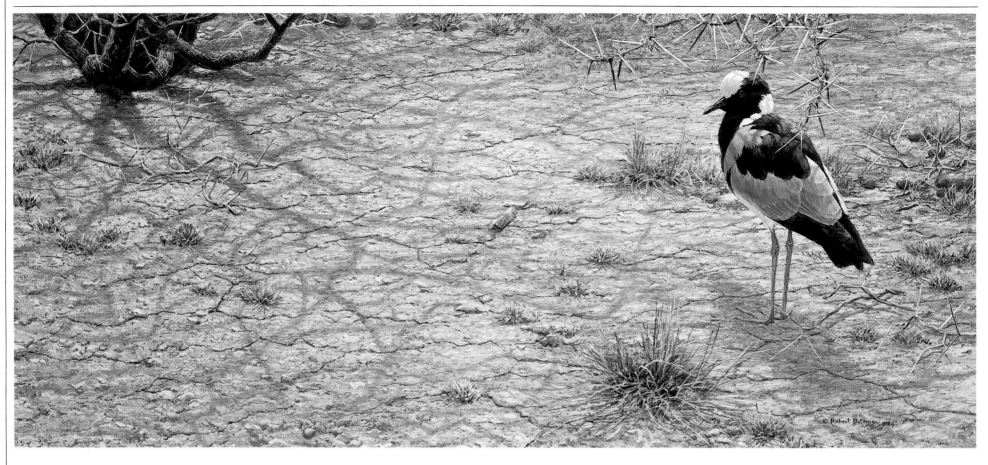

Blacksmith Plover; acrylic, 16 × 36″, 1984

Blacksmith Plover (detail to size of original)

At midday in the semi-arid climate of Etoshapan in southwest Africa, you feel a sense of intense oppression, as if the whole hot bowl of the sky is bearing down on you. Along with almost every other creature, your instinct is to seek shade and remain still until the beautiful time later in the afternoon when the light softens and the heat slackens. Like Noel Coward's Mad Dogs and Englishmen, we were out in this relentless midday sun one day, hoping to see some rhinos, driving through a dry scrubland with only a few skimpy acacia trees giving the most feeble shade you can imagine. As we turned from one track onto another I glanced down, squinting against the brightness, and saw on the cracked mud a pattern of shadows from the thin leaves and branches of an acacia. Standing absolutely still in a patch of shade where the leaves had intertwined a little more densely was a blacksmith plover, waiting for this merciless part of the day to pass.

We didn't stop, but this little scene had made an intense, lasting impression. It was one of those seemingly nondescript but actually complex bits of landscape that often fascinate me, and the handsome blacksmith plover, which you see and hear so frequently in Africa, seemed a worthy subject. Almost immediately I began thinking about doing a painting.

Technically I had set myself a hard task. The picture would be in midday light which I usually avoid because it is so harsh and the shadows are so black. I wanted to establish a counterpoint between the complex pattern of shadows, which are the strongest shapes, and yet have no substance, and the busy pattern of cracks and lines in the mud and gravel. The shadows also criss-cross the plover but must be distinct from the bird's markings. The shadow pattern must recede in perspective along with the flat cracked mud and the little sprigs of grass. The overhanging tree which casts the shadow must be conveyed although most of it is out of the picture.

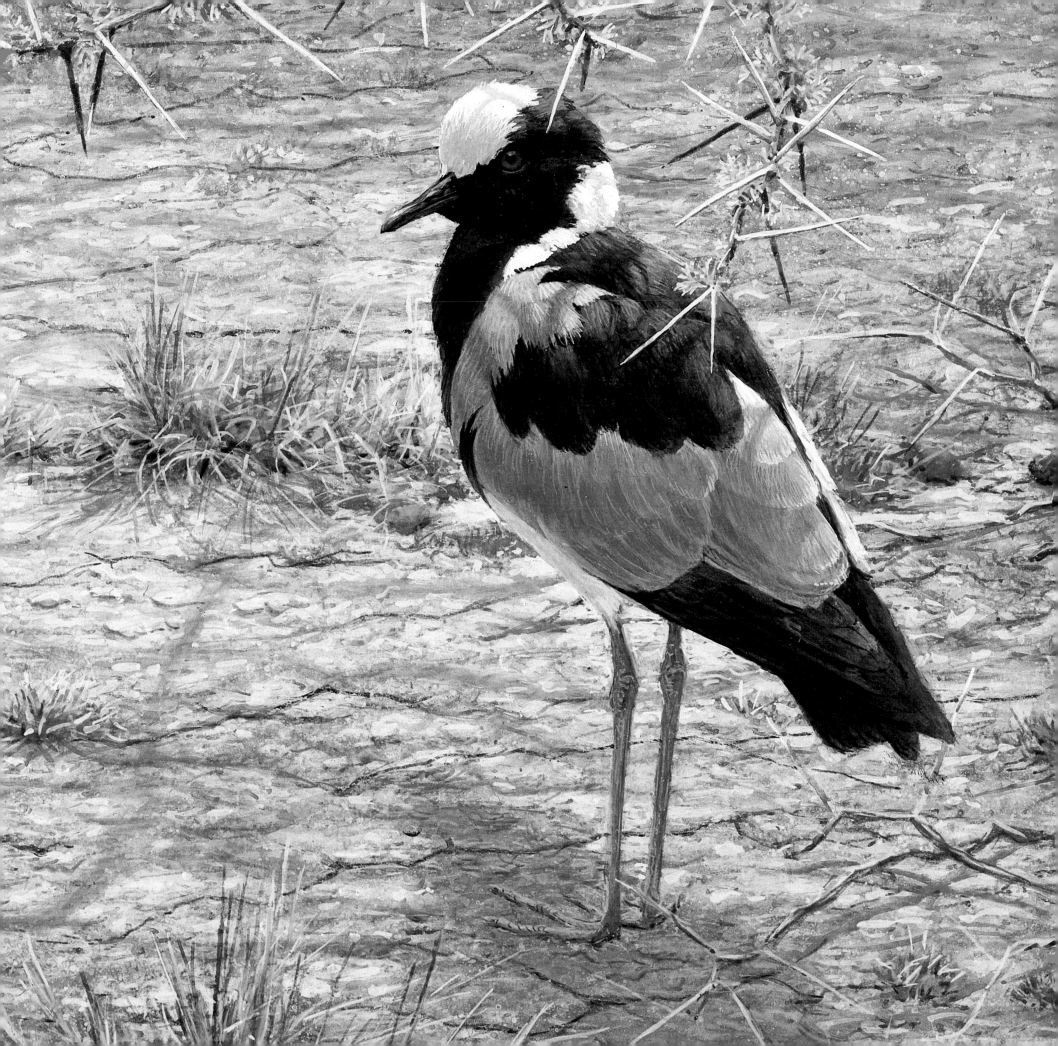

Secretary Birds

The name secretary bird came about in the nineteenth century because the plumes emerging from the back of the bird's head reminded people of male secretaries who kept their quill pens behind their ears.

Secretary birds are raptors and are unique in that they stalk their prey while walking. They stand about four feet tall with long, rather tough, scaly legs and long necks, and they strut along in a stately way looking down for their victims, mainly snakes. When a bird spots a snake it jumps,

and almost dances above it, trying to immobilize it, and then strikes at the back of the neck.

When I saw these two birds flapping their wings and ruffling their feathers as they settled down in their nest, the long head and tail feathers blowing and flapping in the wind reminded me more of exotic warriors wearing flamboyant, ceremonial costumes. When I painted them, I was attracted by these shapes, and by the modulation and angle of the feathers protruding and fanning out and downwards.

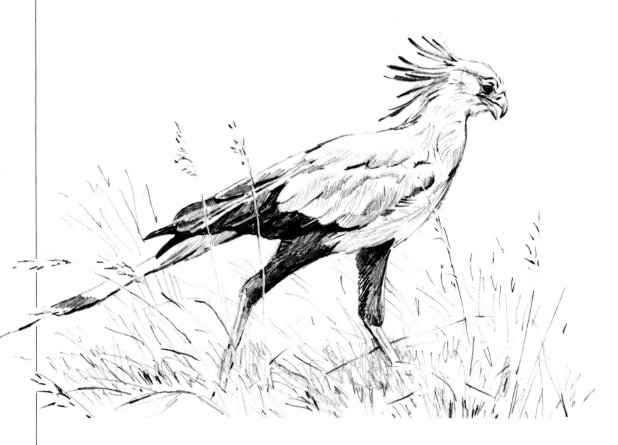

Secretary Bird; pencil, 10 × 7½″, 1985

Secretary Birds; acrylic, 29½ × 40″, 1976

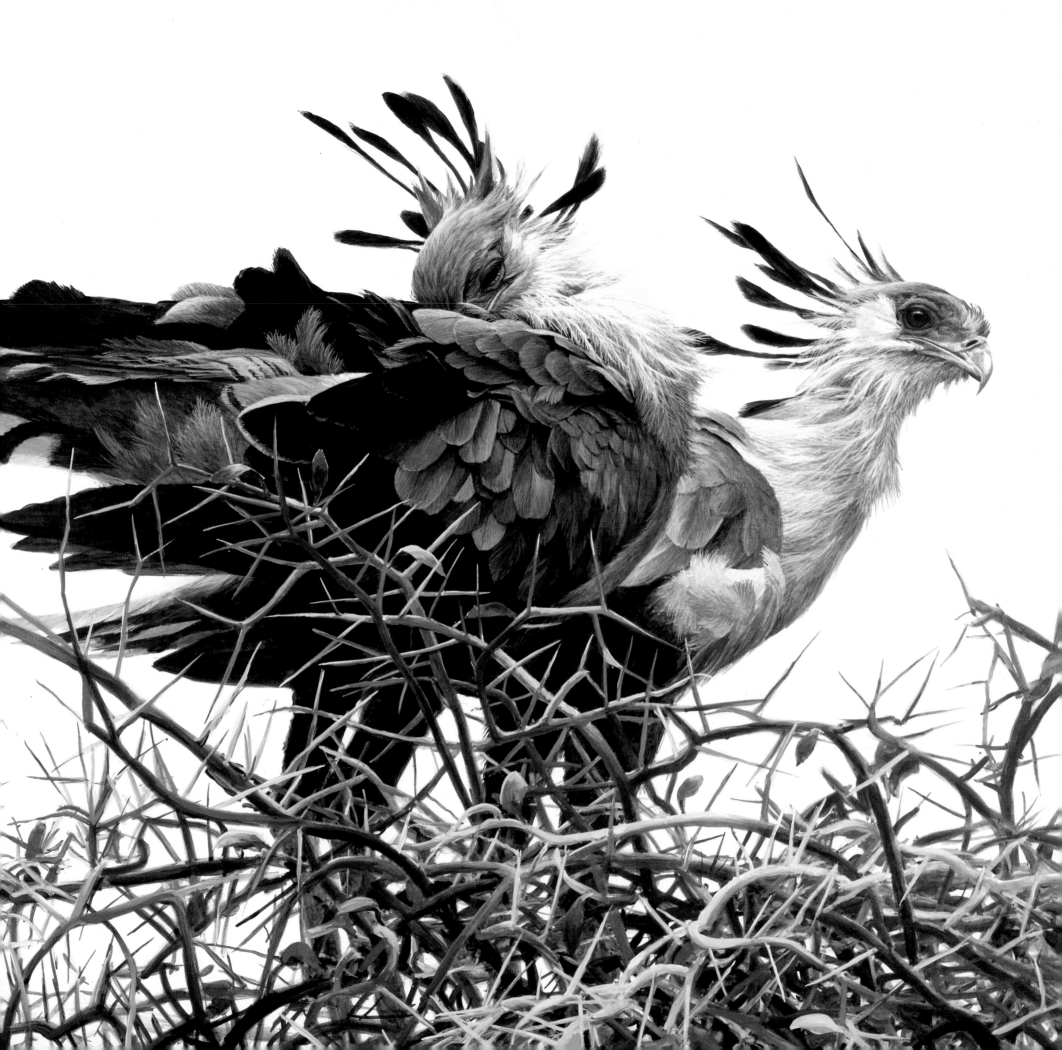

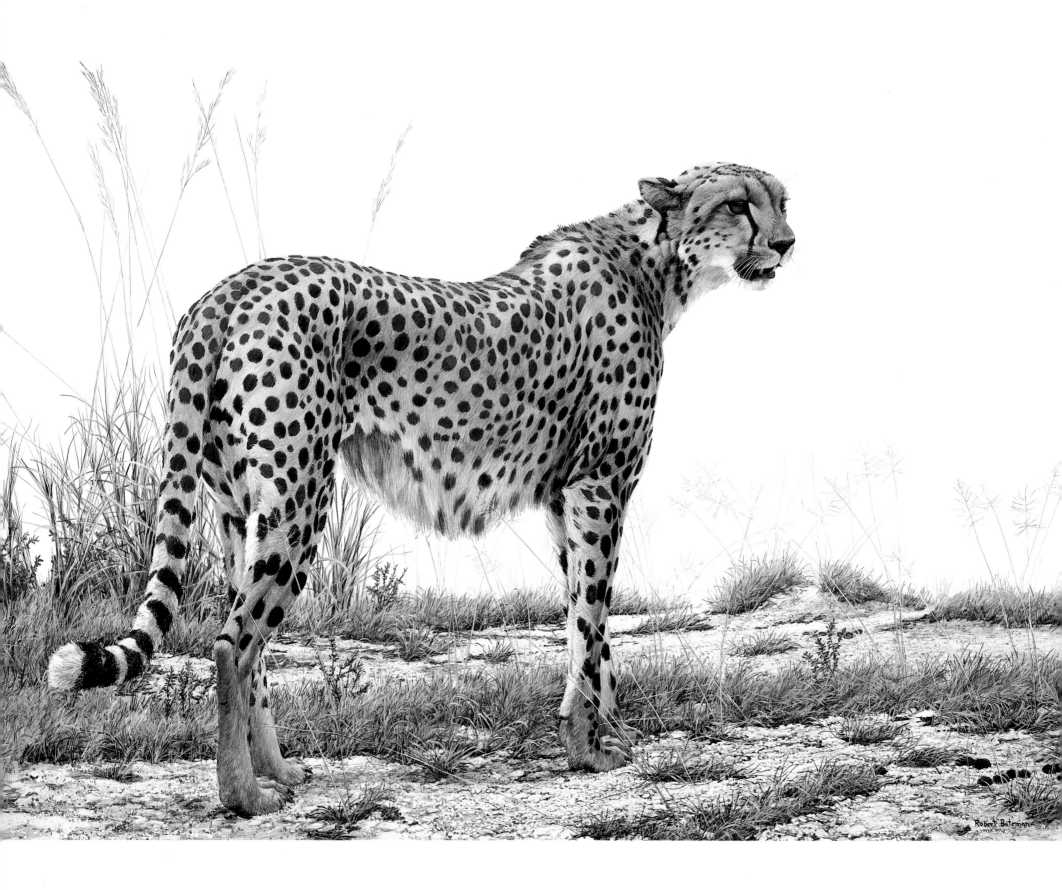

Cheetah Profile; acrylic, 32 × 48″, 1972

Lioness in Red Oats; acrylic, 30 × 40″, 1977

Whenever I visit the English countryside I am struck by the ancient, complex, and familiar relationship between the domestic and the wild. I am fascinated by the intense and loving way in which a knowledgeable naturalist or country person can point out and analyze in wonderful detail all the minute activities and inter-relationships that go on in a comparatively tiny area of land. These thoughts occurred to me again when I saw this simple old garden wall, built long ago along a country road and now half forgotten. At some stage more recently, but perhaps still many years ago, someone must have planted some nasturtiums which have continued to seed themselves. Into this scene I have introduced a chaffinch, a common enough bird in such a setting, but one whose colors relate in a restrained way to the surroundings.

As I was painting the nasturtiums, a completely different association came to mind — a comic strip called *Tillie the Toiler* which I used to read when I was growing up, and which was drawn in a rounded, art deco style reminiscent of the shape of the nasturtium leaves.

When I began the painting on the right, I knew it was going to be presented to Princess Grace of Monaco, and I chose subjects that related both to her early life in Philadelphia and to her married life in Monaco. I knew of her interest in floral designs, and the rhododendron seemed ideal because it is found in the United States and Monaco as well as many other parts of the world. It always seems to grow in beautiful country. I had seen these particular rhododendrons surrounding a small lake in England, and they were so heavily laden with blossoms that some of the branches dipped down into the water.

The golden-crowned kinglet is found both in the eastern United States and in southern Europe, where it is known as the firecrest. I wanted to emphasize the diminutive size of the bird by subordinating it to the blossoms. Pink and green are not my favorite colors, especially in combination, but the back-lighting allowed me to darken them down and to bring in more shadowy colors. The images are elegant and feminine, but I was also intrigued by the abstract power created by the shapes in the reflections.

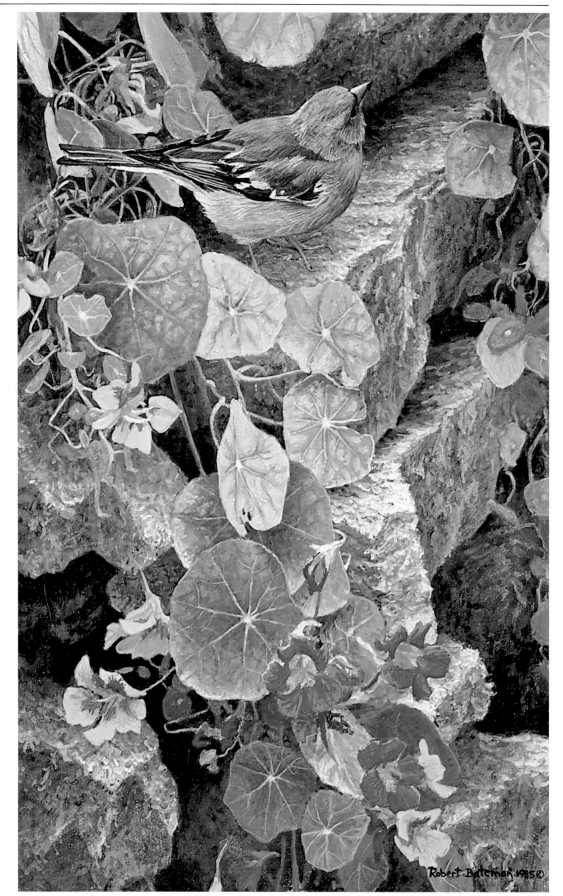

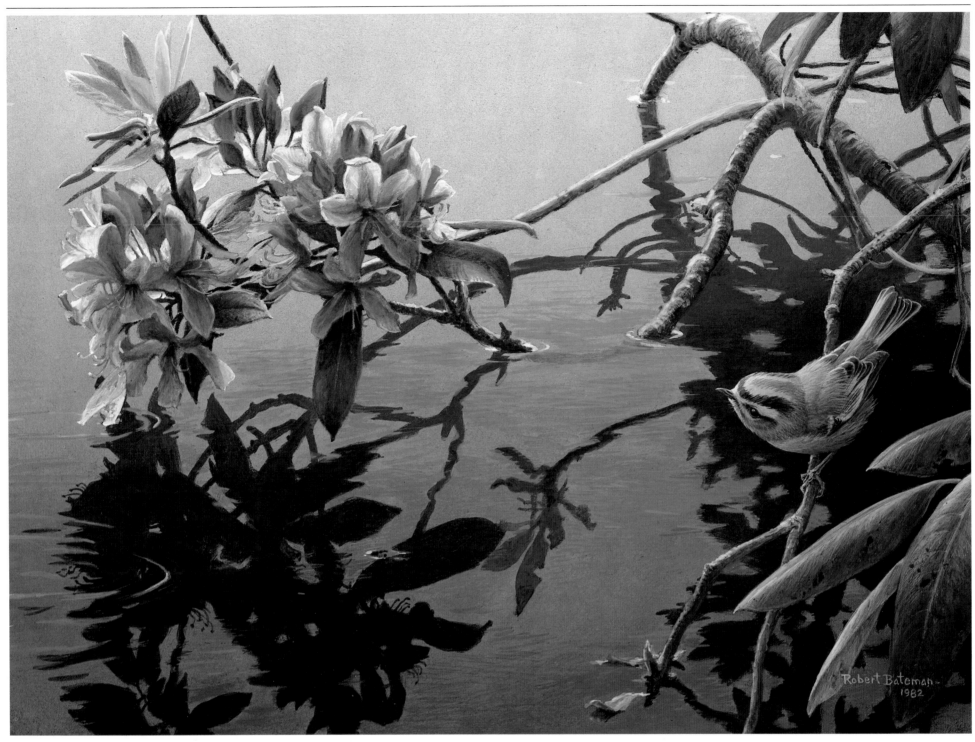

On the Garden Wall − Chaffinch and Nasturtiums; acrylic, 12 × 8″, 1985

Golden-crowned Kinglet and Rhododendron; acrylic, 12 × 16″, 1982

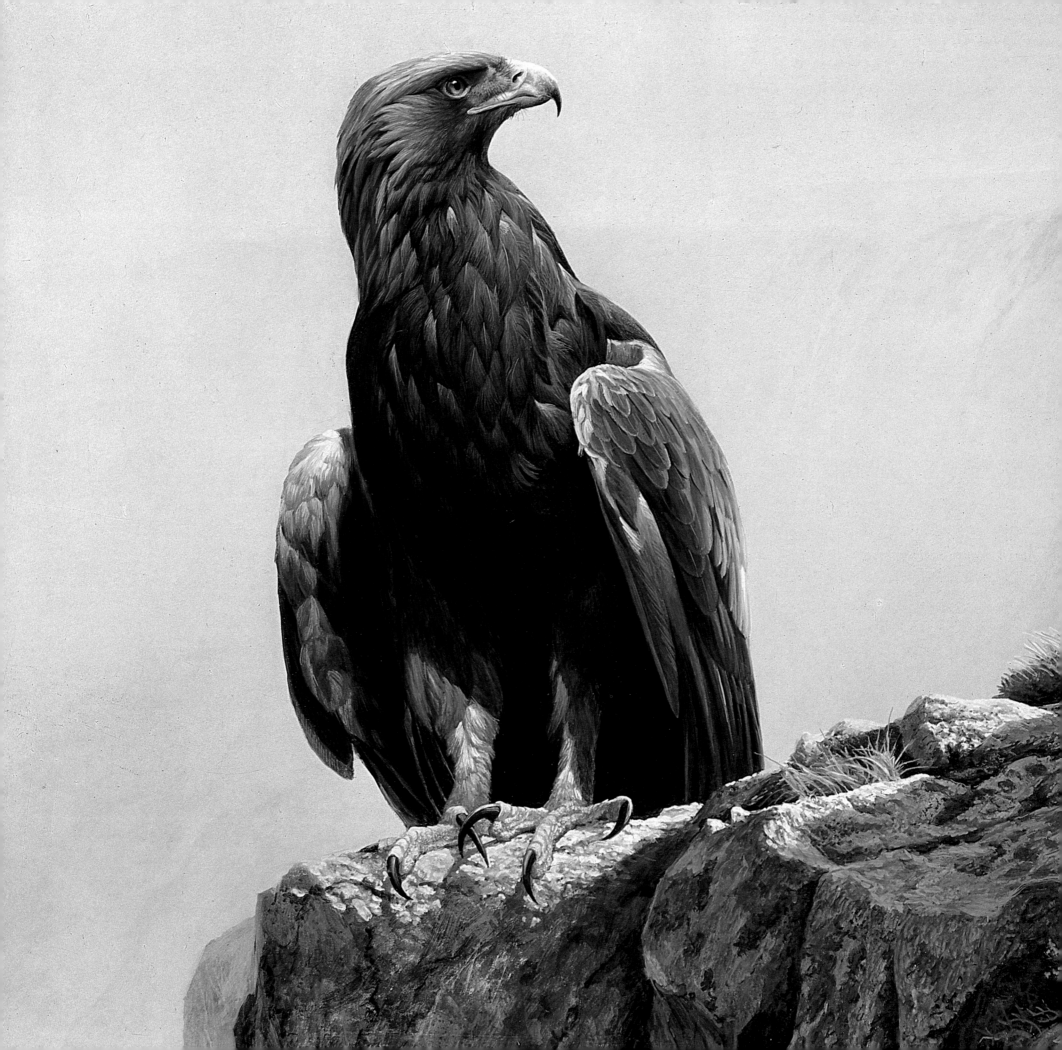

Golden Eagle in the Highlands

The golden eagle is rare but can be found in various places in the northern hemisphere. Here, the early morning setting is the Scottish Highlands. I wanted the viewer of the picture to feel a part of the habitat, surrounded by the mosses and white heather, and by recognizable and specific geology.

The golden eagle is near the top of the hierarchy of the eagle and hawk family, and because it is usually found only in remote regions, seeing one is always a special thrill. In this portrait, I was very conscious of its feathers being hard, almost armor-like, not fluffy, and of its noble pose.

In the Highlands — Golden Eagle; acrylic, 30 × 42″, 1977

Antarctic Elements

When I had an opportunity to join a cruise to the Antarctic I did so more out of curiosity than out of any particular interest. I expected unrelieved vistas of ocean, glaciers, and mountains, with an occasional distant penguin that I could have seen better in a zoo. Instead, I was astonished by the wealth and accessibility of the natural life and by the spectacular beauty.

The interior of the continent is buried under a thick coating of ice, with mountain tips protruding like islands. But at the coastlines where rock and ice meet sea, there is an, at times, dazzling abundance of wildlife based entirely on the marine food chain. The cold waters surrounding the continent are extremely rich in oxygen and in the summer the copious sunlight creates abundant plant plankton and krill, the staff of life for most of these animals from the great whales to tiny

seabirds. The creatures which do not feed directly on krill feed on those that do. As we travelled along close to the coastline, occasionally going ashore, we saw petrels, cormorants, gulls, and huge flocks of penguins, as well as various species of seals (such as crab-eater, Weddel, elephant, leopard, and fur seals), numerous porpoises, and whales (humpbacks, fins, and minkes).

All of this was set against a backdrop of bleak, almost savage beauty that is truly primitive. I felt I was looking at a landscape as it might have appeared on the day of creation, as described in the Book of Genesis.

The elements dominating this painting are the air, the ice, the rock, and the sea, with its embellishment of wildlife. The central bird is a Dominican gull, but there are also Adélie penguins as well as a skua, a kind of predatory gull.

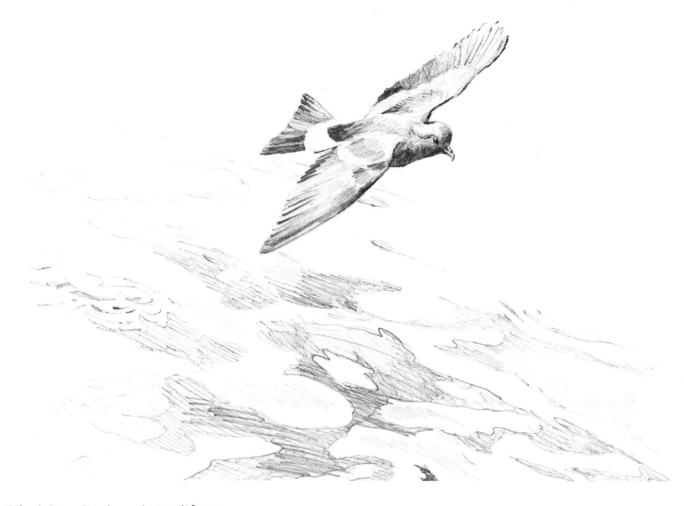

Wilson's Storm Petrel; pencil, 10 × 7¹/₂″, 1985

Antarctic Elements; oil, 24 × 29¹/₂″, 1979

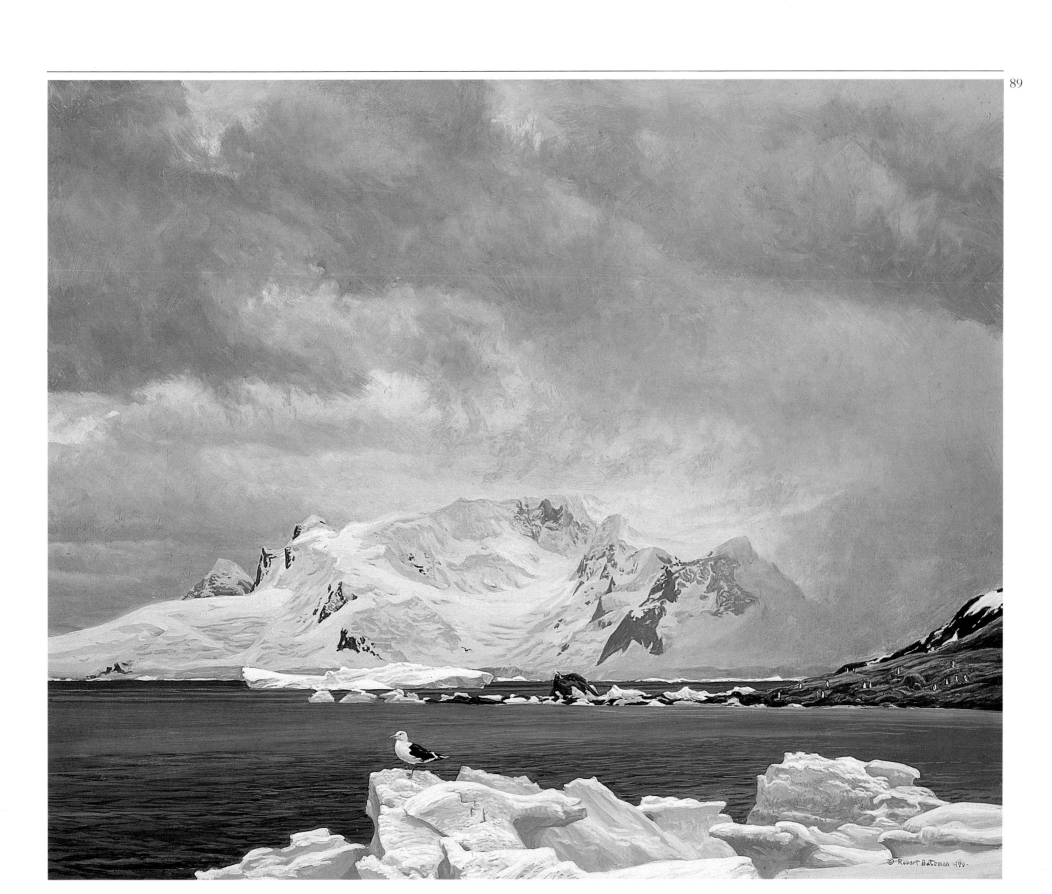

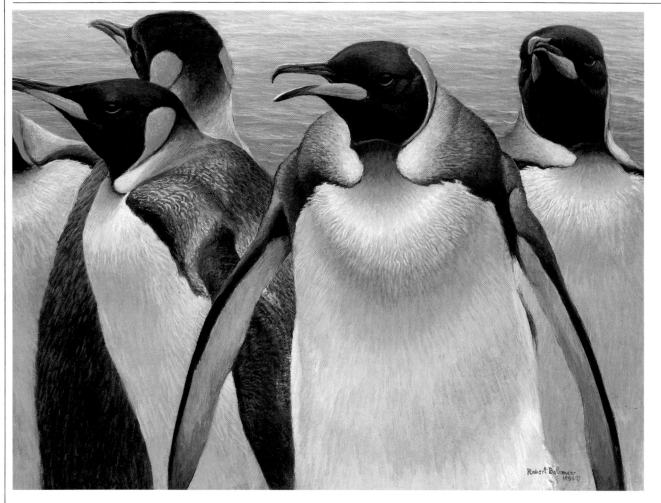

The Kerguelen or southern fur seals were also victims of the whaling industry, being slaughtered and their fat then rendered down for oil. They, too, were almost extinguished but they have since recovered some of their numbers. I have shown a big bull seal, probably a bachelor without a harem of cows. We saw a number of these bachelors strung out along a beach. They may look very pompous and ponderous, but they are, in fact, surprisingly nimble. They are closer to sea lions than to true seals, and they can use their tail flippers to gallop along quite quickly. Two people we know were badly bitten by fur seals in the Antarctic when they wandered too close to them.

The setting of the painting is a volcanic island off the Antarctic coast. The ancient crater, which is accessible from the sea, makes an ideal harbor and is the site of an abandoned whaling station. In the cold, dry mausoleum of Antarctica, decomposition is a slow process. Up and down the beach are scattered huge bones like colossal monuments to the slaughtered whales. The remains of a wooden lighter once used for transportation between the large whaling ships and the shore also survives as a reminder of those days. In the distance is a flock of pintado petrels.

At times the sheer number of penguins that can be seen in the Antarctic is overwhelming to the eye, the ear, and the nostrils. Among the most spectacular are the king penguins, which are found here and also in the Falkland Islands. They are large and beautifully colored — almost abstract paintings in themselves — and in their tightly packed nesting colonies they keep just out of pecking distance of each other. As I did this painting, I was thinking of the richness of Antarctic coastal life and of the denseness of these colonies.

Despite its remoteness and inhospitality, the Antarctic has been clearly marked by the hand of man. At the present time there are the various national scientific research stations, several of which we visited, and there are also the huge krill-harvesting ships which now threaten the whole ecological structure and the survival of animal life in the Antarctic. In the late nineteenth century and the early part of this century there was a period of disastrous exploitation, the "great age of whaling." When the whale stocks of the northern hemisphere were nearly exhausted, the whaling industry came to the Antarctic, and again almost extinguished more species of these huge and intelligent creatures.

King Penguins; acrylic, 12 × 16″, 1985

Old Whaling Base and Fur Seals; acrylic, 14 × 20″, 1985

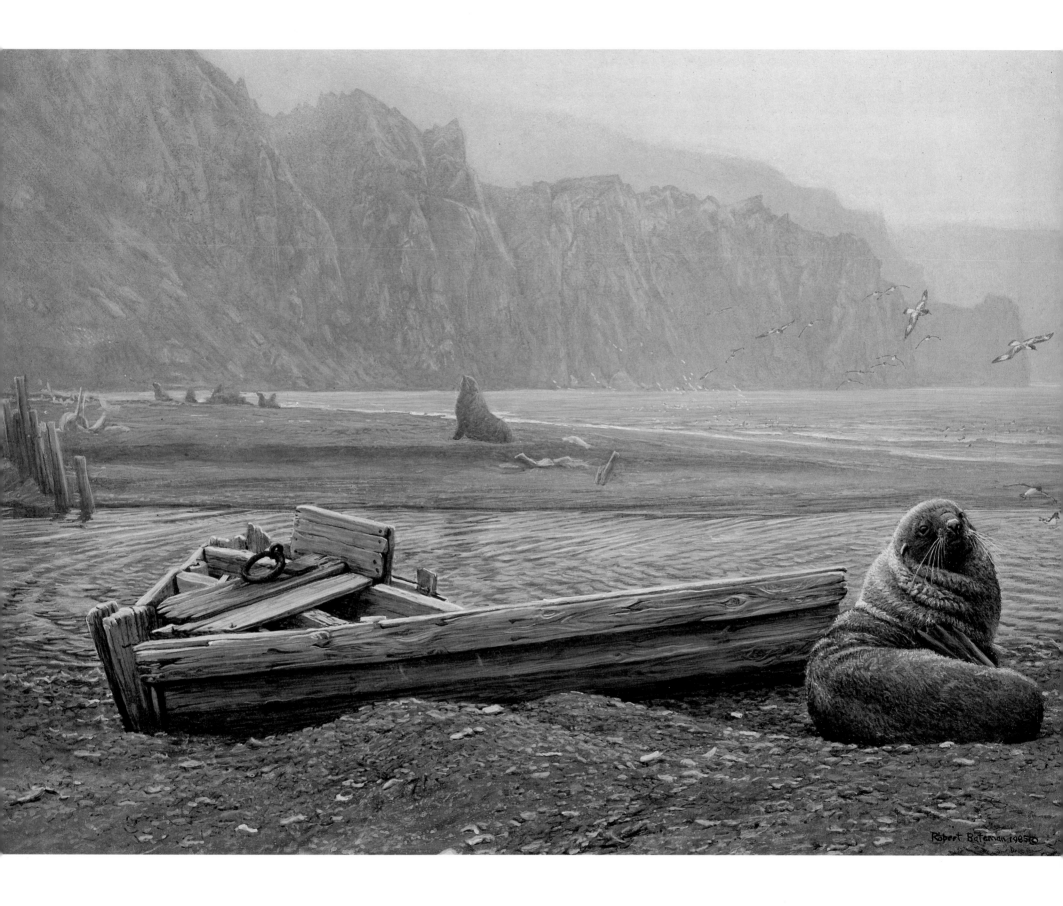

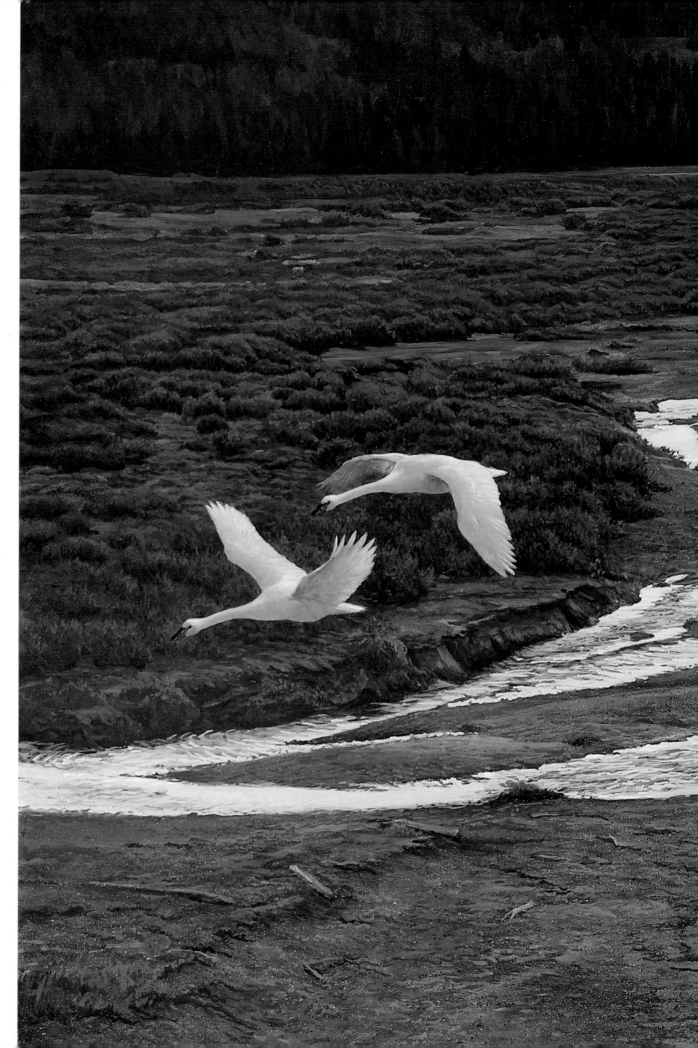

Trumpeter Swans

When I started this painting in 1981, I was obsessed by a strong abstract concept that first germinated in my mind in 1962 when I saw the major Andrew Wyeth exhibition at the Albright-Knox Gallery in Buffalo. That exhibition had a major effect on my psyche as well as on my career as an artist. One of my favorite paintings in the show was *Hoffman's Slough*. The powerful abstract form in that painting of a dark pasture after sunset, with slashing bright water reflecting the evening sky, excited me and stayed in my mind for years. I wanted to find a subject of my own that I could adapt to such a concept and I began looking for fast-flowing, braided rivers that flow out of the mountains through broad, terraced valleys. These rivers, typically cluttered with gravel bars, attract a good deal of wildlife and are challenging and interesting to paddle down in a canoe, but mainly it was a particular shape I was looking for. I finally found it in the Buffalo Fork River just south of Yellowstone Park in Wyoming.

The light source in the painting comes from the sky after the sun has set — the river and the backs and wings of the swans are reflecting the after-glow. Even though the landscape is dark I wanted you to see that you could move through it, hiking across the gravelly foreground, picking your way across the stream onto the little islands and then on to the tableland on the other side.

Above the River — Trumpeter Swans; oil, 24 × 42", 1981

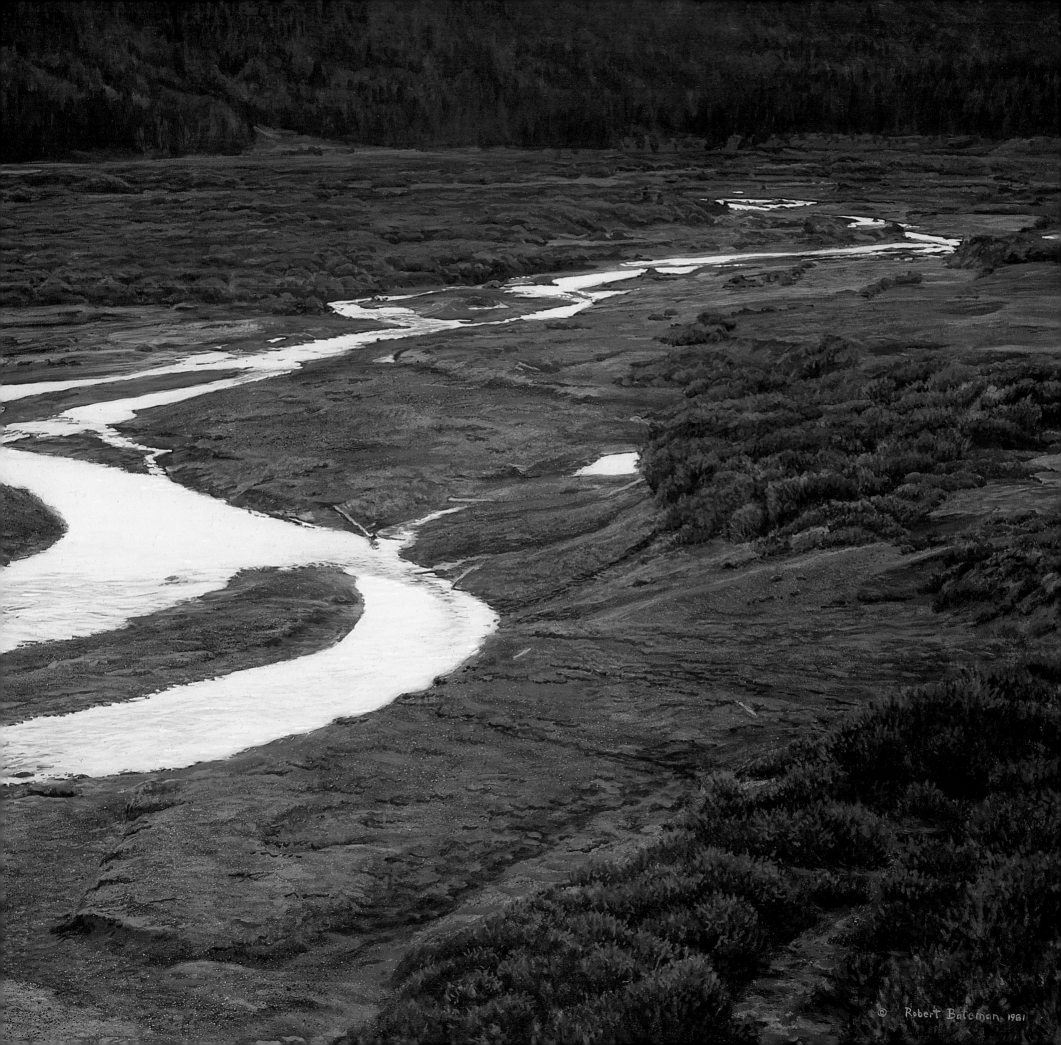

Snow Geese

The most spectacular display of birds can be seen on the wintering grounds of the great flocks of waterfowl. Here, geese, ducks, and their many relatives gather in concentrations of thousands. The sheer quantity of birds is amazing, as is the variety of species, and it's especially exciting to spot rarer species among the milling throngs of more familiar ones. There is constant movement — the geese in particular are always restless, flying from field to field or from field to water, sometimes because of a disturbance but usually just because of a change of mood. This activity is always accompanied by a clamor of excited goose "conversation."

I was able to spend some time at one of these wintering grounds in northern California. Throughout my visit the weather was misty. I like a certain amount of fog or mist because it helps separate the elements in the landscape and gives a "presence" to the atmosphere. This sense of air and space and sky was heightened immeasurably by the skeins of geese cutting pathways through the air at different heights and in different directions. I thought of dancers swirling veils in arcs through the air. On one memorable occasion I painstakingly crept under cover right up beside a flock of several thousand birds. After a while they took off. The air was literally thick with geese and their sounds. My entire view — from horizon to horizon — was filled with geese wheeling back and forth in layer upon layer far up into the sky.

I wanted to depict in the painting that feeling of a layered, moving atmosphere and the way the endless flocks in the mist created a vast architectural structure out of the air. I realized that a huge mass of geese would be too confusing, so I concentrated here on a small flock of snow geese, perhaps the most elegant of North American geese with their clean, white plumage and black wing tips. A good birder might be able to spot a Ross' goose among them, as well as white-fronted geese, and elsewhere in the painting a sandhill crane and a white-tailed kite.

Across the Sky — Snow Geese; acrylic, 36 × 48″, 1983

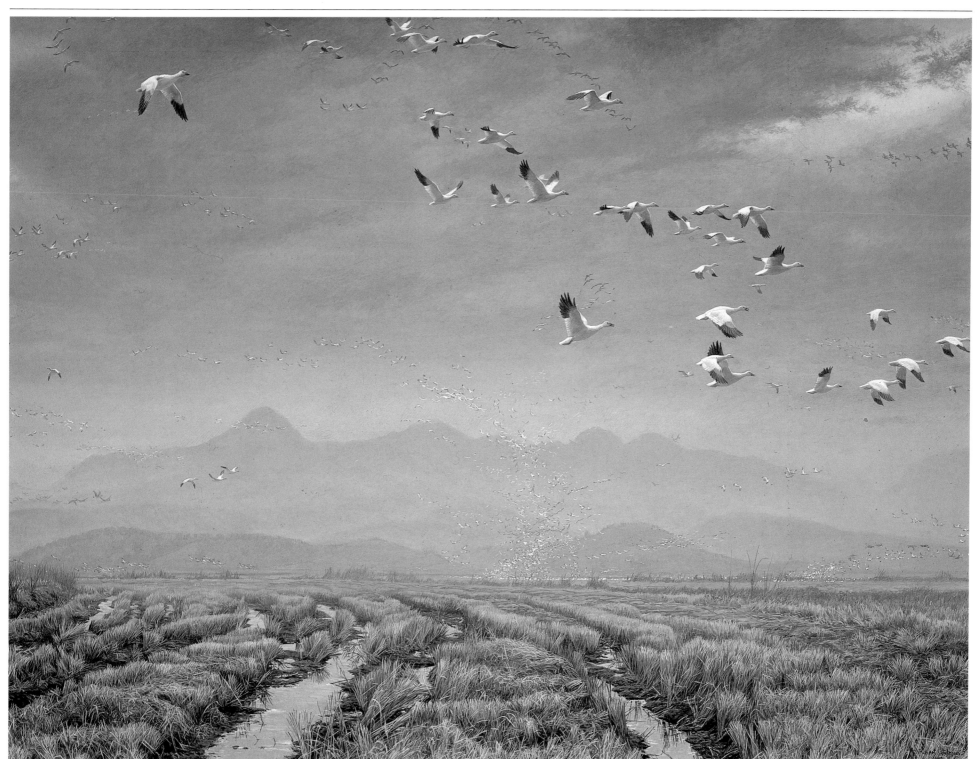

Gambel's Quail/White-winged Doves

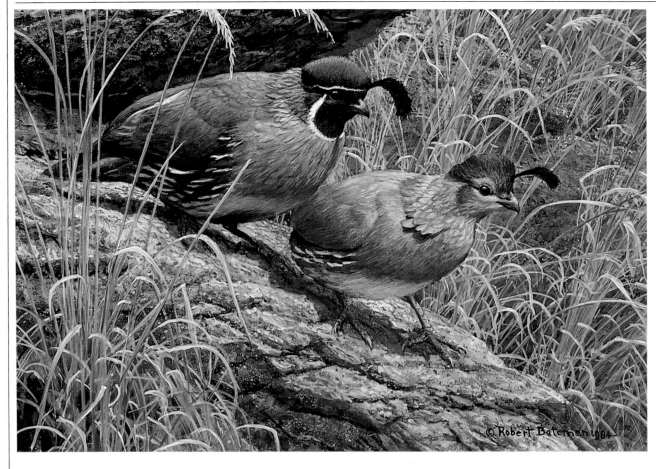

Quail somehow seem like miniature versions of larger birds, just as elves or gnomes are like miniature versions of people. Quail also behave a bit like gnomes, scurrying about in little groups, feeding and communicating with each other. I have shown this pair of Gambel's quail in a typical southwestern desert habitat on a fairly dry, rocky hillside. The shapes of the rocks echo the plump bird bodies, and the seed heads of the grasses repeat the shape of the little forehead tassel on the male.

We visited this old fort and monastery in the Big Bend country of Texas on a birding expedition a few years ago. These old Spanish buildings of the Southwest combine elegance and earthiness in a way I find very satisfying. Built of adobe and other local materials that the Pueblo Indians have used for thousands of years, they are classically balanced, harmonious, and restrained. New buildings don't often appeal to me as subjects, but I enjoy painting older ones which have become weathered and worn in ways that tell each building's story. Here, for instance, you can see at the top of the door a place where a leak in the roof may have been patched years ago.

Doves, which are thought of as peaceful and rather domestic birds, seemed to me appropriate for this setting. These white-winged doves are typical of this countryside around the Mexican border.

I wanted this painting to be essentially a series of flat planes viewed from different distances and different angles. Apart from the one low wall, I wasn't showing the tops or bottoms of the planes, and I had to give the viewer the information needed to understand what they are, by conveying texture and light. One of the solutions was to recreate a spider's web pattern of cracks in the adobe which then is foreshortened when seen from an angle.

Gambel's Quail Pair; acrylic, 8 × 12″, 1984

Old Adobe − White-winged Doves; acrylic, 9 × 12″, 1982

© Robert Bateman 1982

Elf Owl/House Finch and Yucca

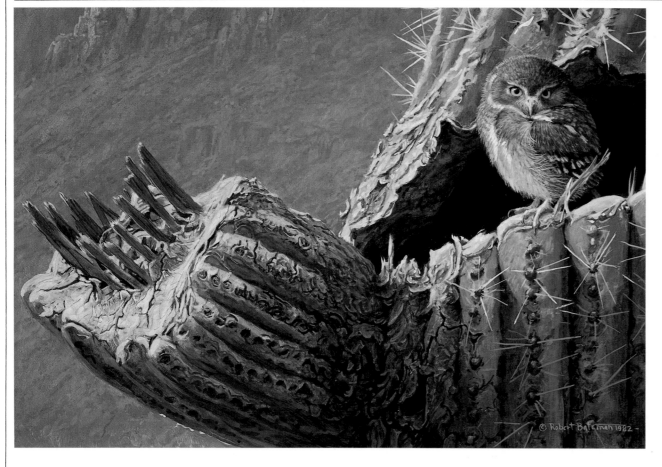

The giant saguaro cactuses in Arizona, as they become old and ravaged by time, remind me of the wrecks of old wooden ships, with their skeletal framework sticking out in some places. The cavities in these huge, tough, prickly old things are secure nesting places for the tiny elf owl. I've shown a young owl, with down still on much of his head and body, taking a look around in the enchanted hour between sunset and dusk, the most glorious and active time in the desert.

The house finch resembles a purple finch, but is slightly brighter and more delicately colored. If the purple finch is like a sparrow dipped in a glass of burgundy, the house finch has been dipped in a glass of rosé. Although it is found in many different habitats, extending as far north as Canada, I always think of it as a bird of the more verdant parts of the arid country of the Southwest. Many times I've heard the house finch's lively warbling song and located the male announcing his territory from the tip of a yucca spike.

I had two associations in mind as I was painting this picture. One was the mood of some of the paintings of Georgia O'Keeffe and the other was the ambience of early Hollywood. The works of Georgia O'Keeffe are dramatic and polished, often with modulated, clear blue skies. The predominant Hollywood style of the twenties and thirties was art deco, which was also dramatic and polished, almost to the point of slickness. Although this is not a style I am always fond of, it has nostalgic appeal for me because the movie theater I used to go to as a boy was decorated in this style.

Young Elf Owl – Old Saguaro; acrylic, 8 × 12″, 1982

House Finch and Yucca; acrylic, 8 × 12″, 1984

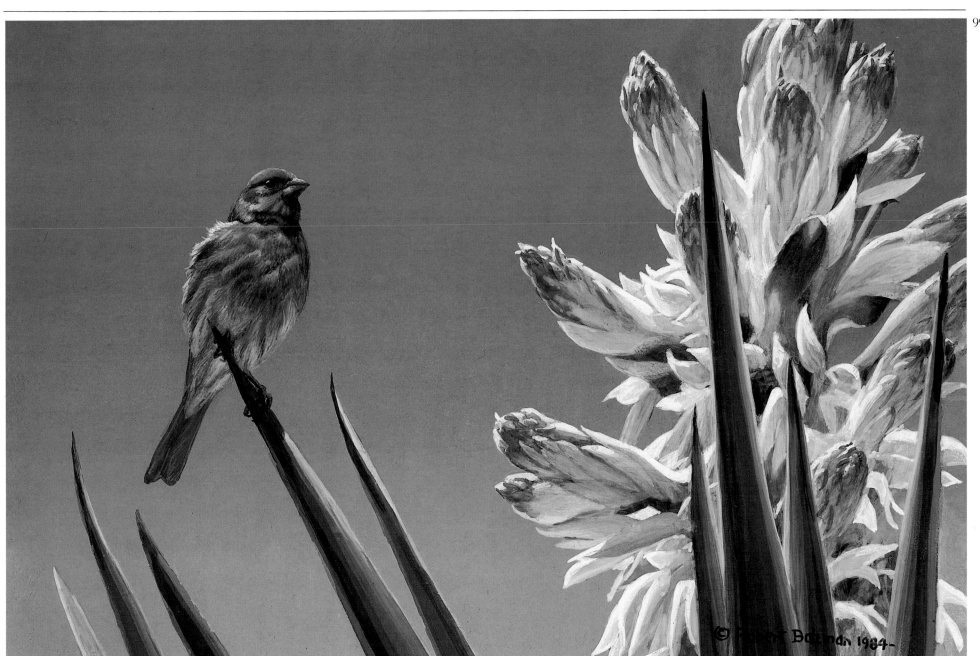

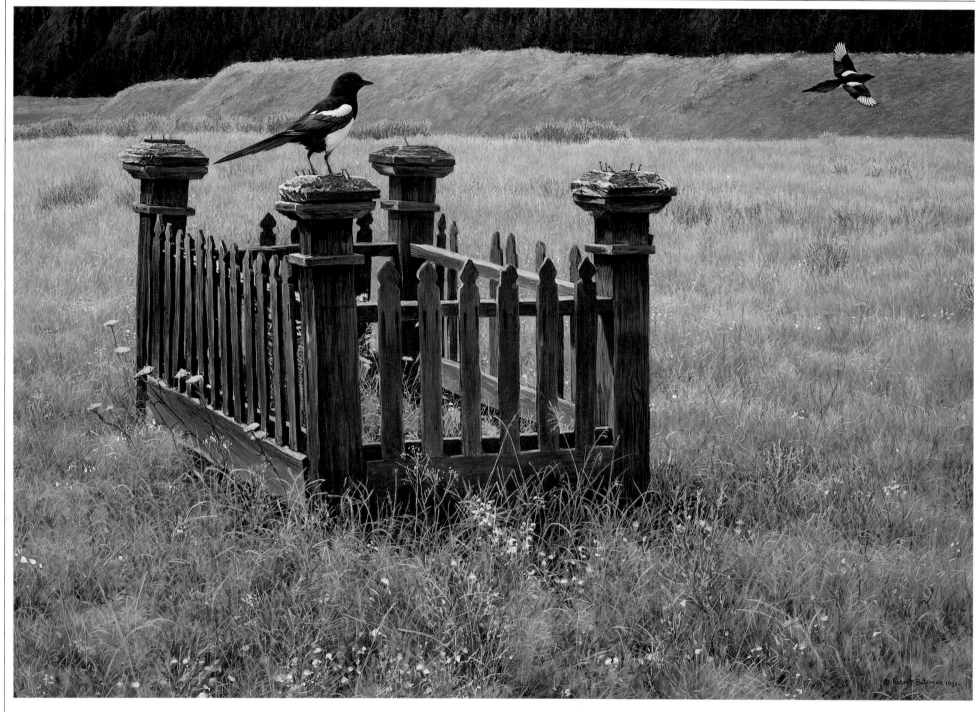

Pioneer Memories — Magpie Pair; acrylic, 24 × 36″, 1981

But Not Forgotten; acrylic, 15½ × 10″, 1967

I get a feeling of poignancy when I come across traces of nineteenth-century pioneers who probably spent their entire lives striving to make a living out of the wilderness, while at the same time trying to bring a little gentility and grace into their days. Sometimes their graves are all that is left of their efforts.

I saw the fenced grave standing all on its own in a meadow when my family and I were camping by the side of a country road in the interior of British Columbia. The marker was gone and the name has been forgotten, but the carefully carved picket fence and solid, once-elaborate corner posts still stand as a modest symbol of Victorian yearning for dignity and permanence. As I painted the flowers in the foreground, I thought of those arrangements of dried flowers and plants under glass of which the Victorians were so fond. I played up the rhythms in the grasses and sagebrush to faintly suggest wagon tracks leading far into the distance.

Magpies, with their strong black-and-white markings and swooping, graceful flight, are resilient, resourceful birds, qualities that seem to me to represent the spirit of the early settlers, and so perhaps the birds take on a slightly allegorical role in this picture. Despite the sense of poignancy and nostalgia I don't think of this as a gloomy or lugubrious painting. Indeed, it depicts a bright, sunny, summer day in an expansive, exhilarating landscape.

I found the worn marble gravestone in the painting on the right, near our home in southern Ontario. The departed pioneer is surely forgotten by now, and the domestic flowers that once would have surrounded the grave have long been overwhelmed by wildflowers and weeds — a gentle reminder that nature recovers her own.

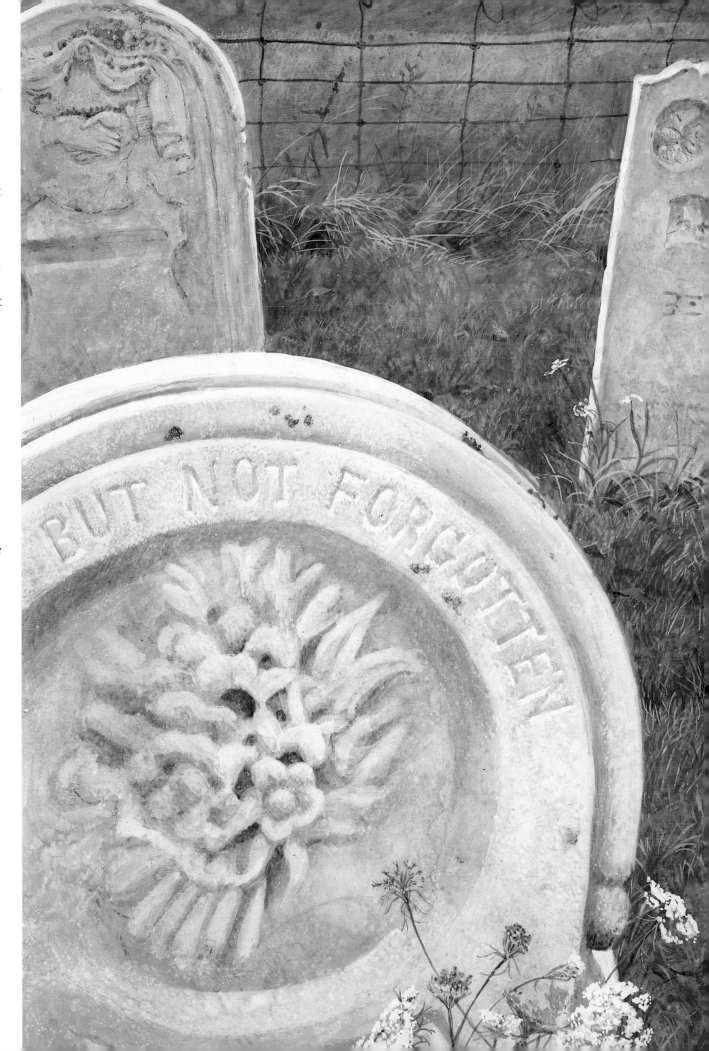

Bison

When I was drawing the bison head I found it exciting to explore the planes and angles and varieties of textures. I treated it as a complex landscape with all sorts of humps and hollows, and it was easy to imagine a world of castles and caves and secret lairs.

These river flats in Yellowstone Park have a winter Garden of Eden quality to them. The warm water from geysers and hot springs keeps the rivers open through the winter months, affecting the micro-climate in the immediate vicinity and allowing the plants and grasses to continue to grow. This attracts all sorts of wild-life, including a variety of waterfowl and especially the big grazing animals like bison, elk, and deer that have the rare privilege in a North American winter of having access to fresh vegetation.

There is a mysterious, primeval quality to the whole scene. Curtains of mist and steam rise from the warm water into the cold air, as the animals graze peacefully together, looming out of the fog and mist into patches of sunlight.

Buffalo Head; ink, 10$\frac{1}{2}$ × 8″, 1975

Morning on the Flats − Bison; acrylic, 12 × 24″, 1982

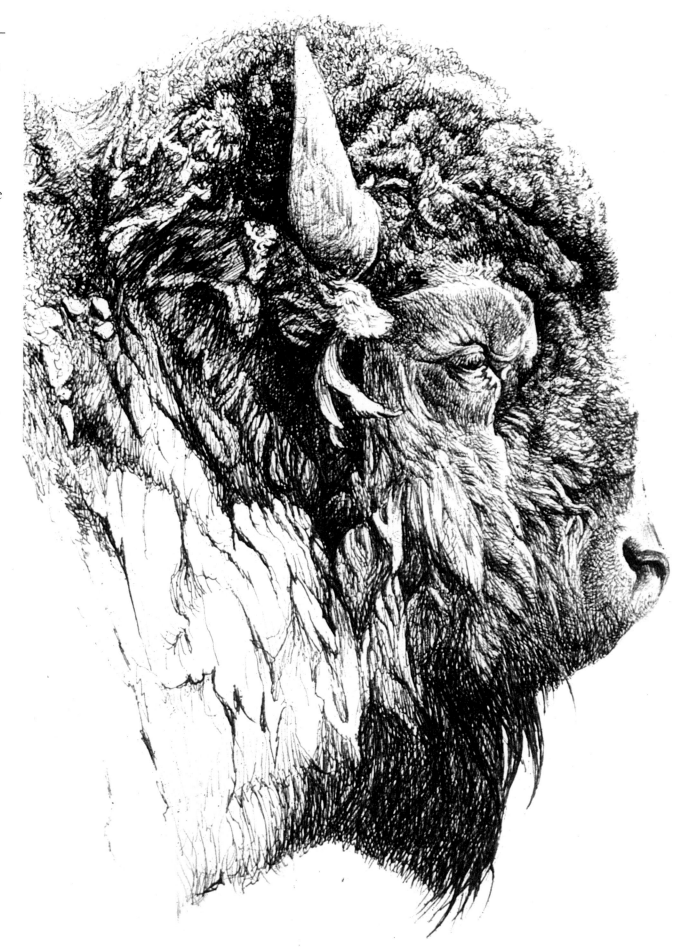

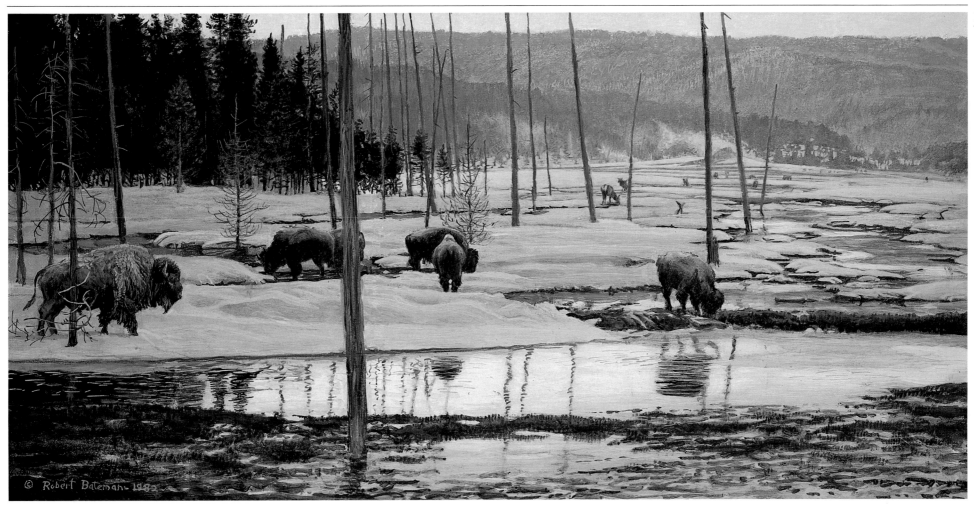

Gray Jay/Ravens

At the end of the day on a pack-horse trip in the mountains, the horses are unloaded and tethered for the night, poles are cut for the tent, and dead wood is gathered and chopped for the fire. Then the wrangler strikes his axe into a tree, where it will be safe and easily reached, and takes off his chaps, the leather leggings that are still worn for leg protection in rough country. Sometimes these are hung on a branch, but what better clothes hook than the axe? Soon there may be a visit from a gray jay. These birds, rarely seen in civilized areas, often turn up at campsites in forested country where they are surprisingly confident and companionable.

I enjoyed working on the different textures in this painting — the detailing of the bark with axe marks in it, the folds and markings on the old leather, and the patina of use on the axe handle.

Ravens have a strong symbolic association with death for some people, and for that reason they are often disliked. For the most part they are found in the wilder parts of the world, in deserts, in the high Arctic, and in the mountains. They are wonderful flyers and I enjoy their fine, powerful shapes. I usually avoid painting the obvious and the spectacular in landscapes, but on this occasion I was drawn to the wonderful snowy slopes in Yellowstone Park, a strong, bright landscape that combined well with the powerful form of the raven.

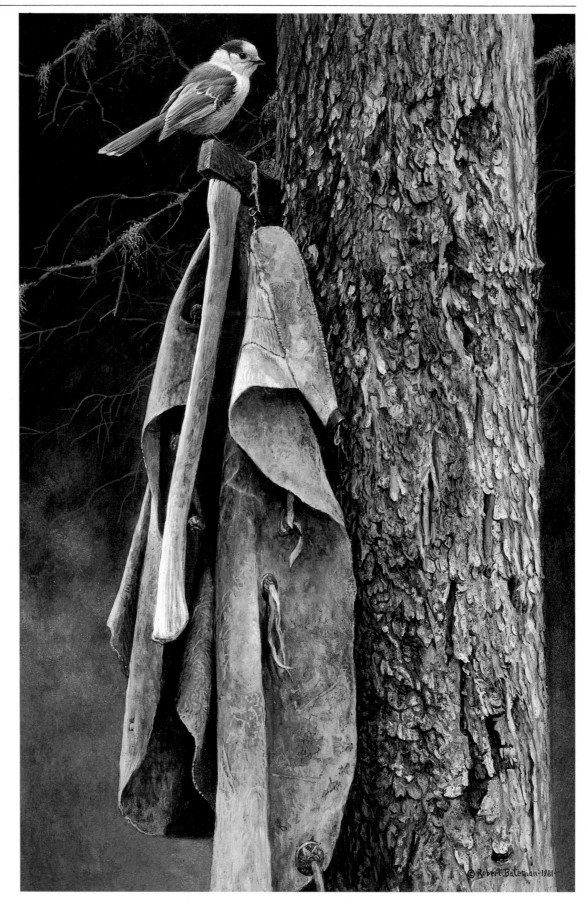

Wrangler's Campsite — Gray Jay; acrylic, 24 × 16″, 1981

Winter in the Mountains — Raven; acrylic, 20 × 24″, 1982

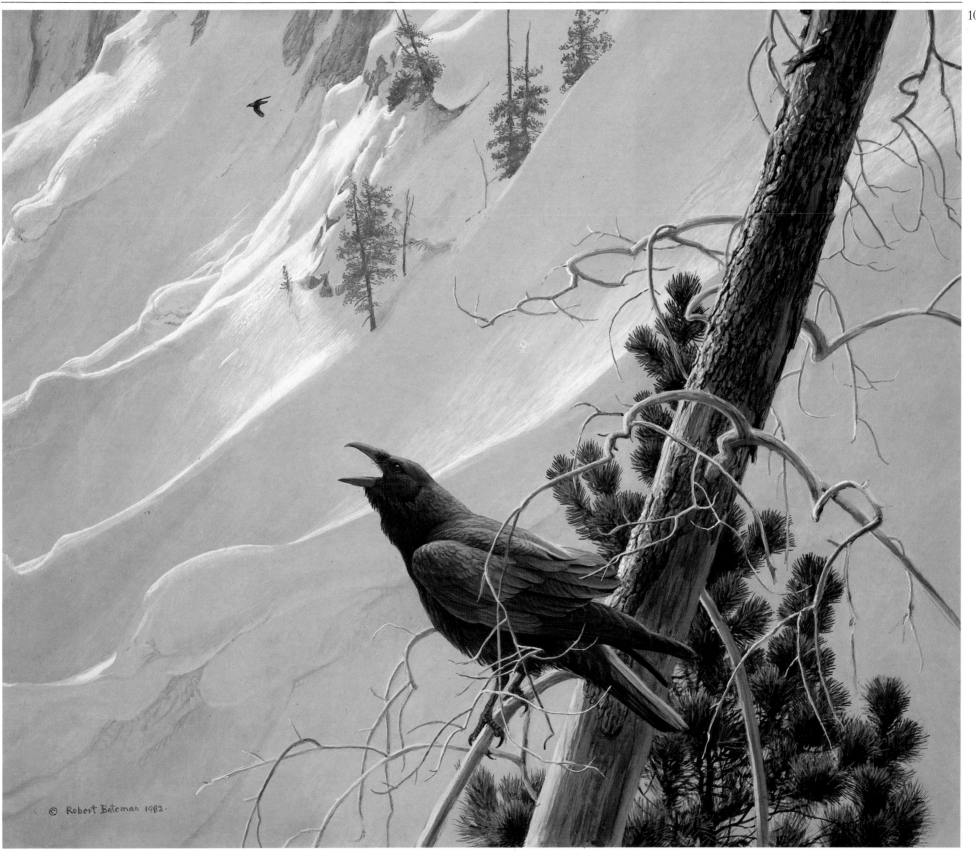

© Robert Bateman 1982

Cougar

A cougar, one of the most secretive of animals, here has followed a quarry, perhaps a deer, which has wandered into a clearing. The cougar is now lying watching it, hesitant about making a dash into the open to attack its prey. In this painting I was seeking a mood of mystery and tension, which I established with the diagonal structure and the twigs and little patches of snow on the branches. These set up a sort of field of electric sparks around the cougar, emphasizing the direction of its gaze, but the eyes are almost hidden. In order to convey the animal's secretive, almost invisible quality, I "threw away" the handsomest part of the cougar — the head — by laying it back under heavy shadow and by putting strong, bright twigs in front of it. The shape of the big powerful paw is reinforced in the undulations of the snow.

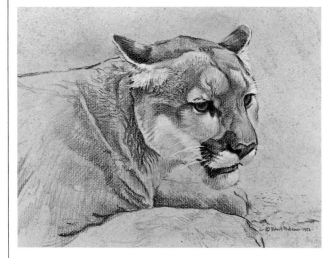

Cougar Head; pencil and crayon, 9½ × 12″, 1982

Cougar in the Snow; oil, 36 × 48″, 1978

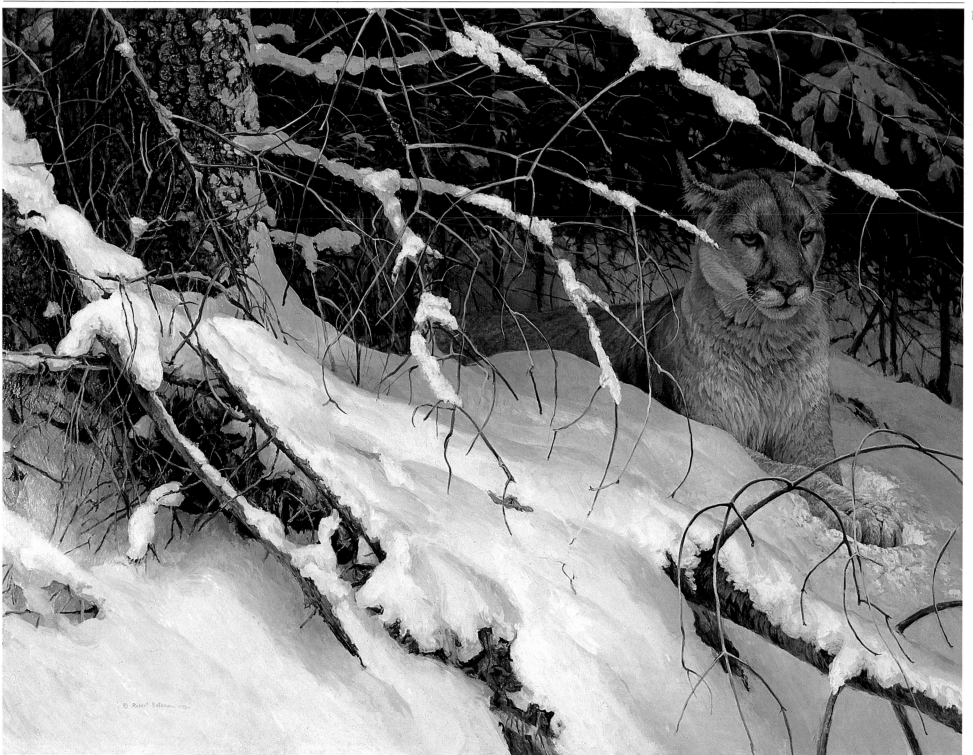

White Wolf/Swift Fox

White wolves are the light-color phase of timber wolves living in the northern regions. I have shown a female standing on an esker, a high gravel ridge that was once the bed of a river under the ancient continental glacier. These eskers, which criss-cross the boggy Arctic tundra, serve as dry den areas for the wolves as well as good vantage points. Wolves used to be the prime predator in North America after aboriginal man, but they have been driven out of urban areas and are sometimes under attack in even more remote regions. Naturally, in the Arctic, there are very few wolves because there is simply not enough prey to support many of them.

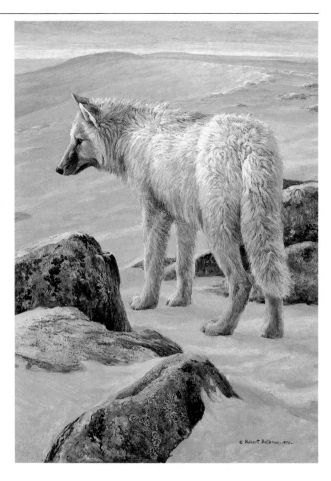

The swift fox is a rare little animal related to the more common kit fox. They live on the grassy plains of the north-central United States and Canada. Swift foxes are nervous, nimble animals and I wanted to catch the delicate, fidgety quality they have even in repose. I enjoyed the sensual way the late-afternoon winter light played on the fur, and I wanted to show it accurately and to bring out the richness as much as possible.

Painting a furred animal is very different from painting a feathered one. Feathers are like panels on a suit of armor or an insect's exoskeleton; they mask the bones and muscles inside. Fur does just the opposite. Everything that the skin and muscles do is reflected in the fur as it opens up or closes in on itself. The physiology of the animal is shown in every square inch of the fur. You get interesting splits and changes of direction and there are different angles and densities. When I paint the fur of an animal, I think of it as a complex landscape with chasms and pinnacles and a variety of basic shapes. That way I can get into it; I try to understand how I can use light and shade to show form and to reflect what is going on with the body underneath the fur.

Arctic Evening − White Wolf; acrylic, 24 × 18″, 1978

Swift Fox; acrylic, 12 × 24″, 1981

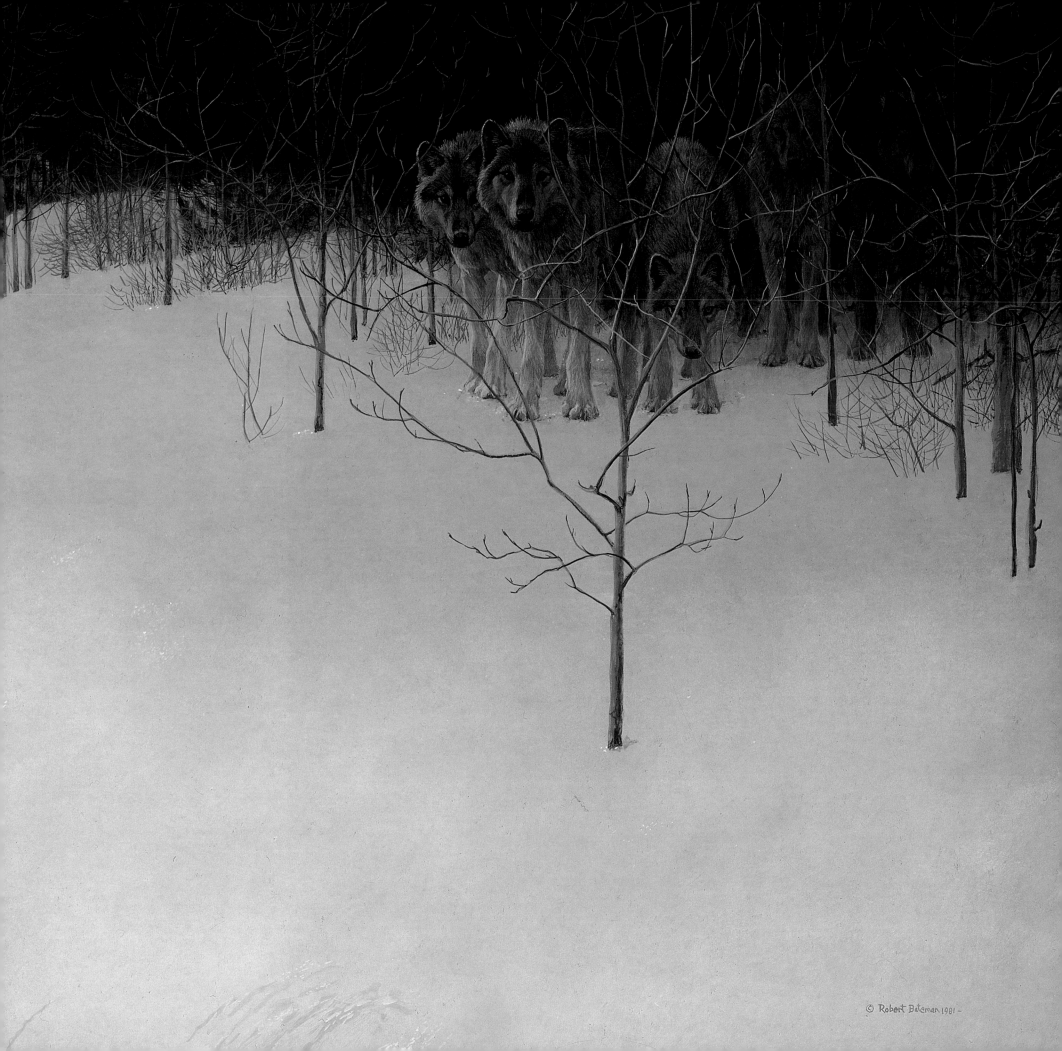

Gyrfalcons

These two gyrfalcon portraits were painted several years apart. The gyrfalcon, the largest member of the falcon family, lives in the far north but is much in demand in the Arab world as a hunting bird and has consequently been the target of nest robbers and poachers. When I painted the earlier of the two paintings, I was very conscious of the bird's threatened status, and so I depicted it in the dark-color phase, looking a bit forlorn. In the later painting, I have given the bird a noble and triumphant position and shown it in the more spectacular white-color phase.

In both paintings the rocks took on particular importance. In the earlier painting the quartz line running through the bedrock in the foreground and background echoes the white markings on the bird. In the second painting the rocks are low sandstone cliffs I saw near Fort Churchill on Hudson Bay. I liked the quality of light on the rock and the positive and negative forms nestling into each other.

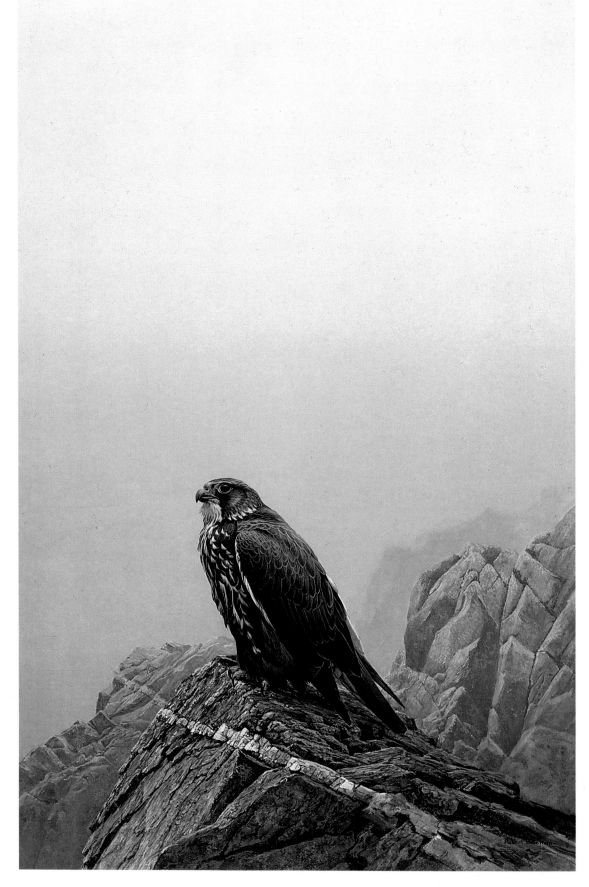

Gyrfalcon – Dark Phase; acrylic, 35½ × 23½″, 1972

Evening Light – White Gyrfalcon; acrylic, 36 × 48″, 1981

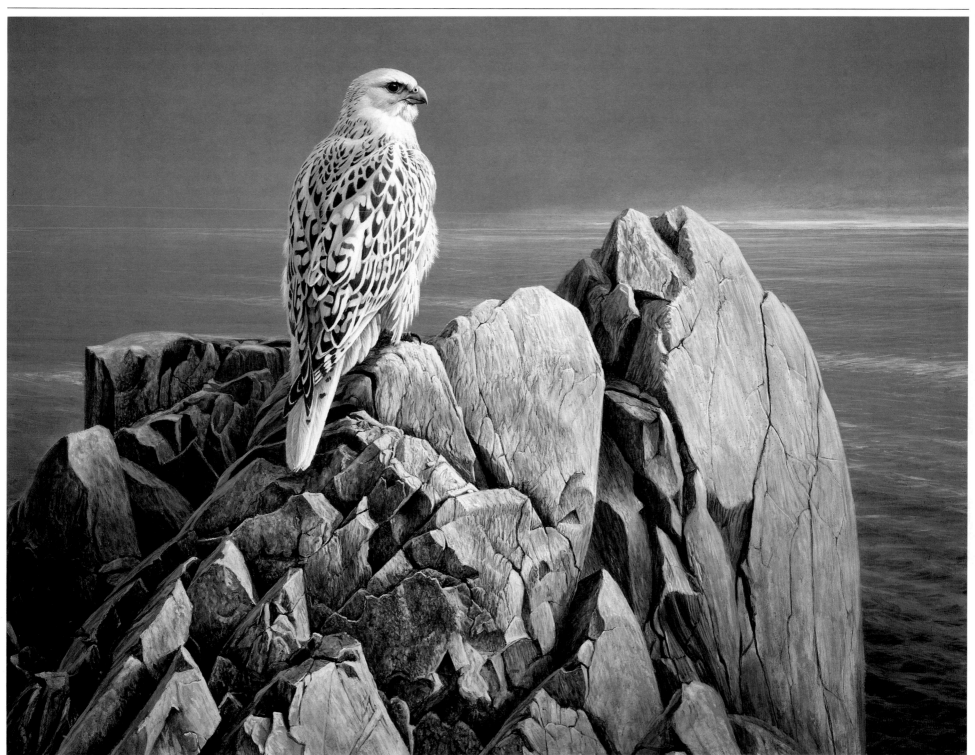

Golden Eagle

The sky is a great world, obviously greater in size than the earth's surface and far more dynamic in its movements and changes. Clouds are the signals of atmospheric activity, from the massive slabs of stratus that may blanket half a continent to the wispy little cirrus near the outer edge of the atmosphere. The towering giants are the cumulonimbus or thunderhead clouds. They start life as fair-weather cumulus clouds, but the rising air can build them upwards as fast as three thousand feet per minute to heights of seventy-five thousand feet. Sometimes the top spreads out in a wide anvil shape of ice crystals. A rapidly building cloud looks far from soft and fleecy. It contains enormous energy, and can look as hard and nubbly as a giant cauliflower.

I wanted to convey the edges of the growing cloud and the soft vaporous mass in the middle of the painting. The composition called out for something in the top left-hand corner triangle. I didn't want to let the cloud bulge out in that direction because cumulonimbus clouds grow upwards towards the sun, which in this picture would be up and to the right. Instead I introduced the streams of higher cirrus clouds.

The little wisp of cloud at the edge of the painting to the right of the eagle is fundamental to the dynamics of the picture. It suggests the shape of the eagle's wing, and gives the cloud mass a depth so that you can feel where the eagle came from and where it is going.

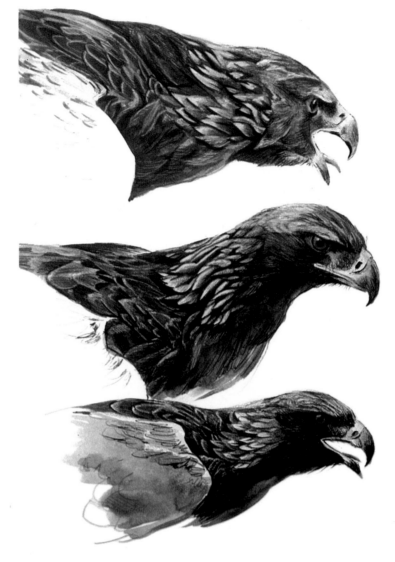

Golden Eagle Heads; pen and acrylic, 9 × 12″ (approx.), 1978

Flying High – Golden Eagle; acrylic, 42 × 30″, 1979

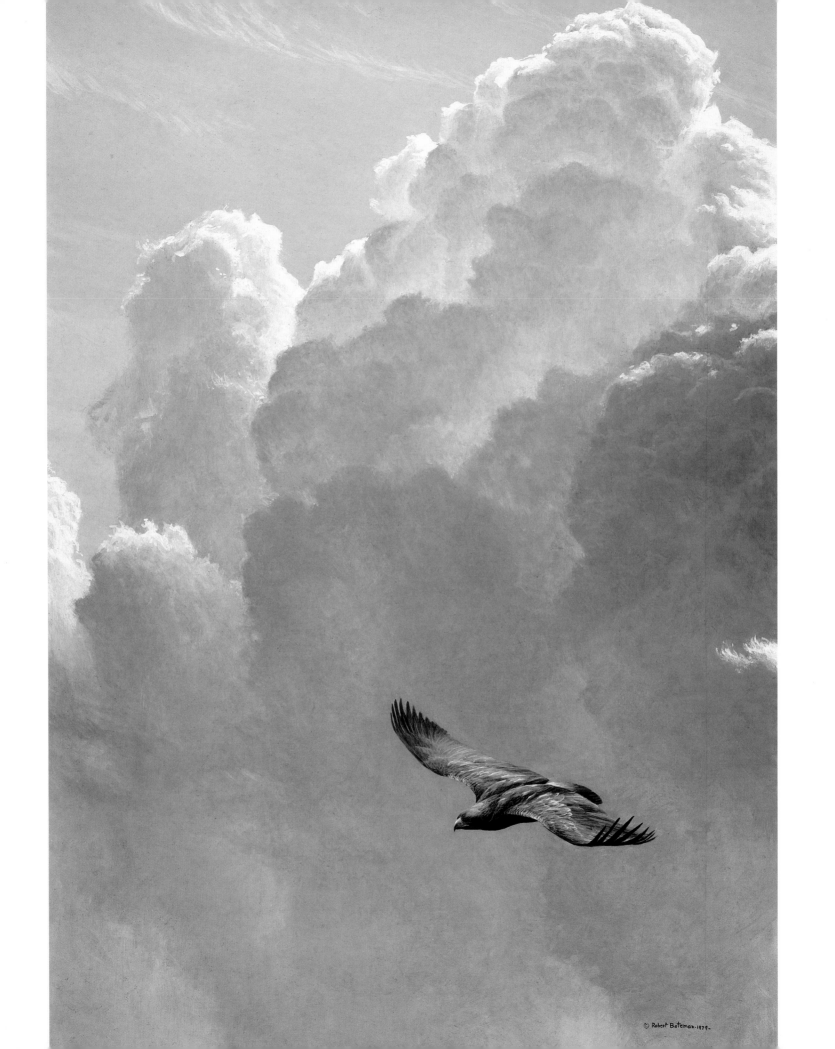

Polar Bear

I was out driving on one of those bright, cold, January days after a snowstorm when there is a strong northwest wind. The back roads near our home were mostly cleared, but here and there I came to thick, blowing drifts which the snow-ploughs had been unable to keep clear. In order to cross these, I had to drive very fast to buck through the snow. But the blowing snow made a wall of white and for a few seconds there would be zero visibility. What if another car was heading into the drift from the other side? Then I thought about travelling in the Arctic during a winter storm. What if you entered a drift and, unknown to you, a polar bear entered the drift from the other side?

White Encounter; acrylic, 36 × 48″, 1980

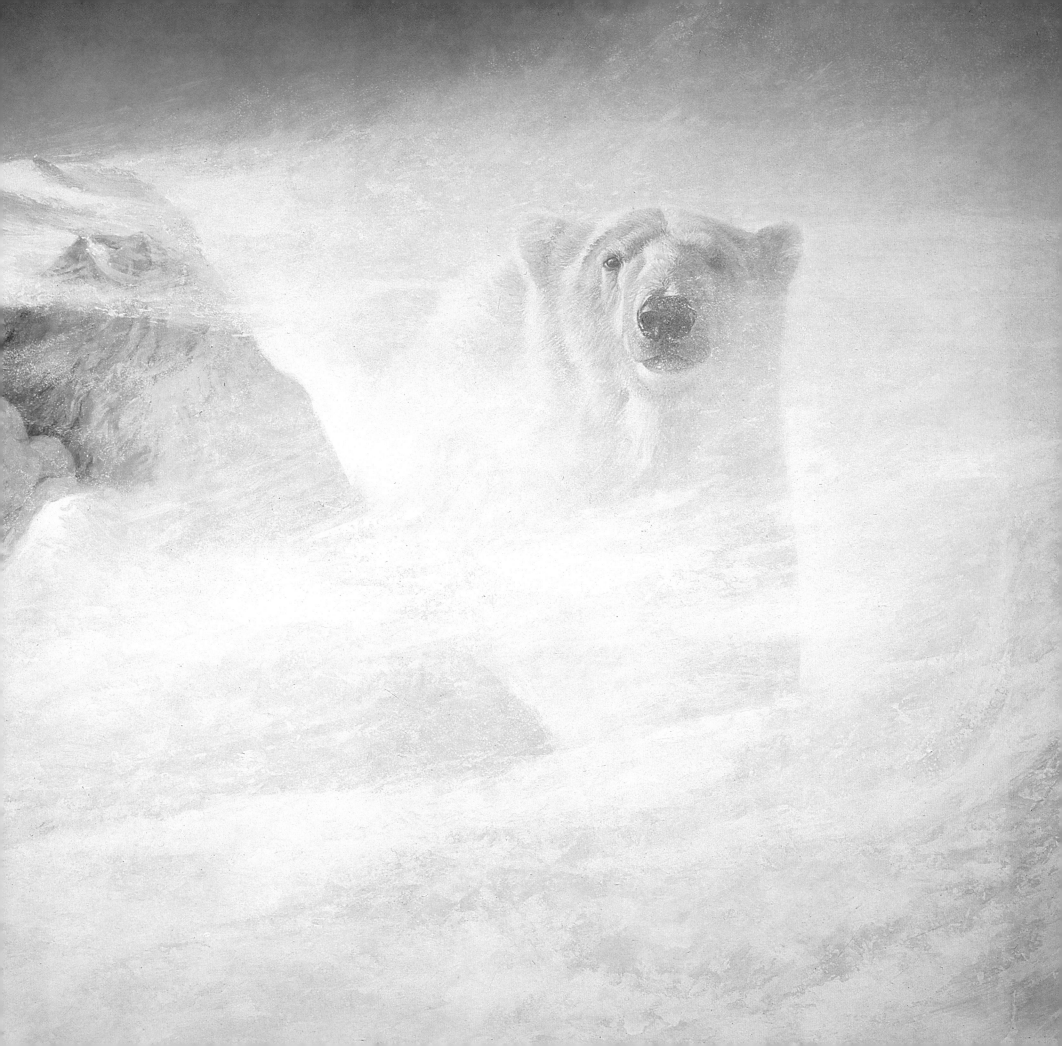

Grizzly Bears

Usually I avoid allowing the main elements in my paintings to compete. When there is an animal subject, either it or the surrounding landscape predominates. Sometimes I will hide a little bird or a butterfly or even a beer can in one of my paintings – something that is important, but which might not be noticed at first or even second glance.

Here, the main subject is one of the largest carnivores in the world – a grizzly bear with her cubs. What I have hidden is the highest mountain in North America. In this part of Alaska one is surrounded and awed by the rolling tundra and magnificent mountain ranges. Then one looks up into the cloudy sky, perhaps to follow the flight of an eagle, and realizes that rising far above all the other mountains and the cloud layer are the snowy slopes and glaciers of Mount McKinley – or Denali, as it has now been renamed.

Grizzly; charcoal, 6½ × 10½″, 1980

Along the Ridge – Grizzly Bears; acrylic, 24 × 36″, 1984

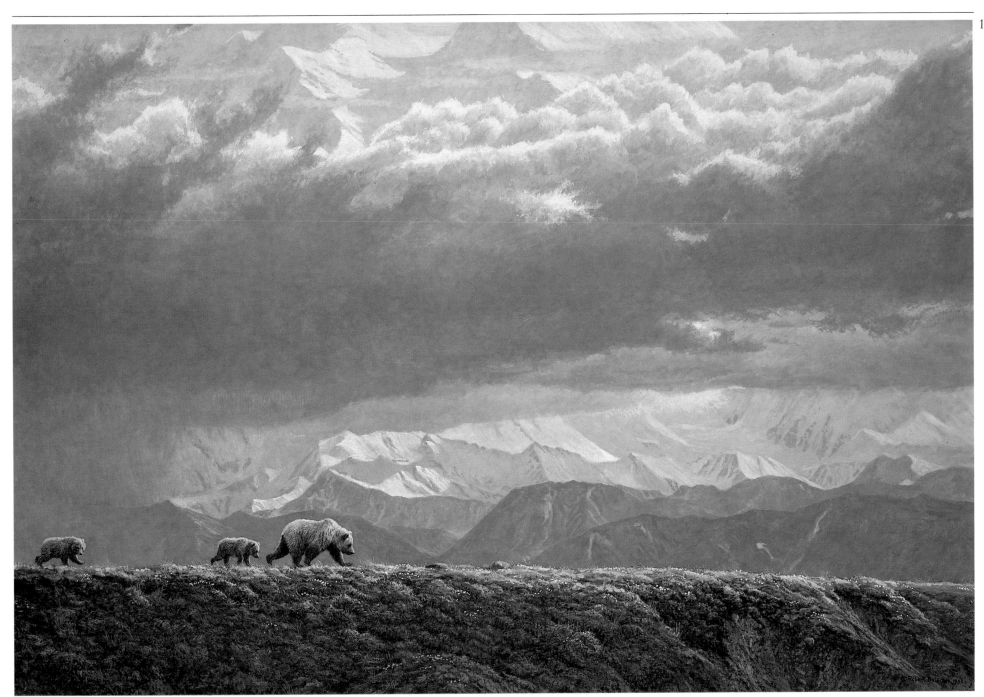

Bald Eagles

The Pacific coast of British Columbia draws me back again and again. The combination of mountain, forest, and sea makes spectacular landscapes, and there is a tremendous wealth of natural life as well as a fascinating human history.

The small sketch was done at Squamish, north of Vancouver. Bald eagles are quite common there, and I have presented them as just a part of the landscape.

Bald Eagle with Salmon is set on one of those big rivers that seem so huge and fresh and clean as they empty into the Pacific, with the sound of water flowing over the massive rounded boulders that have rolled down out of the mountains. The salmon run up these rivers to spawn and so this is where the bald eagles congregate as well. In the picture, the eagle is the center of interest but I enjoyed painting the great coniferous forest in the background, the glaucous-winged gulls typical of this coast, and the mini-landscape of the drift-wood and gravel of the river bed. I also enjoyed the salmon. The model for it was caught by my friend Bristol Foster and I was able to get a close look at it and sketch it before he filleted it. We ate it for supper.

Bald Eagles at Squamish; acrylic, 12 × 24″, 1980

Bald Eagle with Salmon; acrylic, 32 × 47¹/₂″, 1972

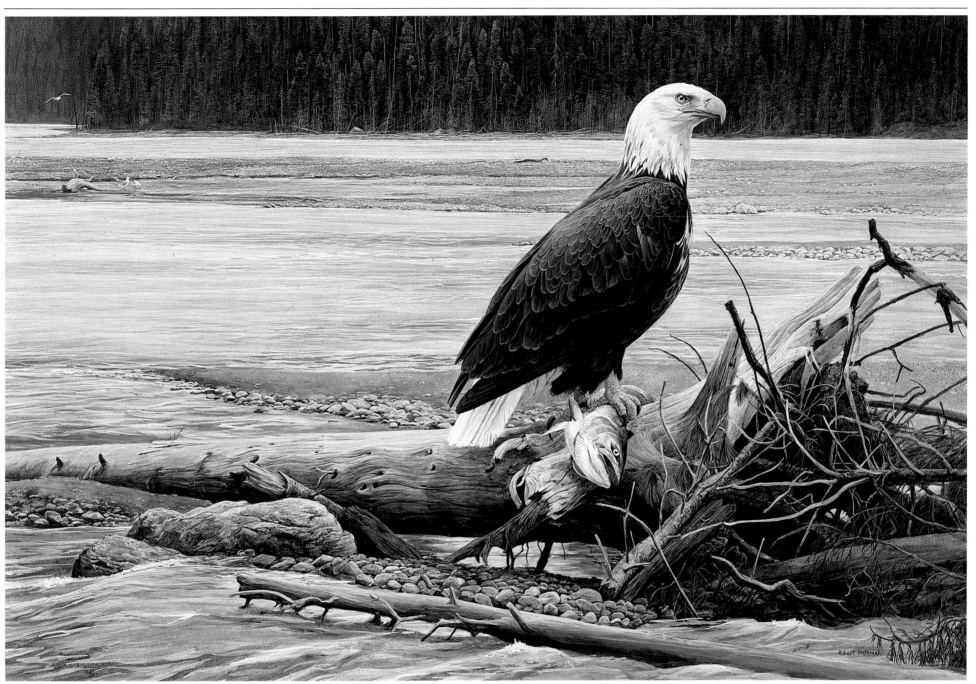

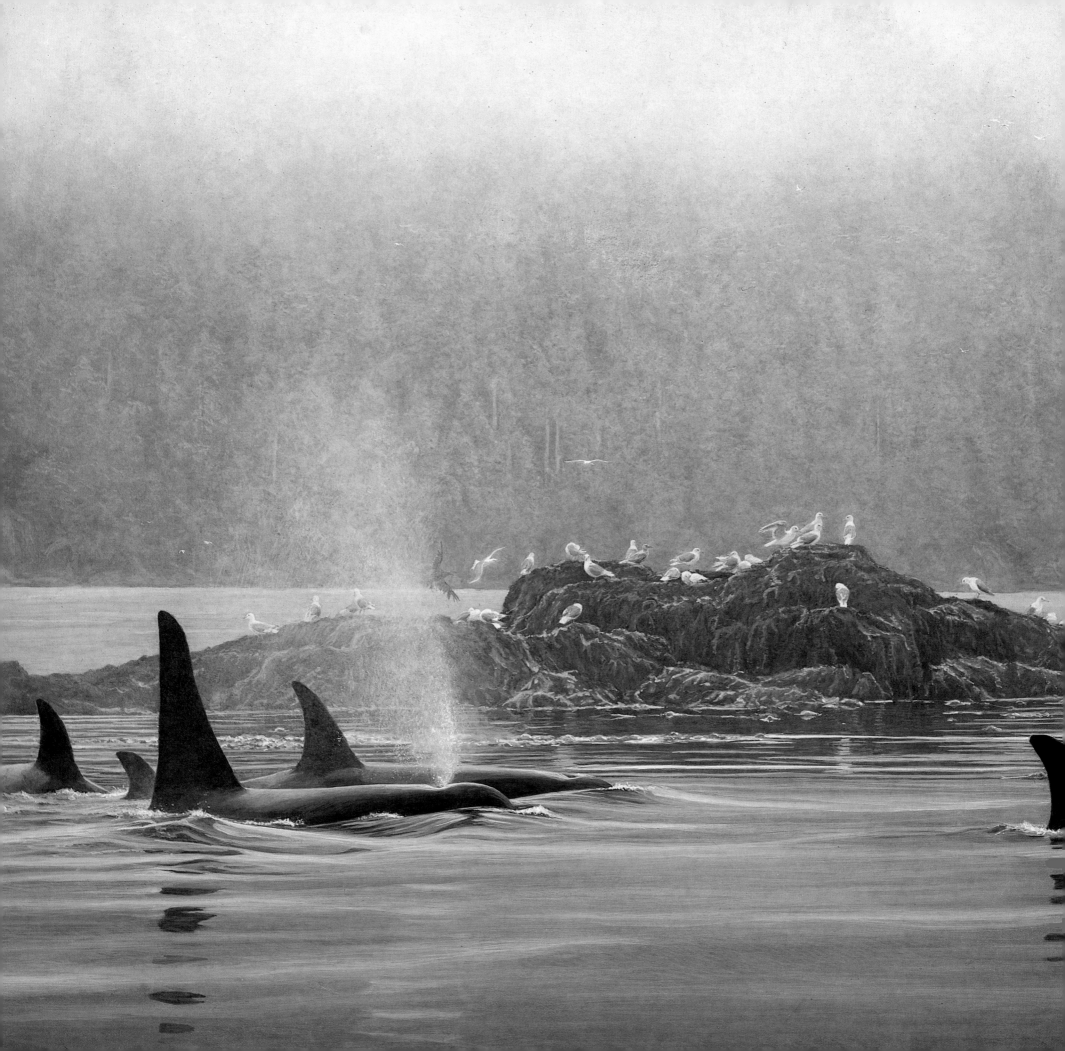

Orca

n this picture I wanted to get across a feeling of the richness of the British Columbia coast. The setting is the south end of the Queen Charlotte Islands, which lie just south of Alaska. The weather in this region can be brilliantly clear but is most characteristically misty, the atmosphere saturated with moisture, a condition I find very satisfying artistically because it gives the air body or substance. Here, the low-lying clouds hang down over the magnificent virgin cedar forests that clothe the mountain side (forests currently threatened by indiscriminate logging).

The little island in the painting was just offshore from our campsite, and I watched it appear and disappear with the tides. During low tide I could see it was teeming with life. The intertidal zone of the northern Pacific coast has the greatest variety of species of plants and animals of all the temperate seashores of the world. The Haida Indians, who once lived throughout this area, knew how to take advantage of the wealth of the sea and had a saying, "when the tide is out the table is set." Here it is the glaucous-winged gulls that are taking advantage of this cafeteria of the sea.

The real subject of the painting is the pod of orcas, or killer whales. Anyone who sees these magnificent animals in the wild must be excited by their grace, exuberance, and confidence. There are many larger species of whales, but the orca is at the top of the ranks of the seas' predators, threatened only by man. As I began to introduce the whales into the painting, making painted paper cutouts in order to try different arrangements, I was thinking of the quality of majesty they convey in their dignified processions. I was also conscious of their close family and social relations. These are obvious even in casual observation and recent studies have revealed how complex and subtle they are. The orca's huge dorsal fin — six feet high for large males — is the distinguishing feature experienced orca watchers use to identify them.

Orca Procession; acrylic, 30 × 42″, 1985

Totem Poles and Hermit Thrush

In all great art there is a balance between variety and harmony. This is shown superbly in the great carved totem poles of the Pacific Northwest. The real world was abstracted by these Haida Indian artists with as much sophistication as was shown by Picasso. All the shapes are composed of clean curves or straight lines, yet each shape shrinks or swells and nestles into its neighbor so that positive and negative become one as in the Chinese Yin-Yang symbol. The characteristic way in which these shapes fit inside each other reminds me of gazing into reflections in gently moving water.

The images carved on these poles are of totemic animals and spirits that represent family heraldry.

Most of the great totem poles were destroyed by warfare or by missionaries or have been carried off by museums and collectors. The remaining ones have been ravaged by time and decay.

At the Ninstints site in the Queen Charlotte Islands, the poles still stand as they were originally erected. As I wandered among them, with their faces to the sea and their backs to the cathedral-like forest, I felt a strong spiritual presence. Ringing through the trees was the delicate song of a hermit thrush. In the painting I have shown a totem pole with the image of an orca or killer whale. At the side is a hermit thrush whose presence there completed one of the most moving experiences of my life.

Spirits of the Forest – Totems and Hermit Thrush; acrylic, 18 × 24″, 1982

© Robert Bateman 1982

Great Gray Owl

The great gray owl of the northern forests is fleeting, silent, and ghostly. While it appears to be the largest of owls, it is mostly feathers and actually weighs much less than the great horned owl. Its wing feathers, like those of all owls, have downy edges, making its flight totally silent. Its colors are subdued and the patterns on the feathers provide excellent camouflage.

I wanted this ghostliness to be the predominant quality in the painting. The colors are restrained and the owl blends in with the soft, yellowy gray of the aspen tree. I used an extremely limited palette of beigy gray, with a little turquoise and olive as accent colors. The painting was finally covered with several thin, milky layers of pigment to heighten the ghostly, misty, translucent quality.

In many of my paintings a pattern or a shape that I discover in the feathers or anatomy or structure of the subject becomes a repeated theme throughout the picture. Here, the shape of the owl's head gradually became the inspiration for the theme of the entire painting.

The most spectacular characteristic of the great gray owl is the face. It consist of two huge saucer-shaped disks with concentric and radiating patterns, set at a slight angle to each other. At the very center of each of these disks, right beside each eye, is an ear, and the disk acts as a parabolic radar screen, picking up the tiniest squeakings and scratchings of the small animals that are the owl's prey. The eyesight of owls is also exceptionally acute — owls are second only to hawks in the sharpness of their vision — and, unlike most other birds and mammals who have orb-shaped eyes, their eyes are cylinders extending back into their heads. This makes owls especially sensitive to dim or nocturnal light. It also means that they cannot turn their eyes in their sockets but must turn their whole head. Thus these large facial disks are extraordinarily sensitive receivers of both sight and sound for the owl.

After I had placed the owl in the composition and had started working on the smaller branches and twigs, I began to see the whole painting as an allegory for the great gray owl's face with its two feathered disks and the axis running down the middle in line with the beak. I started to manipulate the work to enhance this radiating feeling. The composition became two great pinwheels with the tree trunk as the beak axis and the twigs and branches radiating like the owl's facial feathers. The real owl's head is located where the eye would be if the tree represents the allegorical owl's head. I have also used the idea of the owl's white "beard" for some of the light areas in the lower background.

Ghost of the North — Great Gray Owl; acrylic, 37 × 49″, 1982

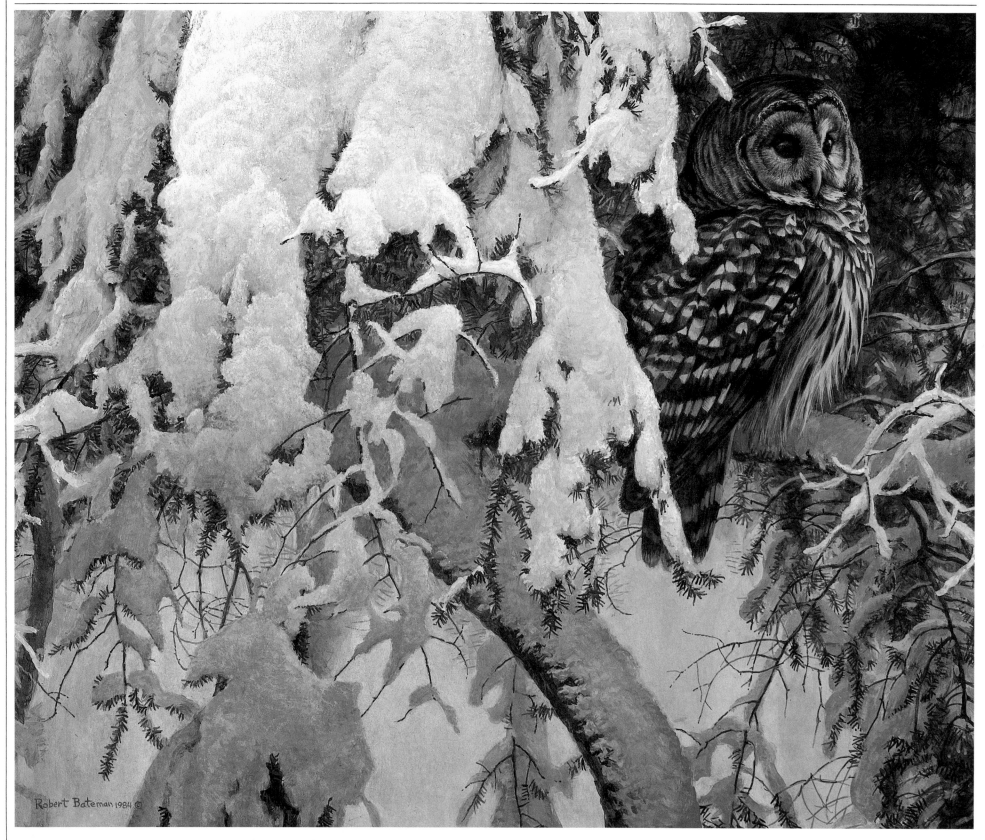

Barred Owl; acrylic, 24 × 31″, 1984

Asleep in the Hemlock – Screech Owl; acrylic, 19¹/₂ × 12″, 1980

Owls are interesting birds to paint, and I know that many people find them particularly appealing birds to look at. With their round faces and forward-looking eyes, they are the most human-looking of birds; in painting them it is important to avoid the tendency to make them too human-looking.

Barred owls live in the depths of thick woods and swamp forests and I associate them with the feel of squishing moss, dark trees, and a greenish light. Their beautiful, soft, camouflaged appearance and dark limpid eyes suggest gnomes and elfin spirits of the forest.

These owls also have a happy human association for me. Since my schooldays, I have had a group of friends with whom I spend time enjoying and learning about nature. Our greeting call to each other is the call of the barred owl, a sort of unearthly, operatic ululation which can be verbalized as "Who cooks? Who cooks? Who cooks for us all?"

The screech owl is one of the smaller owls of North America, about as big as a man's hand, and it often uses old woodpecker holes for nesting sites. The normal call is not a screech but a trembling, descending whistle, a little bit like an extended but gentle horse whinny. Screech owls are rarely active in daytime but rest in hollow trees, old buildings, or on some concealed bough.

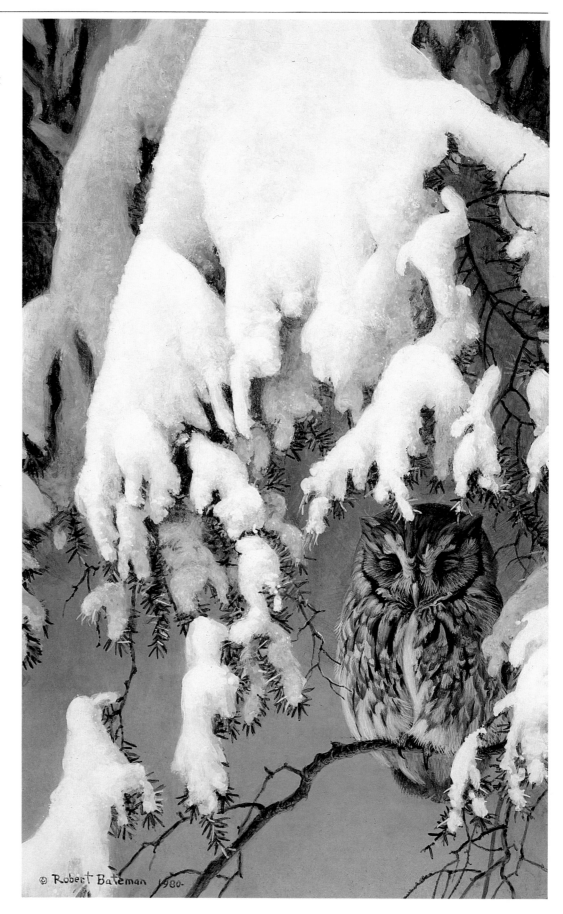

Gray Squirrel/Pileated Woodpecker

Beech trees are favorites of mine. I can find in a small section of their elephant-skin bark a whole landscape of cliffs and valleys. Here, in the gray squirrel painting, I have shown the powerful, rounded, almost animal-like forms of the base of the tree interlocking with the snow. The variety of hues in the gray beech bark and the white snow are echoed in the coloring of the squirrel. The second subject, the little plant on the right that sets up a tension with the squirrel, is a beech drop, which grows as a parasite only on the roots of beech trees.

I saw the beech tree with the pileated woodpecker again as an adventure in space, texture, and shape. I was conscious of the extreme acuity of the woodpecker's vision, and painted the tree as he might see it, with everything in focus and full of potential interest and promise.

The woodpecker's eye itself is steely and totally lacking in emotion. I find the facial arrangement of the pileated woodpecker very satisfying. In common with loons, herons, and kingfishers, this woodpecker has a steeply slanted forehead, a long, very sharp beak, and a throat that extends out ahead of the forehead. These birds always seem cocky and aggressive; when I was working on this painting I was thinking of samurai warriors and I gave the feathers an almost armor-like quality.

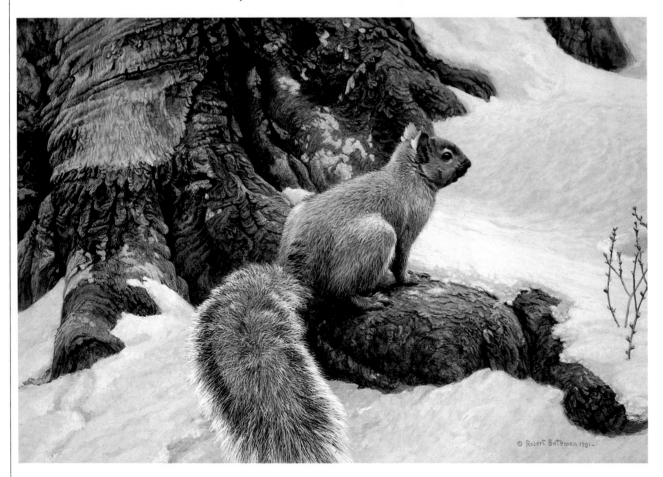

Gray Squirrel; acrylic, 16 × 24″, 1981

Pileated Woodpecker on Beech Tree; acrylic, 36 × 24″, 1977

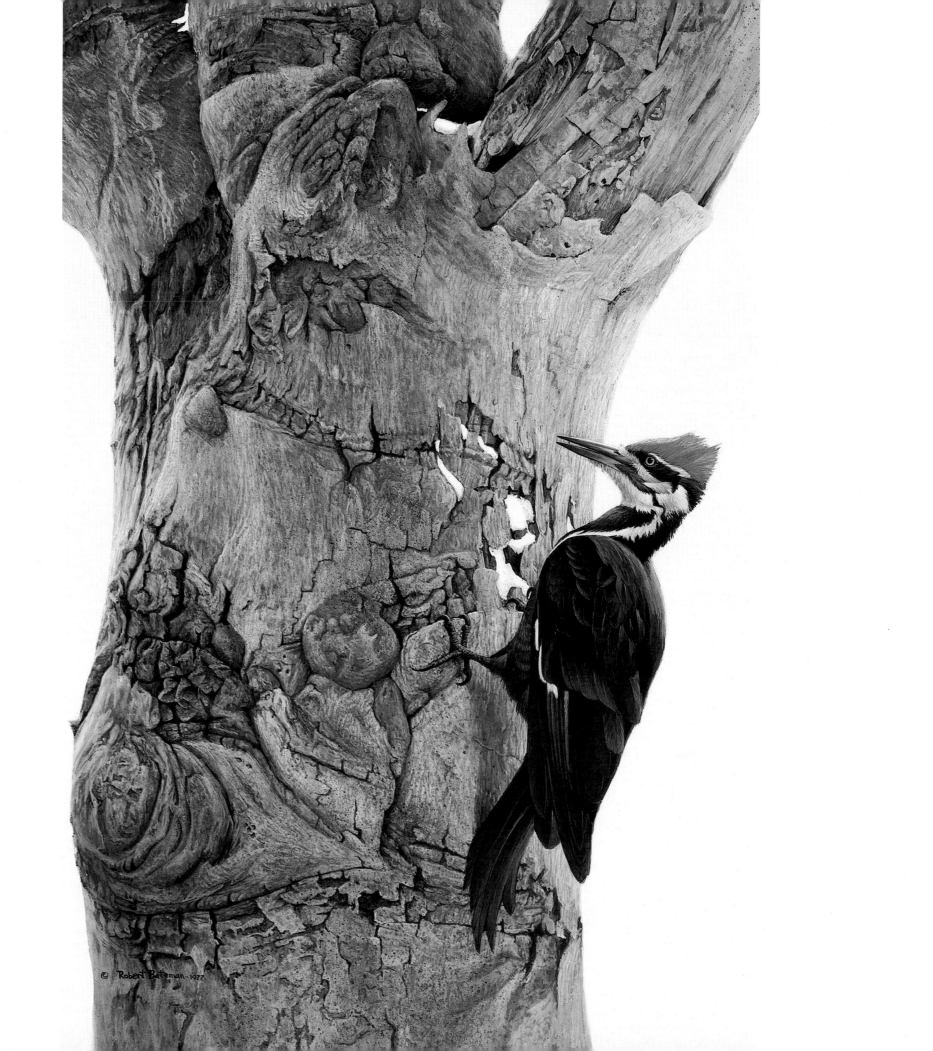

© Robert Bateman–1977

Red Fox

The red fox in this painting is on the prowl. In the winter he has to work harder to find enough food, since the snakes, frogs, insects, and young birds and eggs that he eats in the summer are not available. He is about to check under the pine tree where the snow is thinner and where some of his winter prey — mice, squirrels, or rabbits, for example — might have sheltered. Just before he pushes through the tangle of twigs and grasses he pauses for a moment as he notices some rabbit tracks. The rabbits had probably been romping under the tree the night before, but he is checking just in case they are still around.

In the composition of this painting, the weight is at the top, falling away to emptiness toward the bottom. The setting, a pine tree and thicket near our house, might seem commonplace, but this kind of scene fascinates me, and I enjoyed working through it in the painting, building up the layers of the undergrowth from the back toward the front, finding patterns and rhythms and working to create a sense of space and air.

Red Fox — On the Prowl (detail)

Red Fox — On the Prowl; acrylic, 30 × 48″, 1984

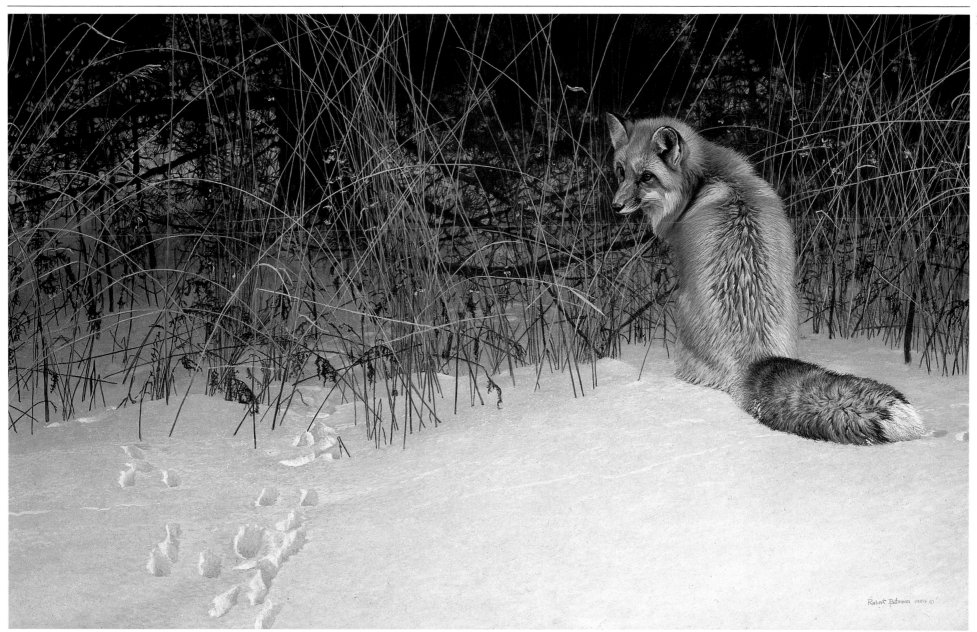

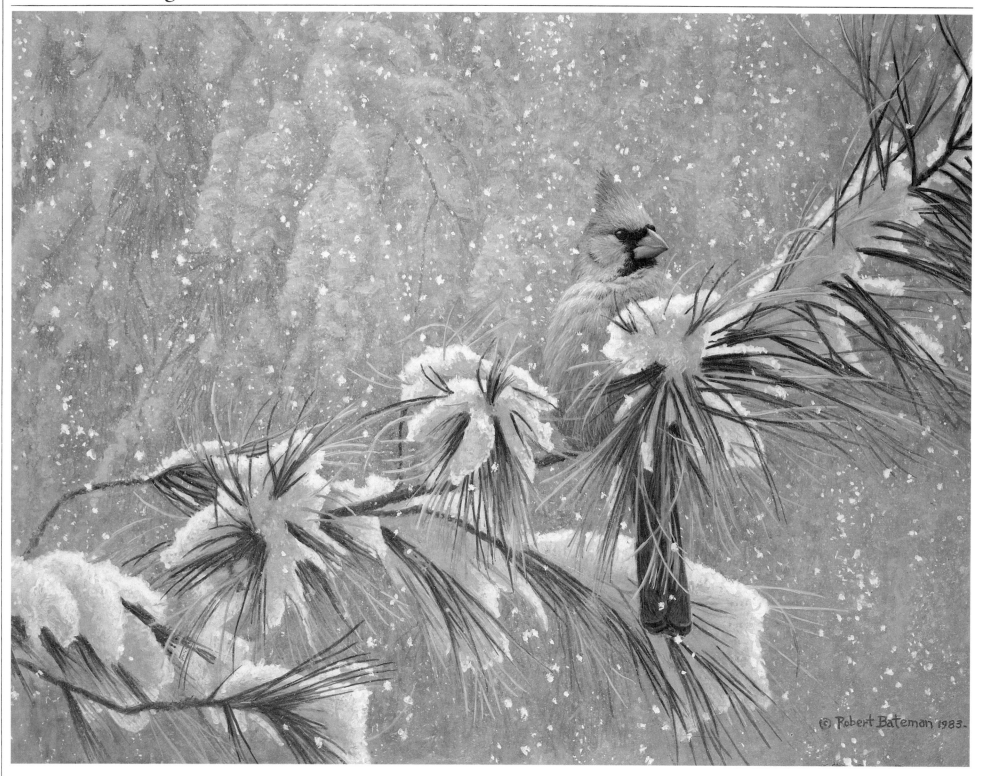

Winter Lady — Cardinal; acrylic, 12 × 16″, 1983

Evening Grosbeaks; acrylic, 21 × 16″, 1980

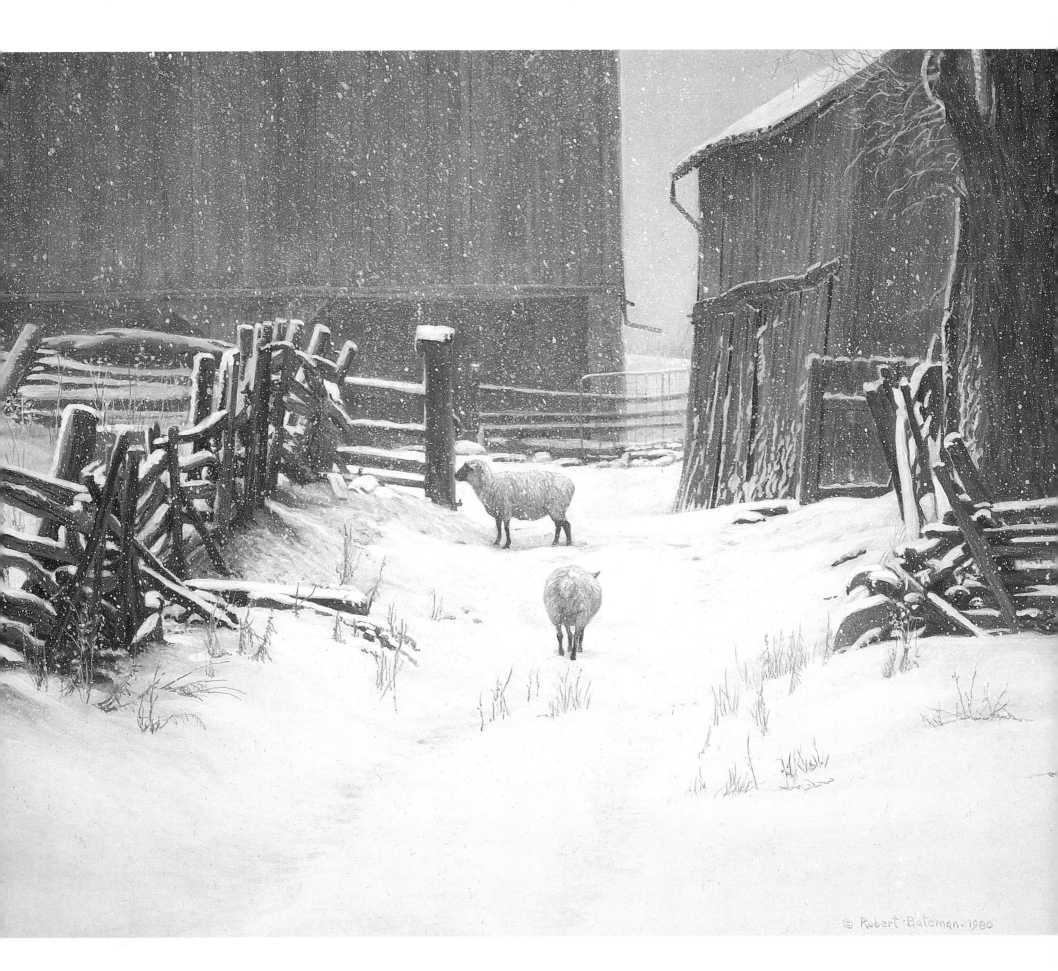

© Robert Bateman - 1980

Maple Leaf Fence/Alliston Road Allowance

In 1967, Canada's centennial year, I gave myself a centennial project. I would paint a number of historical settings or sites in Halton County, where I live. This old decorated wire fence, besides having the appropriate national symbol, seemed to reflect the efforts of the nineteenth-century settlers to introduce some elegance or embellishment into their lives. It also suggested the pioneer entrepreneurial spirit — someone had to think up this design for ordinary wire fence and then get out and sell it to the farmers.

In *Road Allowance near Alliston,* I played with the perspective to bring up and flatten the background, to get an effect similar to that produced by a telephoto lens. It's a technique that was often used by Cézanne and by some of the painters of the Canadian Group of Seven school in their landscapes. The building up of the background and the foreshortening gives the composition a more handsome and powerful effect.

Maple Leaf Fence; acrylic, 21 × 29″, 1967

Road Allowance near Alliston; pencil, ink and acrylic, 19½ × 30″, 1977

Robert Bateman

Along Walker's Line/Ploughed Field and Larks

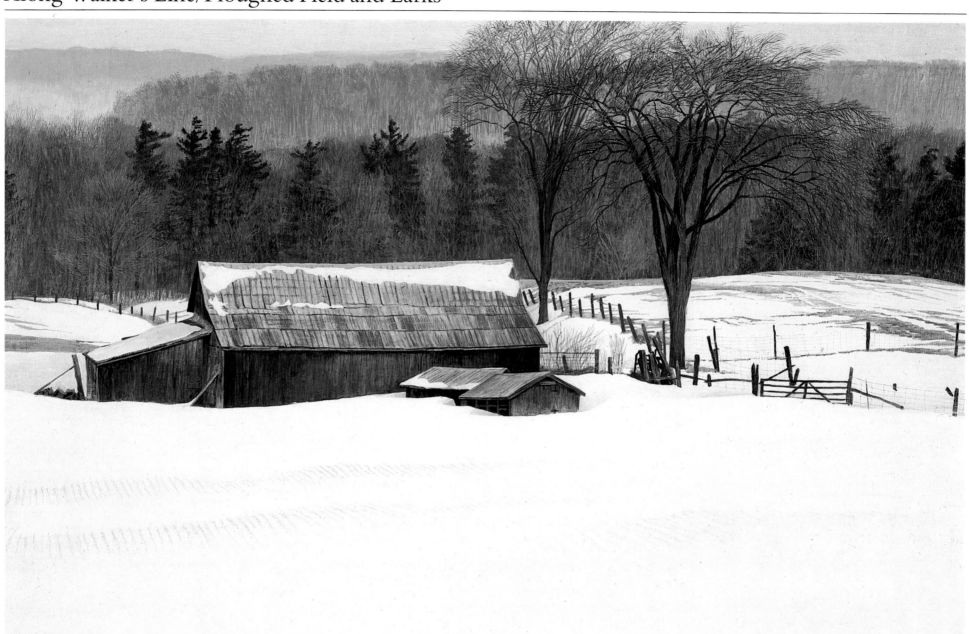

Along Walker's Line; acrylic, 23½ × 35½″, 1967

Ploughed Field — Horned Larks; acrylic, 16 × 19¾″, 1979

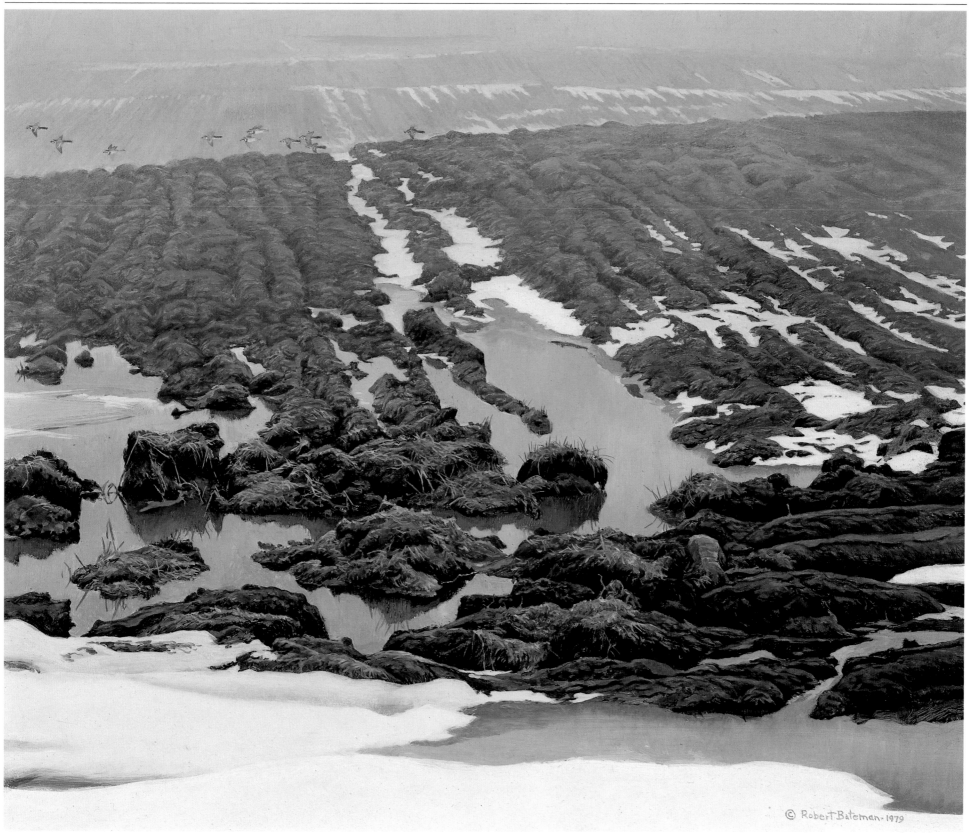

Gudgeon's Barn

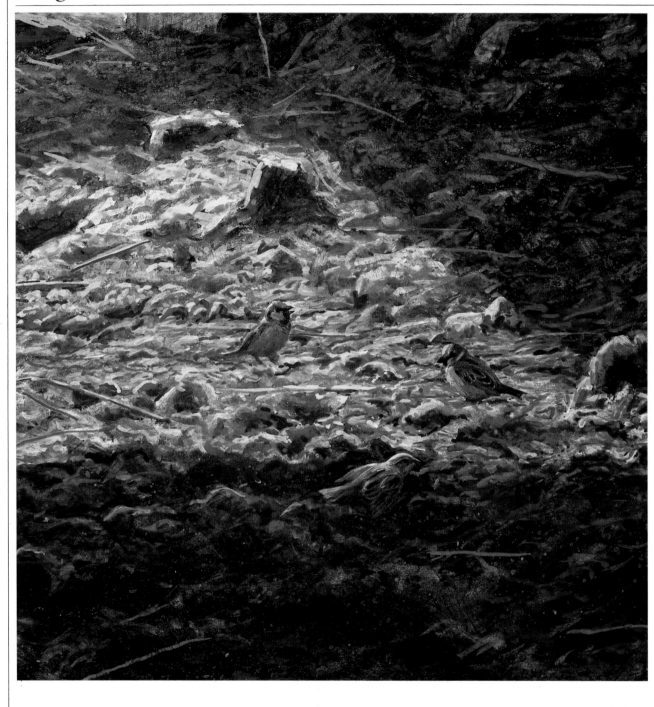

This is a barn in our neighborhood that I've enjoyed visiting at different times of the year. The season here is early spring. The heifer has moved out into the barnyard and you can see the fine black and white markings on her flanks with the fur a bit wet and mussed up. Inside, English sparrows are hopping around on the floor looking for seeds in the manure. The light shining in on the walls and beams picks up their textures and you can see some of the history of the barn in the way they are worn and cracked. I enjoy painting man-made and domestic objects and buildings when they show some wear and age and the surfaces suggest the accumulation of events over the years.

Gudgeon's Barn (detail)

Gudgeon's Barn; acrylic, 23½ × 35″, 1976

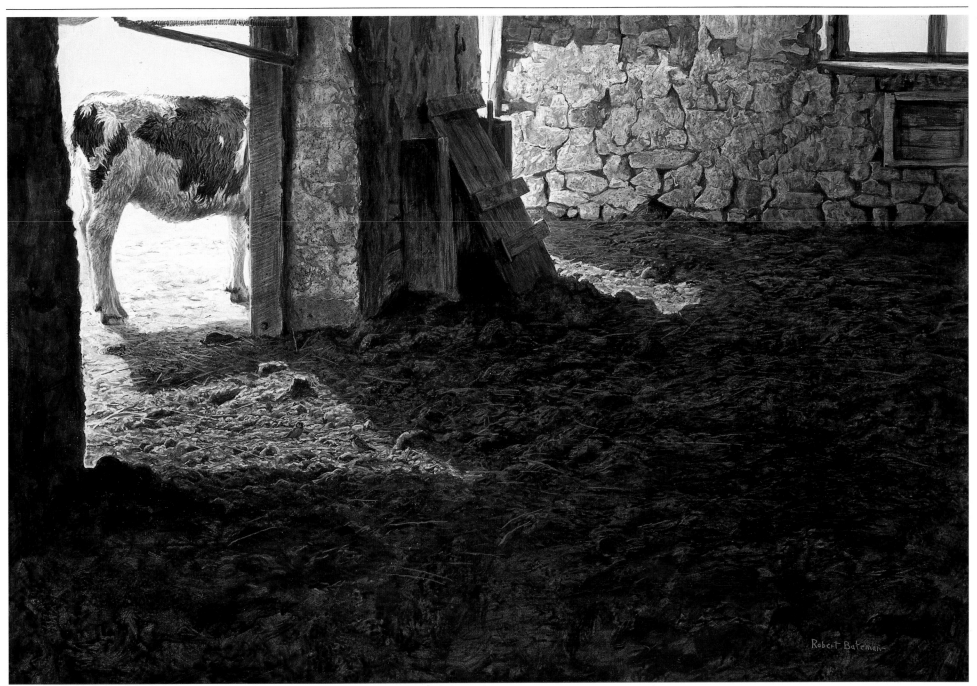

Killdeer

Abandoned railway lines often provide nesting sites for killdeer. The molded pebbles fit the mother's breast and provide perfect camouflage for the eggs and young. The young killdeer, like the shorebirds to which they are related, are precocious and able to run about shortly after hatching.

The delicacy of the little bird contrasts with the heavy power of the railway ties and tracks, yet he fits perfectly in this man-made environment.

I had wanted to do this picture for a long time before I found a genuine old nineteenth-century railbed that had been left alone to let nature act on it.

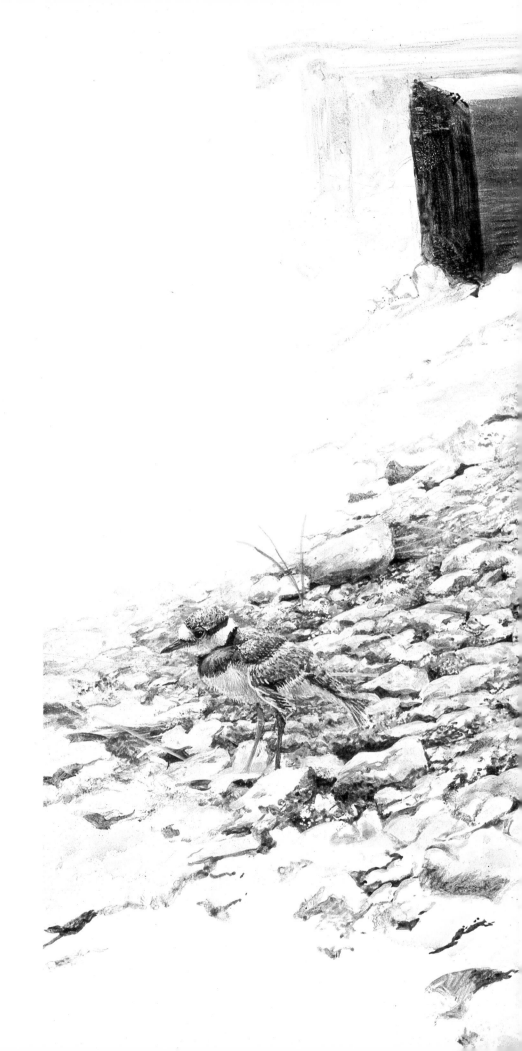

By the Tracks — Killdeer; egg tempera, 17³⁄₄ × 25″, 1971

Queen Anne's Lace and American Goldfinch/Goldfinch with Mullein

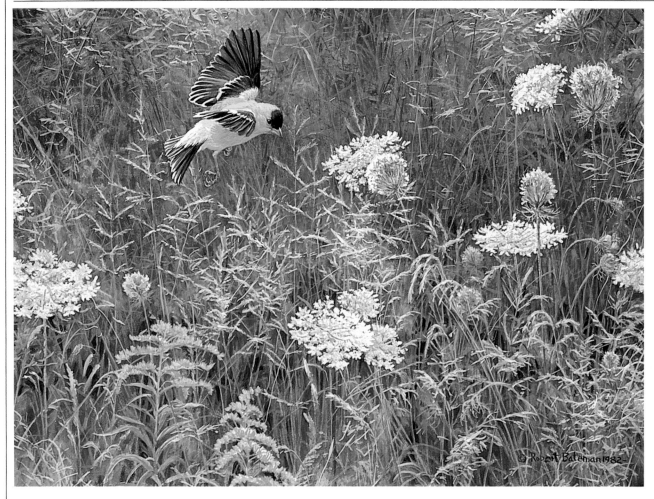

My main aim in this painting was to give form to these few square yards of meadow, to find and develop a rhythmic pattern over the whole area. There is no central composition. Instead, it is as if a flower arrangement had been given a swift kick and scattered about. The goldfinch is part of this open composition. It has not been placed in the center, but is dropping in from above. In spite of the random appearance of the goldenrod and Queen Anne's lace heads they are all deliberately placed. There are many complex relationships in the picture, a playing back and forth of shapes and colors, perhaps somewhat similar to the interweaving themes of a baroque concerto.

Although it may suggest great detail, this is not a detailed painting. I used impressionist and cubist techniques, though on a small scale, and only a small fraction of the plants in the picture are clearly delineated. Rendering fine detail is not of much interest to me as a painter. I often want to present the richness and complexity of a particular scene in nature, but I also want to convey a sense of space and air and life, and the pure delineation of detail on its own cannot do that.

I saw the modest little piece of countryside in the painting on the right, in late summer, liked it, and wanted to enjoy it in a painting. It was done at a time when I was still strongly influenced by the work of Andrew Wyeth. I thought of it primarily as a landscape and the goldfinch is neither the central subject nor an afterthought but simply part of the landscape.

Most people think of mullein as a weed, but seeing it growing on this hillside made me think of the proud ranks of a ragged, tattered nobility. I enjoyed bringing out the form of the hillside behind the mullein, showing the concave and convex flow of the slope. I left the bottom of the painting unfinished, as I did with *By the Tracks,* because I thought I had said all I wanted to say and I found the remaining white shapes quite satisfying.

Queen Anne's Lace and American Goldfinch; acrylic, 11 × 15″, 1982

Goldfinch with Mullein; acrylic, 19 × 24″, 1970

Mallards

I had hesitated to paint a mallard portrait, because it is such a common subject for hunting pictures and because, although I like mallards, their color combination of bright green head and rusty breast does not appeal to me. Here, I have shown the drake as a birder often sees him, in a rather quiet, almost domestic scene, and in the middle of a preening session. He is back-lit and surrounded by flowers, grass, and water which harmonize with the colors of his feathers. Botanists will recognize that the setting of the painting is European. The water strider serves a double purpose. Its complacency in the presence of the duck on the still surface of the pond contributes to the mood of the painting, and its presence helps me technically by making the water appear flat.

At sunset at Cape May on the New Jersey coast, I was attracted by the rich patterns in the lush salt-marsh grass, and the rhythmic shapes it made with the bright water. The painting has a rich, romantic mood, but I thought of it as a color-field painting of the sort made famous by Barnett Newman and Mark Rothko, with the main force being the broad band of yellow striking across it.

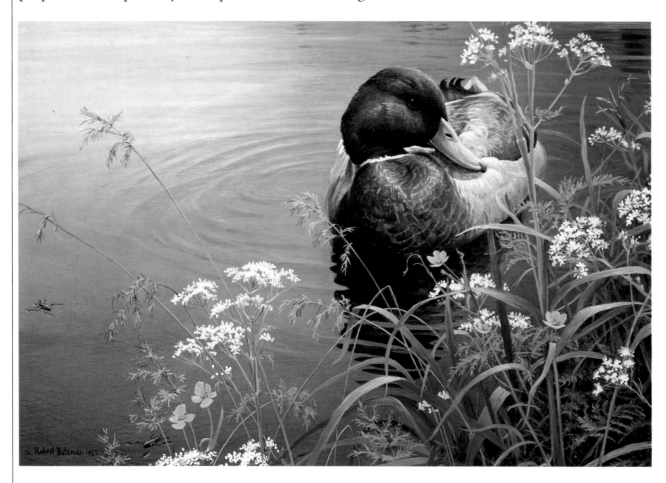

Meadow's Edge – Mallard; acrylic, 15 × 22½", 1982

Mallard Family; oil, 18 × 24", 1981

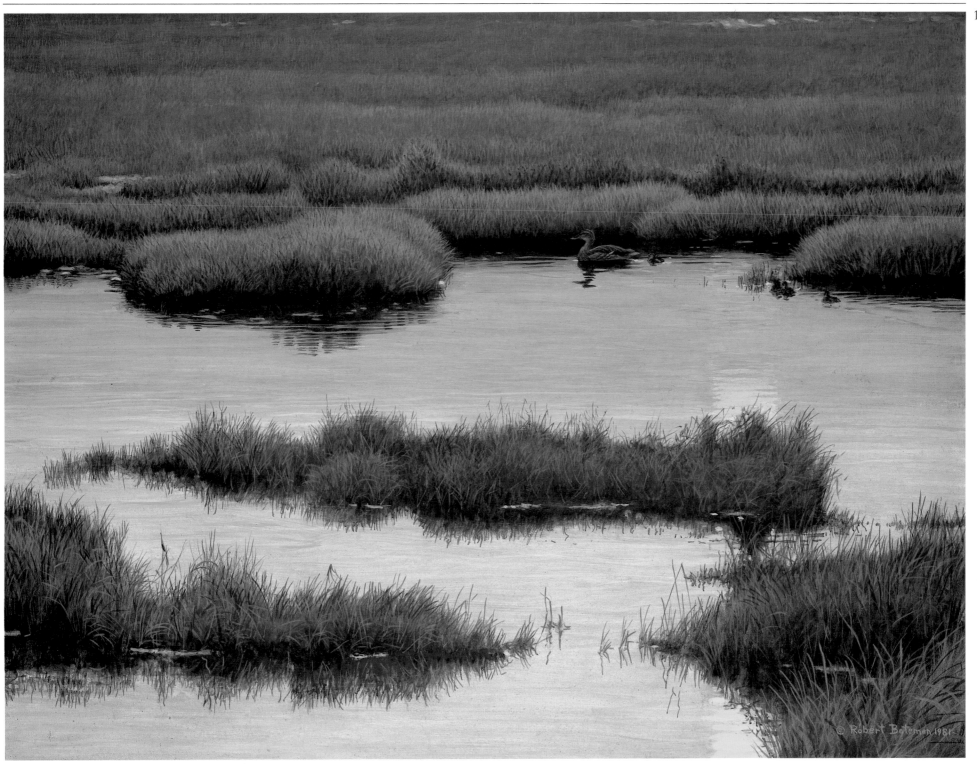

© Robert Bateman 1981

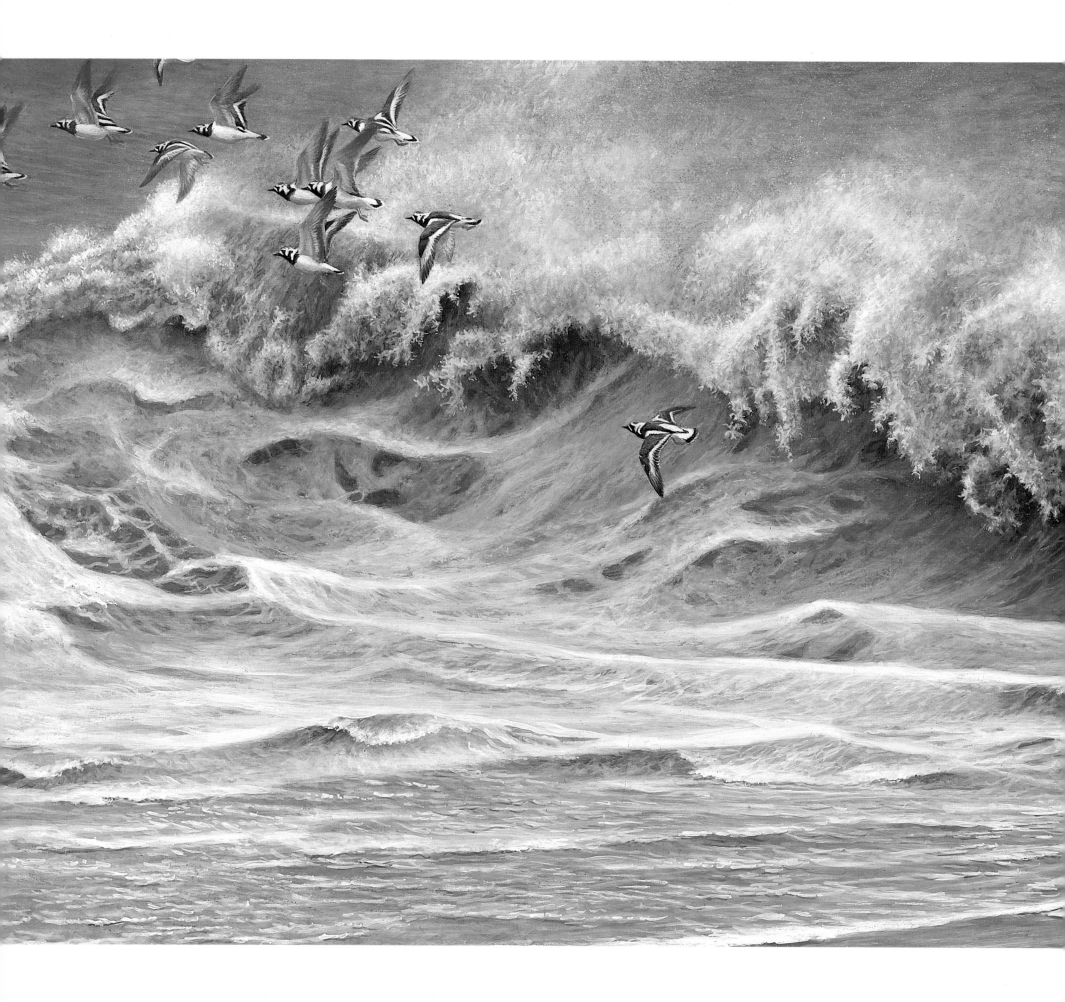

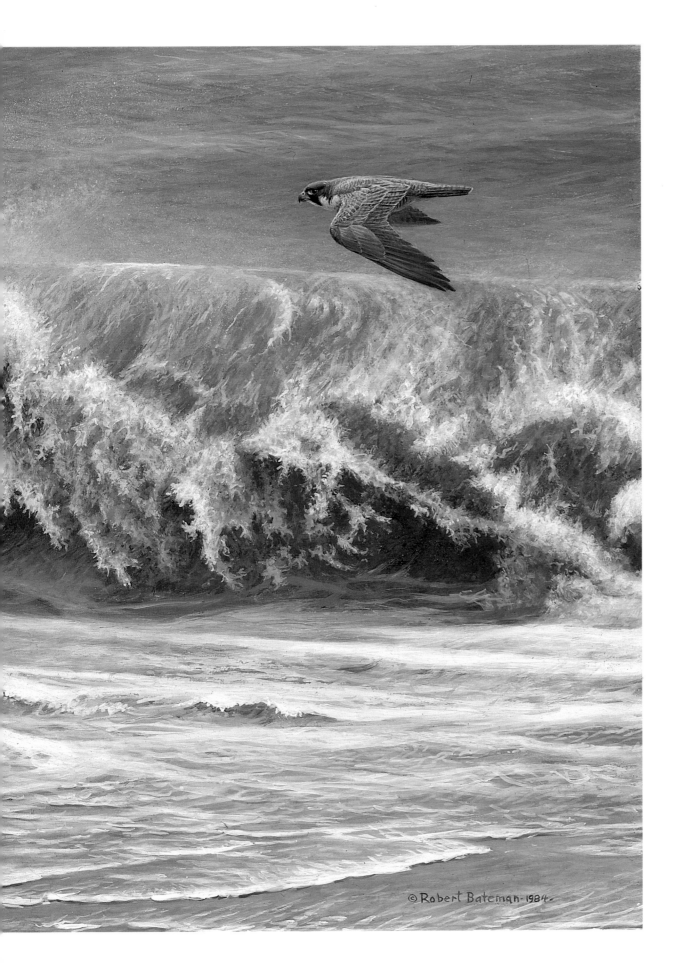

Peregrine Falcon and Turnstones

The most powerful waves I have ever seen were in the Drake Passage between Cape Horn and Antarctica, but the wave in this picture comes a close second. I saw it on the Atlantic seaboard as a hurricane passed by just off the coast. The big waves crashing on the beach sucked tons of sand out to sea and then threw it back again at the shore.

The action of the painting is a whiplash movement from right to left. A wave unleashes itself in a chain reaction like a spark along a dynamite fuse. The left end is disintegrating and bursting in foam, and the top of the spray is whipped off by the buffeting wind.

A peregrine falcon beating his way along the shore has disturbed a flock of ruddy turnstones. I painted them exploding into the wind off to the left of the picture to emphasize the thrust of the waves. The turnstones are a bit small to interest a peregrine, but he would take one if he could catch it easily.

Peregrine and Ruddy Turnstones; acrylic, 18 × 36″, 1984

Laughing Gull and Horseshoe Crab/Dead Gull

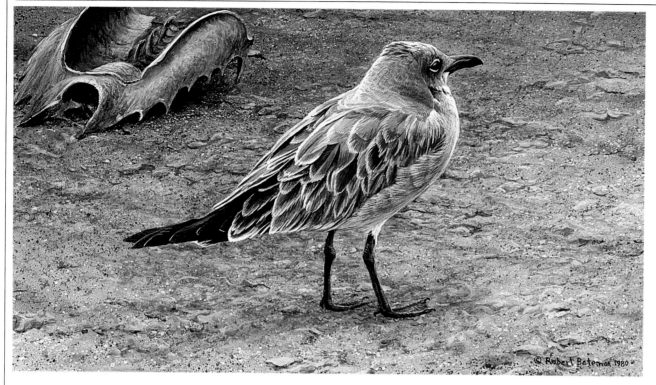

Laughing gulls in their adult breeding plumage are a dapper gray and white with a black head. Here, however, I have shown a young one with its immature feather pattern of cool grays and warm browns.

Laughing gulls congregate by the thousands at Cape May in New Jersey when horseshoe crabs are spawning; they devour the eggs and even the flesh of the adults which are washed ashore. When I looked at the crab's exoskeleton and the young gull together I saw the form of the crab echoed in the form and pattern of the bird.

I enjoy working, as I did here, with a limited, harmonious palette without a great deal of contrast and having to make a statement within those limitations.

While it is true that this painting of the dead ring-billed gull began as an ecological message, I became just as interested in the painting itself, in the modulation and flaring of the bird's feathers in death (in life they are so sleek and streamlined) and in the contrast between the texture of the bird's feathers and the hard, even gravel of Long Point, a long narrow spit that stretches out into Lake Erie. I normally avoid centered, symmetrical compositions, but here the natural landscape had an almost surreal perspective.

The great technical challenge in the painting was to make Long Point seem to lie flat rather than slanting upwards. I did this by gradually decreasing the size of the pebbles and by changing their shape, compressing them from top to bottom and stretching them out from side to side. I also reduced the contrasts between light and dark.

Laughing Gull and Horseshoe Crab; acrylic, 9³⁄4 × 18¹⁄2″, 1980

Dead Gull; acrylic, 35¹⁄2 × 23¹⁄2″, 1968

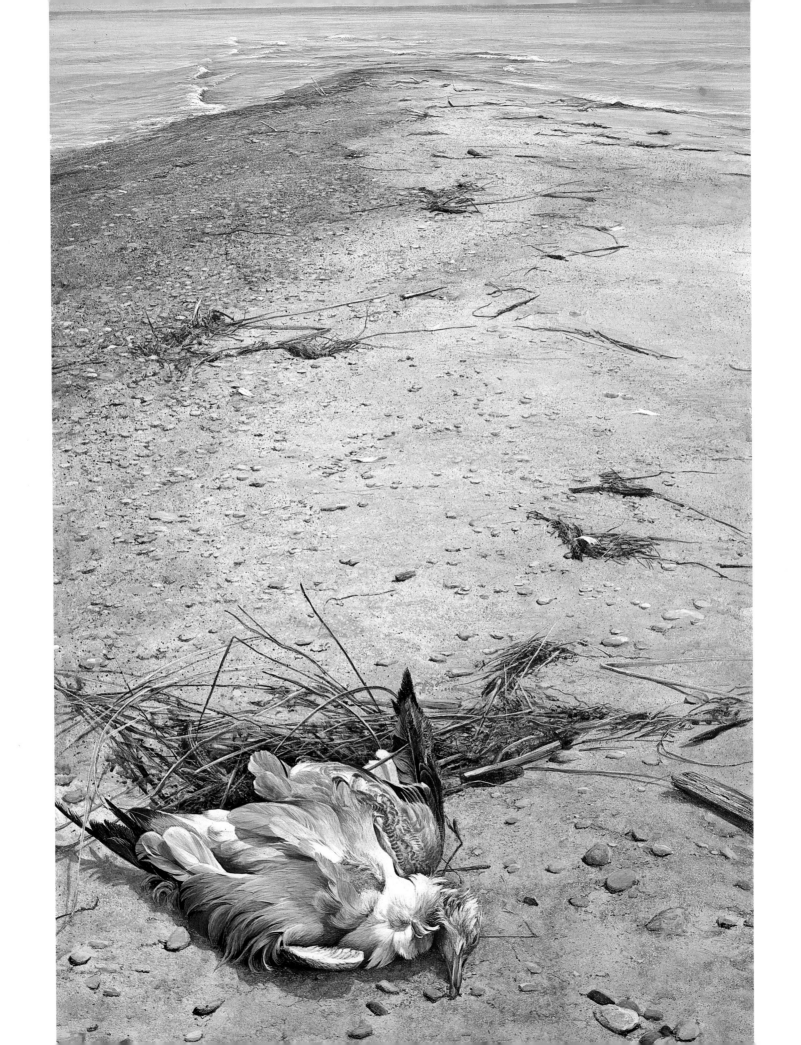

Lily Pads and Loon

Loons are so secretive at nesting time that I have never found the nests of loon pairs on our cottage lake even though I have been going there since I was a boy. It is surprising how a small lake can hide such large birds.

Very few sites are suitable for the nests of loons. Since they cannot walk on land but can only push themselves along, sliding on their bellies, the nest must be only inches from the water buried in grasses or reeds. The nest must also be protected from waves and sheltered from prevailing winds. A power boat's wake in a sheltered bay can easily wipe out the loon-hatching for that year.

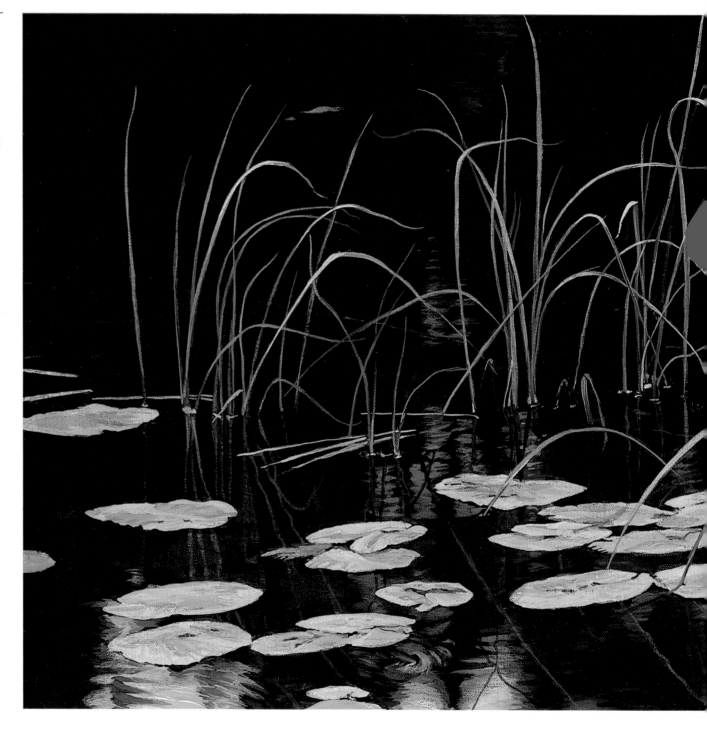

Lily Pads and Loon; acrylic, 16 × 42″, 1970

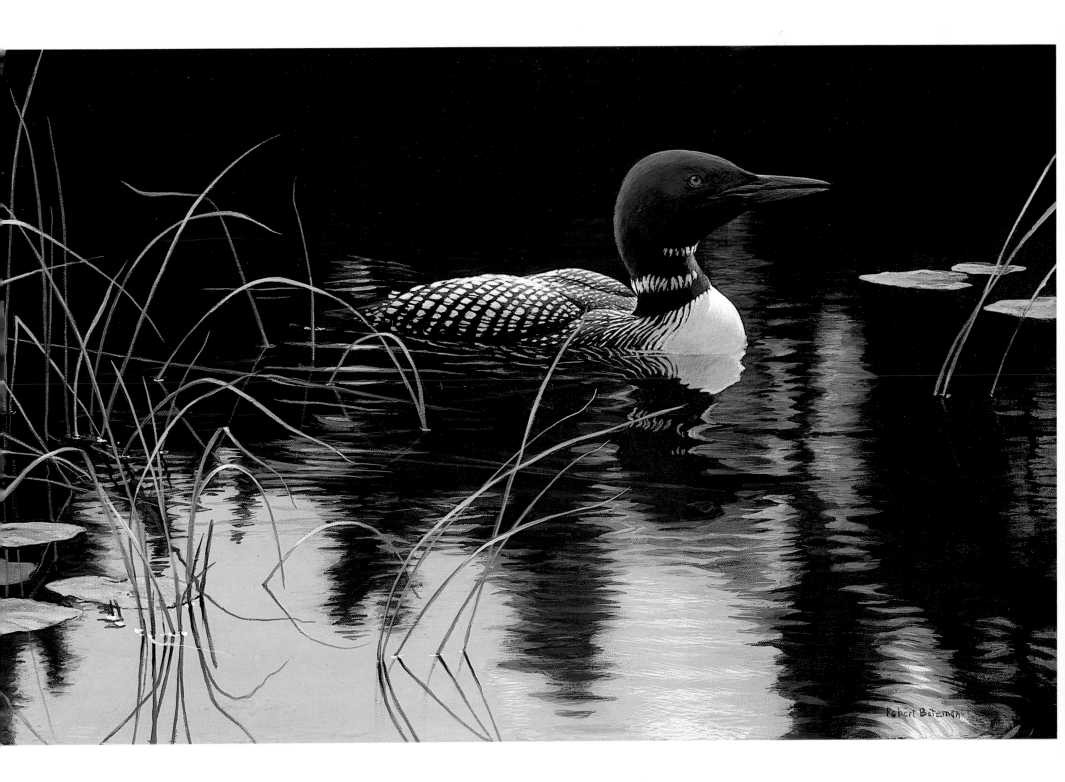
Robert Bateman

Loons

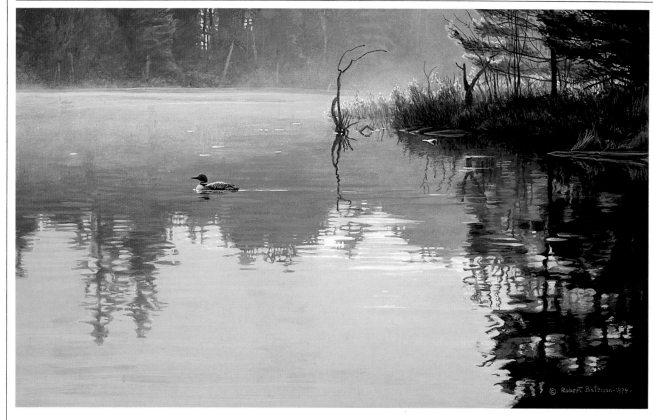

The most magical time to canoe on lakes like the one depicted in *Summer Morning – Loon* is at dawn. I have spent most of the summers of my life on lakes like this one in the Canadian Shield, where the water is still, the wildlife is active, and faint wisps of mist usually give a sense of tangible presence to the air and the atmosphere.

In 1981 I was invited to do a painting which would be the wedding gift of the Government of Canada to Prince Charles. The subject suggested for the painting was loons, which delighted me as they are among my favorite birds with wonderful associations with the Canadian northland. Their ringing call is one of the North's most memorable sounds.

The setting of *Northern Reflections* is in Killarney Park in northern Ontario, and the pre-Cambrian quartzite cliff, the clear water, and the plants and bushes are all very typical of this part of Canada.

Looking at these cliff faces is almost like looking at a painted mural. Nature has been working on it, building up a pattern of lichens and mosses and ferns. I wanted to recreate this mural effect, and established a strong abstract shape which is repeated in the reflection in a broken-up, many-faceted impressionist way. The scene is placid, but the composition's interest comes from the tension set up by having the loons in the bottom right-hand corner and the overhanging hemlock branches up on the left.

The lighting is fundamental to the effect of the painting. I put almost the entire painting in shadow, with the accents coming from the highlights. The early-morning light is striking across the scene, picking up just a bit of the cliff face and the heads of the two adult loons.

Summer Morning – Loon; acrylic, 14¹⁄₈ × 24″, 1979

Northern Reflections – Loon Family; oil, 24 × 36″, 1981

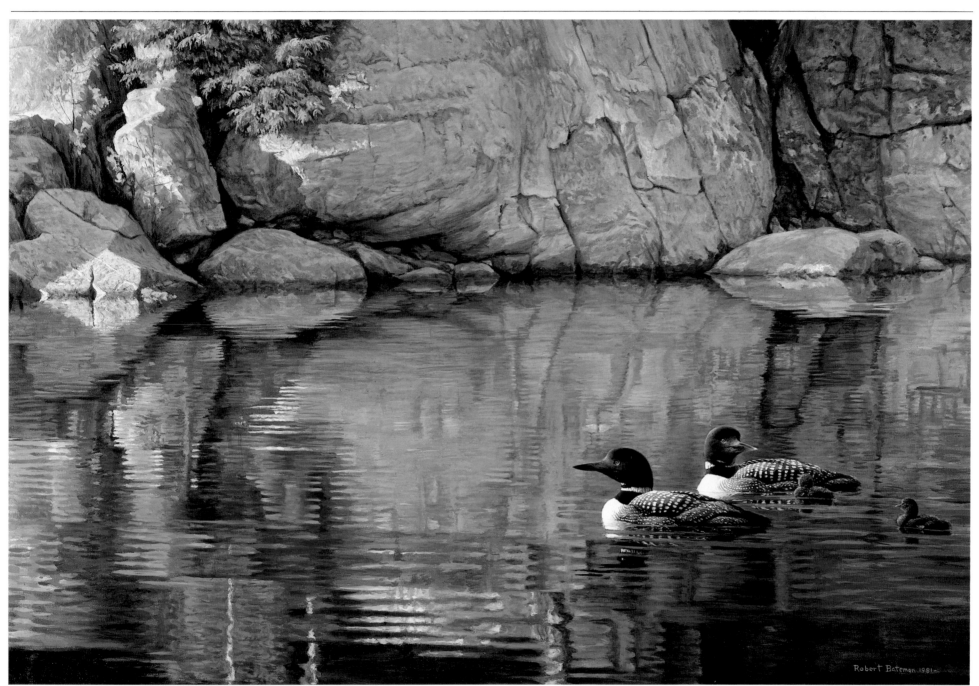

Herring Gulls/Mute Swans

About ten minutes away by canoe from our summer cottage is an island. I usually paddle to it in the early morning or late evening, when the lake is calm and quiet and the colors more interesting. This is also the best time to see wildlife.

Among the birds I never tire of seeing are the herring gulls which roost on the island each night. They are seldom there during the day. Here, two of them are relaxing in the early morning before they set off for a day of feeding. The gulls are perched on the pre-Cambrian gneiss which forms the island and which can be seen beneath the surface of the still water. A feather picked out during preening floats on the surface. To keep the mood easy and relaxed I left the painting relatively empty at the center. This encourages the viewer to let his eyes wander around in a casual way.

The mute swan is a European domestic bird associated with royalty, that has established itself as a wild bird in North America. Here I wanted a mood of domestic tranquillity, and in keeping with the royal connection I gave the painting a silvery, flat look similar to that of a medallion. The floating willow leaf is placed as a garnish, like a piquant sliver of lemon or lime in a cool drink.

The cygnets, of course, are the ugly ducklings of the children's tale. They are not cute, but they do have a sculptural dignity of their own and are not at all like their parents. They form an interacting flotilla with the queenly mother in command.

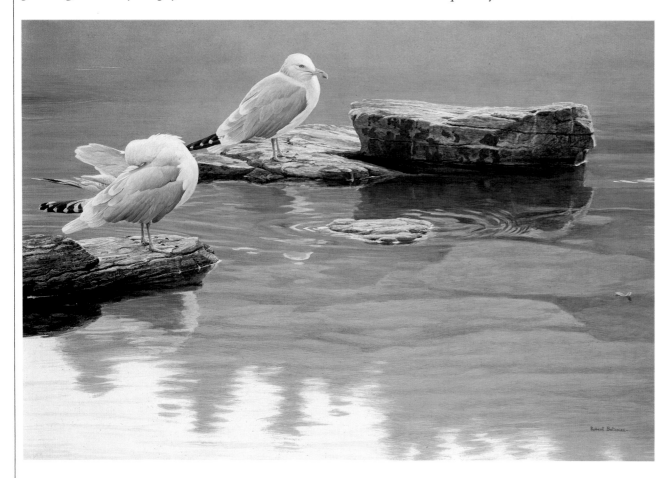

Still Morning – Herring Gulls; acrylic, 24 × 36", 1972

Royal Family – Mute Swans; acrylic, 34 × 52", 1979

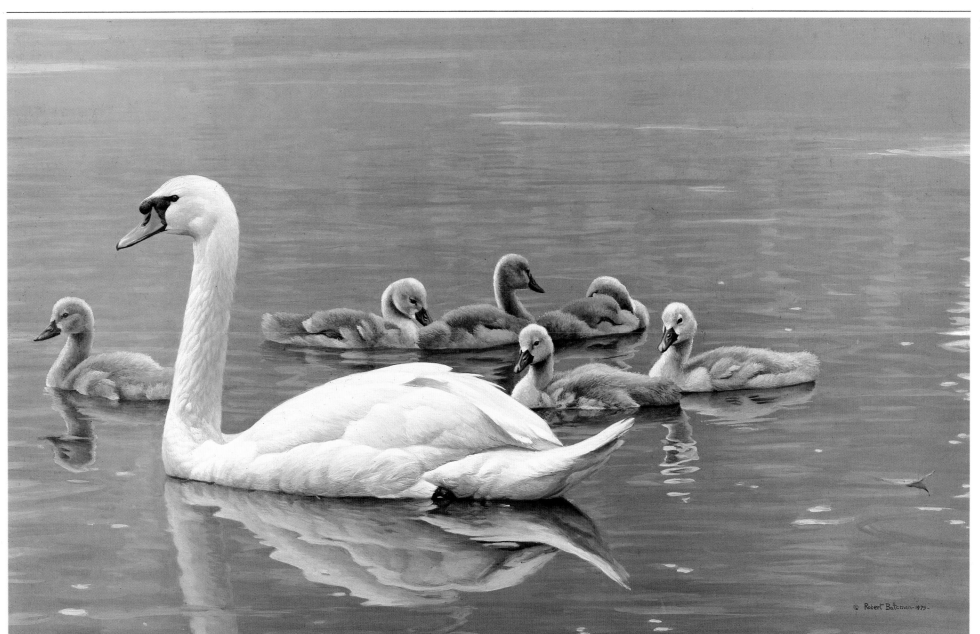

Ruby-throat and Columbine

In this painting I was working to produce a jewel-like effect, showing the columbine, one of the most elegant and beautiful of flowers, and the ruby-throated hummingbird, which is often seen feeding around the columbine. I wanted a dark setting for the flower and the bird, and at first I tried a background of ferns and other dense vegetation. But to give the ferns enough body, they had to have contrast, and to set off the main subjects I had to darken the ferns, and the whole thing began to get very heavy and muddy.

Then I started over, this time with a cliff as a background. The effect of the painting depends a lot on the lighting. Back-lighting can give an outline, an almost theatrical glow to the palest object against a dark background, but the colors must be muted, rather than intense. To give drama to the lighting I had to keep killing the background colors by covering them with thin grayish washes so that they didn't have any really rich dark tones. I saved the purest dark colors and the brightest light ones for the little nicks around the eyes and throat of the hummingbird in order to get it to stand out with air all around it.

That one curving blade of grass suggests the soaring, bounding motion that hummingbirds have. I think it lifts the picture off its rather somber, cool, gray background and gives it buoyancy and lightness.

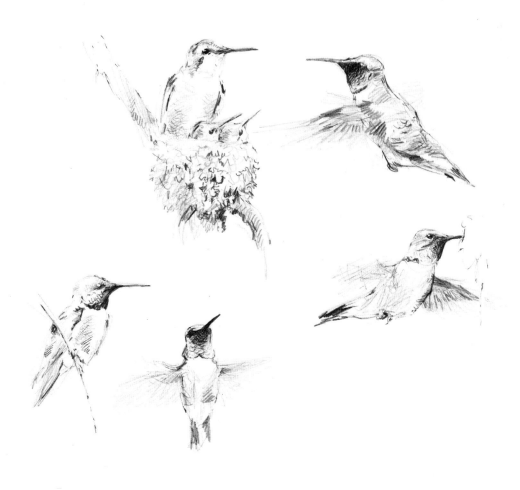

Ruby-throated Hummingbirds; pencil studies, 9 × 11½″, 1985

Ruby-throat and Columbine; acrylic, 12 × 16″, 1983

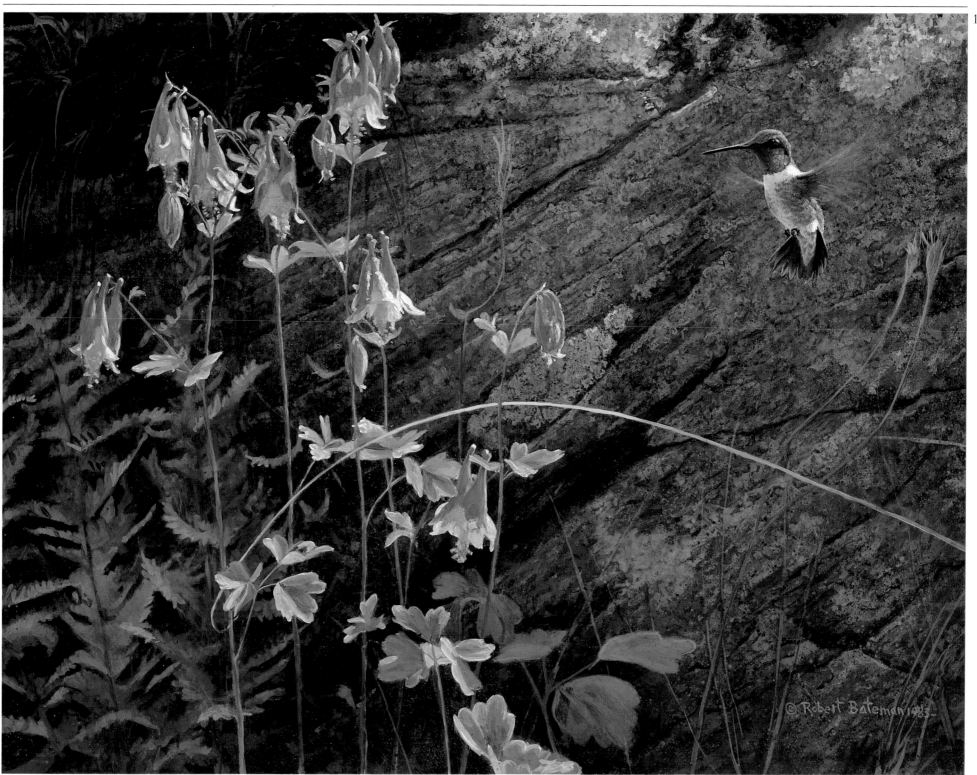

Moose

I visited Banff National Park recently in the early winter, just before Christmas. At this time of year the days are very short, and whenever it was light, I was out looking for settings and interesting wildlife habitats. One day, when I was on the way home in the late afternoon, thinking I'd seen everything there was to see that day, I was struck by this wonderful scene with its strong colors and contrasts and the variety of textures in the water, ice, and snow.

I sometimes resist using the spectacular strong romantic settings and dark, lush colors that are associated with nineteenth-century art, but here they seemed appropriate and I decided to go ahead and enjoy them. In fact, the painting is typical of my work in a number of ways. In the composition I found and developed a set of powerful interlocking dark and light abstract shapes that have their own dynamic force. As always, this was the main and originating reason for doing the painting.

Another, secondary, characteristic of my work is the attention given to the particular natural history of the landscape. In this picture I have tried to convey the feeling of the end of a clear winter day, when the temperature is just below freezing and there is a slight mist rising off the water. Besides the landforms of the Rockies, I wanted to show the ecology of this scene — the various evergreen trees and the bushes, the beaver dam and its effects on the river and the nearby trees. The animal subject, the moose, is a natural part of this world, and I have shown him as he would most likely be seen, comparatively inconspicuous, partly hidden by the trees and shadows. In most of my paintings the elements come from different sources, and in this case the moose was one I had previously seen in another part of Alberta.

The setting has its own importance for me. The painting was commissioned as part of the centenary celebration of the establishment of Canada's National Parks system. Banff was the first of the parks to be established, in 1885, and like Yellowstone Park in the United States it represented the first serious effort on the part of the government to conserve our natural heritage. For me the preservation and celebration of the natural world is a continual concern and it is an underlying motive for virtually all of my art.

Winter Sunset — Moose; acrylic, 24 × 36″, 1984

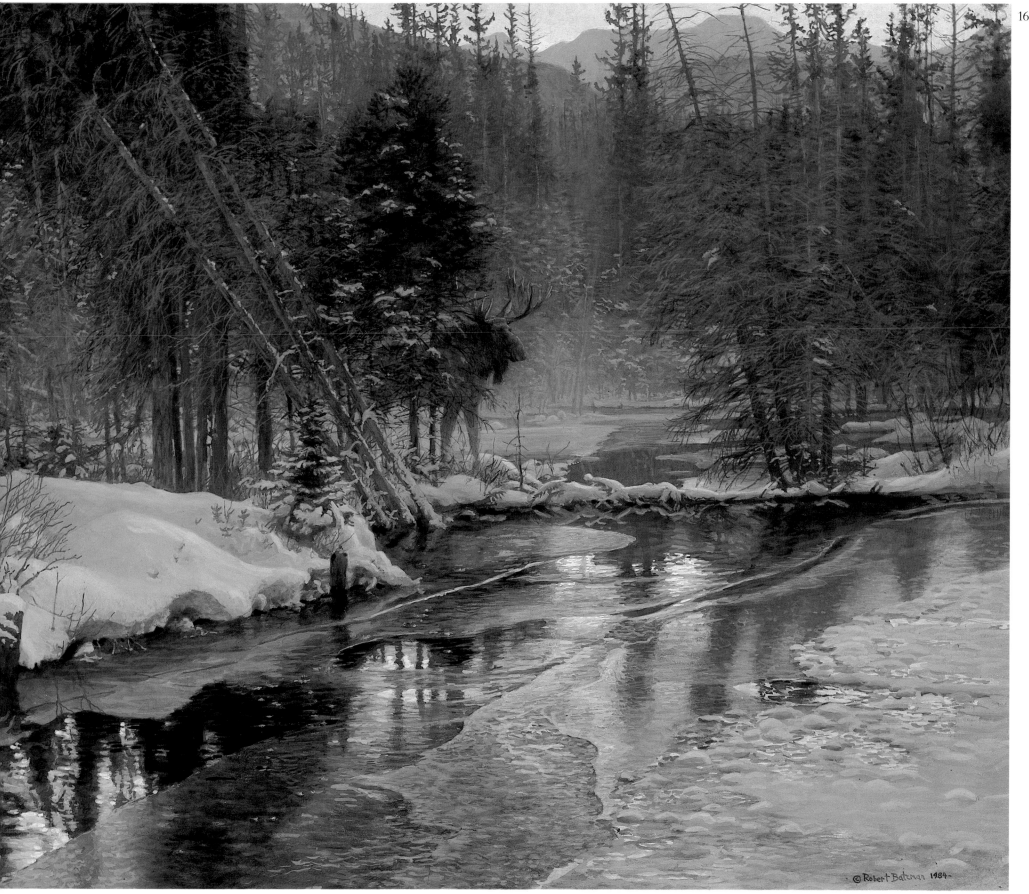

© Robert Bateman 1984

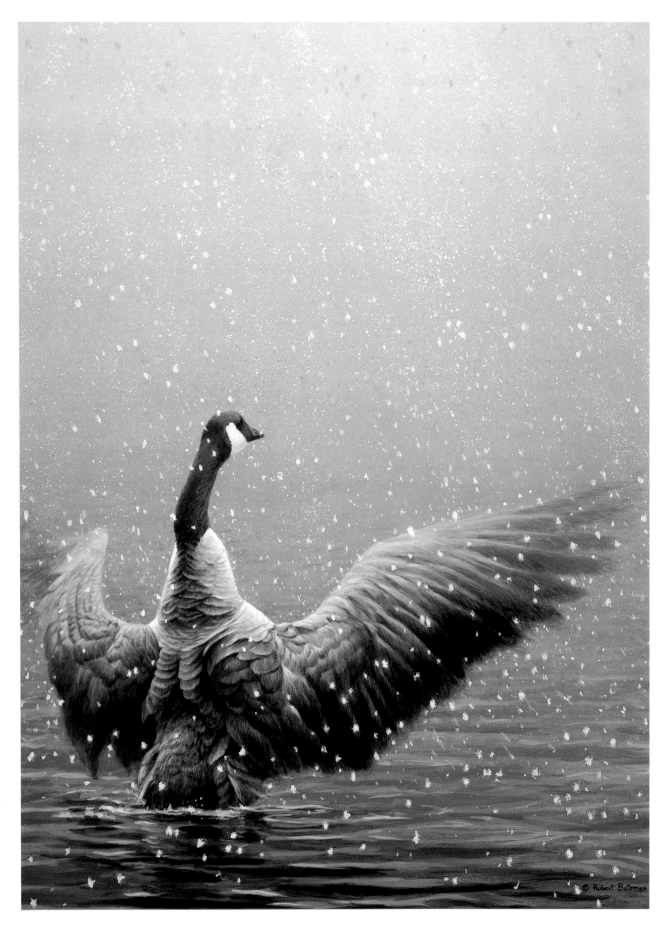

Stretching – Canada Goose; acrylic, 36 × 28″, 1983

APPENDIX

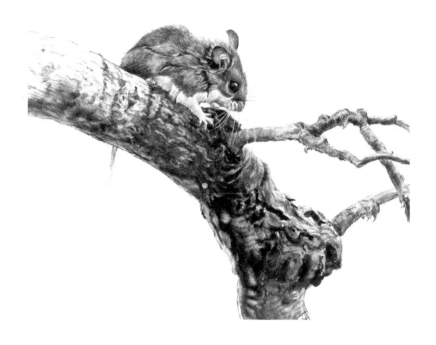

INDEX TO THE COLOR PLATES AND DRAWINGS

*These works, as well as other paintings by Robert Bateman, have
been published as limited edition prints by Mill Pond Press. For
more information about their print publishing program please direct
inquiries to the appropriate address.

In the United States:
Mill Pond Press Inc.
204 S. Nassau Street
Venice, Florida
33595

In Canada:
Nature's Scene
991 Matheson Blvd.
Mississauga, Ontario
L4W 2V3

EXHIBITIONS

1959 — Hart House Gallery, University of Toronto, Toronto, Ontario, Canada

1967 — Alice Peck Gallery, Burlington, Ontario, Canada

1968 — York University, Toronto, Ontario, Canada (group exhibition)

1969 — Pollock Gallery, Toronto, Ontario, Canada

1971 — Beckett Gallery, Hamilton, Ontario, Canada

1972 — *Bird Artists of the World,* Tryon Gallery, London, England (group exhibition)

1974 — *The Acute Image in Canadian Art,* Mount Allison University, Sackville, New Brunswick, Canada (group exhibition)

1975 — *Endangered Species,* Tryon Gallery, London, England (group exhibition)
— *One Man's Africa,* Tryon Gallery, London, England
— *Animals in Art,* Royal Ontario Museum, Toronto, Ontario, Canada (group exhibition)
— *African Bird Art,* Peter Wenning Gallery, Johannesburg, South Africa (group exhibition)
— *Canadian Nature Art,* travelling exhibit sponsored by the Canadian Nature Federation (group exhibition)

1976 — Beckett Gallery, Hamilton, Ontario, Canada

1977 — *Birds of Prey,* Glenbow-Alberta Institute, Calgary, Alberta, Canada (group exhibition)
— *Queen Elizabeth Jubilee Exhibition,* Tryon Gallery, London, England (group exhibition)
— *Federation of Ontario Naturalists Exhibition,* University of Guelph, Guelph, Ontario, Canada (group exhibition)
— *1977 Bird Art Exhibition,* Leigh Yawkey Woodson Art Museum, Wausau, Wisconsin, U.S.A. (group exhibition)
— *A Wildlife Exhibition,* Tryon Gallery, London, England
— *Wolves: Fact versus Fiction,* The Gallery, First Canadian Place, Toronto, Ontario, Canada (group exhibition)

1978 — Art Gallery of Hamilton, Hamilton, Ontario, Canada
— Lynnwood Art Gallery, Simcoe, Ontario, Canada
— *Northwest Rendezvous Group Exhibition,* National Historical Society Building, Helena, Montana, U.S.A. (group exhibition)
— *1978 Bird Art Exhibition,* Leigh Yawkey Woodson Art Museum, Wausau, Wisconsin, U.S.A. (group exhibition)
— Beckett Gallery, Hamilton, Ontario, Canada

— *The Artists and Nature,* travelling exhibit sponsored by the Canadian Wildlife Federation and the National Museum of Natural Sciences, Ottawa, Ontario, Canada (group exhibition)

1979 — *Society of Animal Artists Exhibition,* Sportsman's Edge Ltd., New York, U.S.A. (group exhibition)
— *Four Continents; Birds, Animals and their Environments,* Tryon Gallery, London, England
— *Wildlife Art,* Cowboy Hall of Fame, Oklahoma City, Oklahoma, U.S.A. (group exhibition)
— *Northwest Rendezvous Group Exhibition,* National Historical Society Building, Helena, Montana, U.S.A. (group exhibition)
— *1979 Bird Art Exhibition,* Leigh Yawkey Woodson Art Museum, Wausau, Wisconsin, U.S.A. (group exhibition)
— *The Dofasco Collection,* Art Gallery of Hamilton, Hamilton, Ontario, Canada (group exhibition)

1980 — St. Louis Museum of Science and Natural History, St. Louis, Missouri, U.S.A
— *Selections from the Dofasco Collection,* Art Gallery of Brant, Brantford, Ontario, Canada (group exhibition)
— *Birds,* Smithsonian Institution, Washington, D.C., U.S.A. (group exhibition)
— *Northwest Rendezvous Group Exhibition,* National Historical Society Building, Helena, Montana, U.S.A. (group exhibition)
— *Trailside Group Exhibition,* Trailside Gallery, Jackson Hole, Wyoming, U.S.A. (group exhibition)
— *1980 Bird Art Exhibition,* Leigh Yawkey Woodson Art Museum, Wausau, Wisconsin, U.S.A. (group exhibition)
— *Society of Animal Artists Exhibition,* Four Seasons Internacional, San Antonio, Texas, U.S.A. (group exhibition)
— Sportsman's Edge Ltd., New York, New York, U.S.A
— Beckett Gallery, Hamilton, Ontario, Canada
— Trailside Gallery, Jackson Hole, Wyoming, U.S.A. (two-man exhibition)

1981 — *Images of the Wild,* travelling exhibit, sponsored by the National Museum of Natural Sciences, Ottawa, Ontario, Canada. The final appearance of this exhibit took place in 1983 at the Royal Ontario Museum in Toronto, Ontario, Canada.
— *Canadian Nature Art Exhibition,* University of Guelph, Guelph, Ontario, Canada, sponsored by the Canadian Nature Federation (group exhibition)
— *Trailside Gallery Miniature Show,* Jackson Hole, Wyoming, U.S.A. (group exhibition)

— *1981 Bird Art Exhibition,* Leigh Yawkey Woodson Art Museum, Wausau, Wisconsin, U.S.A. (group exhibition)
— *Northwest Rendezvous Group Exhibition,* National Historical Society Building, Helena, Montana, U.S.A.
— *Settler's West Miniature Show,* Tucson, Arizona, U.S.A. (group exhibition)

1982 — Mzuri Safari Foundation, Reno, Nevada, U.S.A. (group exhibition)
— *Trailside Gallery Miniature Show,* Jackson Hole, Wyoming, U.S.A. (group exhibition)
— *1982 Bird Art Exhibition,* Leigh Yawkey Woodson Art Museum, Wausau, Wisconsin, U.S.A. (group exhibition)
— *Northwest Rendezvous Group Exhibition,* National Historical Society Building, Helena, Montana, U.S.A. (group exhibition)
— *Settler's West Miniature Show,* Tucson, Arizona, U.S.A. (group exhibition)
— Musée du Québec, Quebec City, Quebec, Canada
— Museum of Man and Nature, Winnipeg, Manitoba, Canada
— Provincial Museum of Alberta, Edmonton, Alberta, Canada
— Centennial Museum, Vancouver, British Columbia, Canada
— *Le Conseil International de la Chasse et de la Conservation du Gibier* Annual Meeting, Monte Carlo, Monaco, sponsored by the Canadian Wildlife Federation. After the meeting, this one-man exhibit began an extensive European tour.

1983 — *Images of the Wild,* travelling exhibit, began at the California Academy of Sciences, San Francisco, California, U.S.A. The final appearance of this exhibit took place in 1985 at the Greenville County Museum of Art, Greenville, South Carolina.
— *Trailside Gallery Miniature Show,* Jackson Hole, Wyoming, U.S.A. (group exhibition)
— *1983 Bird Art Exhibition,* Leigh Yawkey Woodson Art Museum, Wausau, Wisconsin, U.S.A. (group exhibition)
— *Northwest Rendezvous Group Exhibition,* National Historical Society Building, Helena, Montana, U.S.A.
— *Settler's West Miniature Show,* Tucson, Arizona, U.S.A. (group exhibition)
— Durham Art Gallery, Durham, Ontario, Canada
— *National Art Exhibition of Alaska,* Audubon Society of Alaska, Anchorage, Alaska, U.S.A. (Robert Bateman appeared as both featured artist and judge.)

EXHIBITIONS

1984 — *Robert Bateman — The Early Years,* Georgetown Art Gallery, Georgetown, Ontario, Canada
— *Science Museum of Virginia Print Exhibit,* Richmond, Virginia, U.S.A.
— *Bird Artists of the World,* Everard Read Gallery, Johannesburg, South Africa (group exhibition)
— *Northwest Rendezvous Group Exhibition,* National Historical Society Building, Helena, Montana, U.S.A.
— *1984 Bird Art Exhibition,* Leigh Yawkey Woodson Art Museum, Wausau, Wisconsin, U.S.A. (group exhibition)
— *Trailside Gallery Miniature Show,* Jackson Hole, Wyoming, U.S.A. (group exhibition)
— *Settler's West Miniature Show,* Tucson, Arizona, U.S.A. (group exhibition)
— *Mzuri,* Safari Foundation, Reno, Nevada, U.S.A. (group exhibition)

1985 — *The World of Robert Bateman,* Tryon Gallery, London, England

BOOKS

The Nature of Birds, in the series "The Illustrated Natural History of Canada," edited by Stanley Fillmore, McClelland and Stewart; Toronto, Canada, 1974. Pages 2-3, 28-29, 46-47, 88-89, 104-105, 134-135.

The Art of Robert Bateman, Ramsay Derry, Madison Press Books/Allen Lane, Penguin Books Canada Ltd./ The Viking Press; Toronto, Canada, and New York, U.S.A., 1981.

Wildlife Artists at Work, Patricia Van Gelder, Watson-Guptill Publications; New York, U.S.A., 1982. Pages 18-33.

FILMS

Robert Bateman. Canadian Broadcasting Corporation, produced by John Lacky for *This Land,* 1972.

Images of the Wild: A Portrait of Robert Bateman. National Film Board of Canada, directed by Norman Lightfoot, produced by Beryl Fox, 1978.

The Nature Art of Robert Bateman. Eco-Art Productions, produced by Norman Lightfoot, 1981.

Robert Bateman: A Celebration of Nature: Canadian Broadcasting Corporation, produced by Brigitte Berman for *Take 30,* 1983.

Robert Bateman: Artist and Naturalist: Canadian Broadcasting Corporation, produced by Donnalu Wigmore as a one-hour special, October 1984.

PUBLICATIONS

The Conservationist: Wayne Trimm, "Robert Bateman," pp. 22-26, vol. 36, no. 1, July/ August 1981.

Maclean's: vol. 94, no. 47, November 1981.

Reader's Digest (Canadian): from the introduction by Roger Tory Peterson to *The Art of Robert Bateman,* "The Wild and Beautiful World of Robert Bateman," pp. 98-105, November 1981.

Equinox: Frank B. Edwards, "Unfettered Realism," pp. 50-61, vol. 1, no. 1, January 1982.

Forêt Conservation: Jean-Pierre Drapeau, "Reflects de la nature," pp. 31-34, vol. 48, no. 8, janvier 1982.

Reader's Digest (United States): from the introduction by Roger Tory Peterson to *The Art of Robert Bateman,* "The Wild and Beautiful World of Robert Bateman," pp. 98-105, February 1982.

Reader's Digest (World): from the introduction by Roger Tory Peterson to *The Art of Robert Bateman,* "The Wild and Beautiful World of Robert Bateman," pp. 98-105, February 1982.

Intrepid: Greg Stott, "Robert Bateman," pp. 8-17, vol. 7, no. 4, Summer 1982.

City & Country Home: Kay Kritzwiser, "The Artist," pp. 126-129; Elaine Sills, "A Visit with Robert Bateman at Home," pp. 130-135, vol. 1, no. 1, Fall 1982.

Art West: Diane Ciarloni Simmons, "Robert Bateman: A World of Surprises!" pp. 88-97, vol. 5, no. 6, October/ November 1982.

Camera Canada: Greg Stott, "An Interview with Robert Bateman," pp. 8-16, 39-40, no. 54, November 1982.

Kosmos: "Mit den Augen Robert Batemans," pp. 42-47, Heft 10, Oktober 1983.

Cuesta: "The Escarpment Art of Robert Bateman," pp. 21-26, p. 29, Spring 1983.

Saturday Night: Mark Abley, "The Painted Bird," pp. 61-63, vol. 99, no. 6, June 1984.

Grasduinen: Margriet Winters, "Robert Bateman," pp. 12-18, no. 10, October 1984 (Holland).

Prints: "Robert Bateman," pp. 18-25, p. 65, vol. 6, no. 5, December 1984.

COMMISSIONS

1976 — World Wildlife Fund: designed a relief sculpture of a polar bear for a limited edition silver bowl to raise funds for endangered species.

1977 — Canada Post: designed the annual stamp series depicting endangered species.
— Board of Trade of Metropolitan Toronto, Ontario, Canada: painted "Window into Ontario".
— Tryon Gallery, London, England: painted "King of the Realm" for the Queen Elizabeth Jubilee Exhibition.

1980 — *American Artist* magazine: painted "Kingfisher in Winter" for the *American Artist* Collection.

1981 — Government of Canada: painted "Northern Reflections — Loon Family" which was presented to H.R.H. Prince Charles, the Prince of Wales, as a wedding gift from the people of Canada.

1985 — Art Gallery of Hamilton, Hamilton, Ontario, Canada: Commission in progress.

HONORS

1977 — Queen Elizabeth's Silver Jubilee Medal (Canada).

1979 — Award of Merit, Society of Animal Artists.

1980 — Artist of the Year, *American Artist* magazine.
— Honorary Life Member, The Audubon Society.
— Honorary Life Member, The Canadian Wildlife Federation.
— Honorary Life Member, The Burlington (Ontario) Cultural Centre.
— Hamilton-Wentworth Regional Government Excellence in the Arts Award for contribution to the artistic community.
— Award of Merit, Society of Animal Artists.

1981 — Honorary Life Member, The Federation of Ontario Naturalists.
— Award of Merit, *Northwest Rendezvous Group Exhibition,* Helena, Montana, U.S.A.
— Award of Merit, Society of Animal Artists.

1982 — Honorary Member, The Federation of Canadian Artists.
— Doctor of Science, *honoris causa,* Carleton University, Ottawa, Ontario, Canada.
— Doctor of Laws (for Fine Arts), *honoris causa,* Brock University, St. Catharines, Ontario, Canada.
— Master Artist, Leigh Yawkey Woodson Art Museum, Wausau, Wisconsin, U.S.A.

1983 — Doctor of Letters (for Fine Arts), *honoris causa,* McMaster University, Hamilton, Ontario, Canada.

1984 — Officer of the Order of Canada.
— The Bicentennial Medal for Ontario for service to the community.

1985 — Doctor of Laws, *honoris causa,* University of Guelph, Guelph, Ontario, Canada.

ROBERT BATEMAN: A CHRONOLOGY

1930 — Born May 24 in Toronto, Ontario, Canada to Joseph Wilberforce Bateman and Annie Maria Bateman (nee McLellan). He is the first of three children; brothers John (Jack) and Ross are born in 1933 and 1936.

1935-43 — Attends primary and elementary school.

1938 — Bateman family rents and eventually purchases a summer cottage in the Haliburton lakes region of Ontario. Time spent here is an important part of Bob's development as an artist and naturalist.

1942 — Joins the Junior Field Naturalist's Club at the Royal Ontario Museum. During his adolescent and teen years there he develops his birdwatching skills and ornithological knowledge under the influence of James L. Baillie and Terence Shortt. Shortt, an outstanding bird painter, is a major and long-lasting influence.

1943-48 — Attends high school at Forest Hill Collegiate in Toronto. During high school he is active in the Biology Club of the University of Toronto.

1947-49 — Spends three summers working at a government wildlife research camp in Algonquin Park in northern Ontario. Here his enthusiasm grows for the landscapes of the painters of the Canadian Group of Seven school.

1948 — Begins taking painting lessons from Gordon Payne, a well-respected Toronto artist, who teaches him the basic skills of representational painting.

1950 — Travels to Vancouver Island by bus, painting and sketching with his friend Erik Thorn.

1950-54 — Attends the University of Toronto in a four-year honors course in geography. Also takes evening courses in the Nikolaides method of drawing from Carl Schaefer. Summer jobs on geological field parties take him to Newfoundland, Ungava Bay, and Hudson Bay.

1954 — Graduates from university and takes a painting and sketching tour of Europe and Scandinavia.

1954-63 — Experiments with a range of painting styles. From the influence of impressionism and the Canadian Group of Seven, he moved into a cubist phase, and, finally, embraced an abstract-expressionist style.

1955 — Receives a teaching certificate from the Ontario College of Education and begins a career as a high school teacher of geography and art in Thornhill, Ontario.

1957-58 — A round-the-world trip in a Land Rover with friends Bristol Foster and Erik Thorn takes him to England, Africa, India, Sikkim, Burma, Thailand, Malaysia, and Australia.

1958 — Resumes his teaching career in Burlington, Ontario.

1960 — Marries Suzanne Bowerman, a sculpture student at the Ontario College of Art.

1962 — Attends a major Andrew Wyeth exhibition at the Albright-Knox Gallery in Buffalo, New York. This encourages him to return to a realist style of painting.

1963-65 — Spends two years teaching in Nigeria under the sponsorship of Canada's External Aid program. Here he begins painting African wildlife in a naturalist style and begins exhibiting at the Fonville Gallery in Nairobi.

1965 — A first child, Alan, is born in Nigeria. Later in the year, the family returns to Canada where Bateman resumes teaching in Burlington, Ontario. He continues to paint African wildlife pictures for the Fonville Gallery in Kenya and begins painting Ontario landscapes and rural settings in a realistic style.

1966 — A second child, Sarah, is born.

1967 — A series of historical scenes of Halton County, Ontario, are painted as the artist's own Canadian Centennial project and are shown at the Alice Peck Gallery in Burlington, Ontario.

1968 — John, the third Bateman child, is born.

1969 — A one-man show is held at the Pollock Gallery in Toronto.

1971 — A well-received show at the Beckett Gallery in Hamilton, Ontario, encourages him to concentrate on wildlife paintings.

1975 — A large show at the Tryon Gallery in London, England, one of the world's foremost galleries of wildlife art, is sold out. This convinces him that he should paint full time.
— *Animals in Art,* a group exhibition at the Royal Ontario Museum in the same year, brings his work to Canadian attention.
— Marries Birgit Freybe after his first marriage concludes in divorce.

1976 — A fourth child, Christopher, is born.

1978 — Shows are held at the Beckett Gallery, Hamilton, and the Art Gallery of Hamilton, Ontario.
— Mill Pond Press begins distributing Bateman images as limited-edition, signed prints. Over 180 Bateman paintings have become prints since this program was launched.
— Travels to the Falkland Islands and the Antarctic aboard the Lindblad *Explorer.*

1979 — Robbie Bateman, a fifth child, is born.

1980 — Drawing lots for paintings is required at sold-out shows at the Beckett Gallery and The Sportsman's Edge Gallery in New York City.
— Bateman is named "Artist of the Year" by *American Artist* magazine.
— Visits Ecuador and the Galapagos Islands.

1981 — *Images of the Wild,* a major Bateman show organized by the National Museum of Natural Sciences, opens in Ottawa, Canada, and travels to museums in Quebec City, Winnipeg, Vancouver, and Toronto over the next two years.
— *Northern Reflections — Loon Family,* a painting commissioned by the Governor-General of Canada, is the official wedding gift of the people of Canada to Prince Charles.
— *The Art of Robert Bateman* is published, a large-format art book featuring over eighty color reproductions of Bateman paintings, with an introduction by Roger Tory Peterson and a text by Ramsay Derry.
— Visits New Zealand, Australia's Great Barrier Reef, and Melanesia.

1982 — Explores the Queen Charlotte Islands.
— Bateman and three of his children visit the game parks of East Africa.

1983 — The *Images of the Wild* exhibit opens at the California Academy of Sciences in San Francisco, and eventually travels to St. Louis, Cleveland, Cincinnati, and Greenville, South Carolina.
— He visits Alaska for the first time.

1984 — Bateman is named an Officer of the Order of Canada.
— *Robert Bateman: Artist and Naturalist,* a one-hour television documentary, is shown on the Canadian Broadcasting network.

1985 — The Tryon Gallery in London exhibits a major Bateman show.
— *The World of Robert Bateman,* a second book devoted to the work of Robert Bateman, is published.

DESIGN AND ART DIRECTION	V. John Lee
ASSEMBLY	Gerard Williams
PRODUCTION	Susan Barrable
PRODUCTION ASSISTANCE	Jane Rubel
EDITORIAL	Hugh Brewster
EDITORIAL ASSISTANCE	Mary Adachi
	Rick Archbold
	Sarah Reid
	Shelley Tanaka
PRODUCTION PHOTOGRAPHY	Mill Pond Press Inc.
	Thomas Moore Photography Inc.
TYPOGRAPHY	Shervill-Dickson Limited
COLOR SEPARATION AND PRINTING	Amilcare Pizzi S.p.A.
BINDING	Legatoria Industriale Olivotto

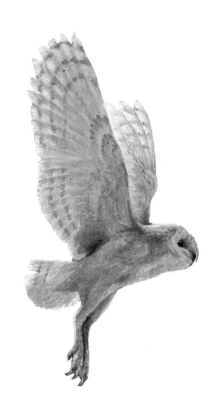

THE WORLD OF ROBERT BATEMAN

was produced by Madison Press Books

under the direction of A. E. Cummings